Watercolour Painter's Handbook
Step by Step

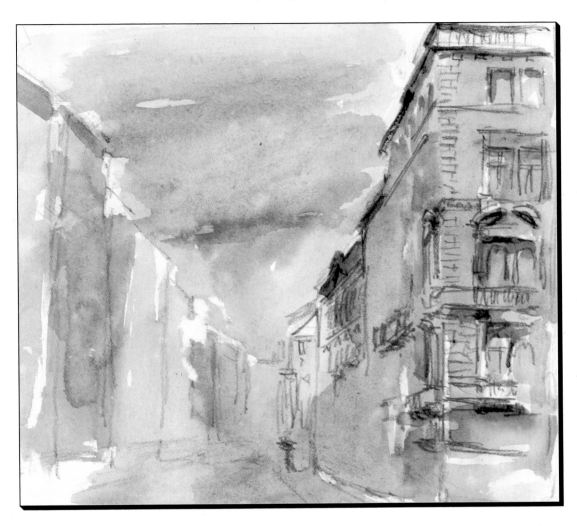

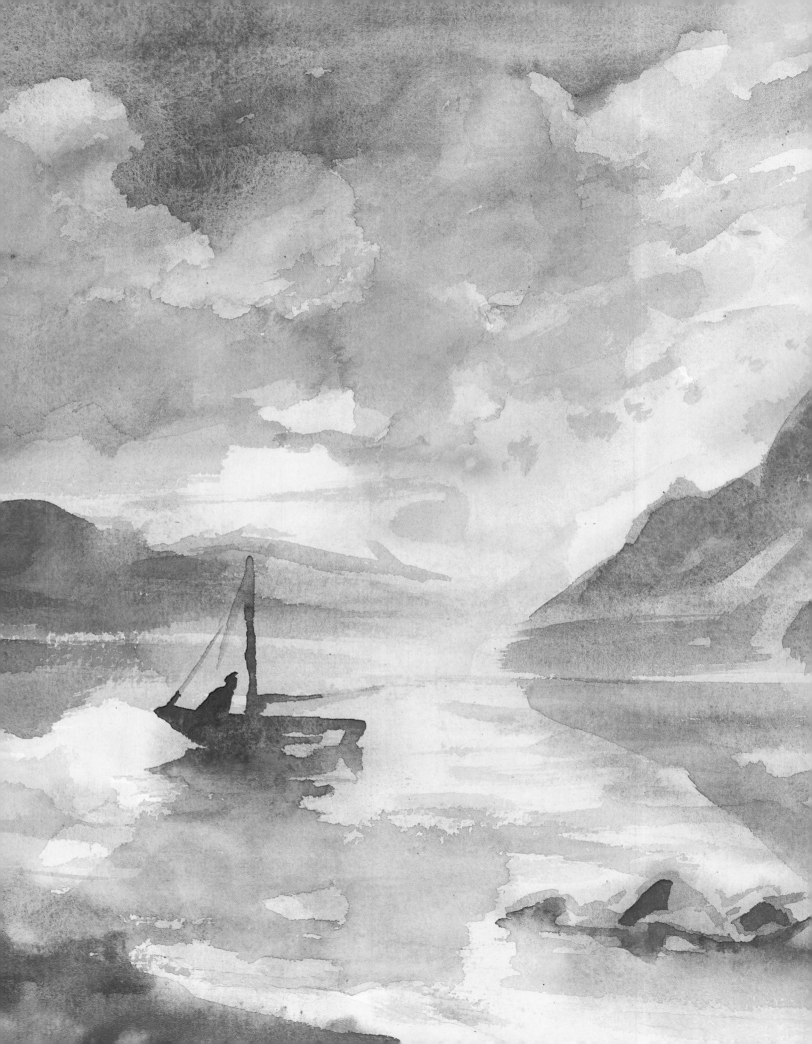

Watercolour Painter's Handbook
Step by Step

by MIROSLAV HRDINA

CAXTON EDITIONS

Designed and produced by Aventinum Publishers, Prague,
Czech Republic
This edition published in 2000 by CAXTON EDITIONS, an imprint of
the Caxton Publishing Group, 20 Bloomsbury Street,
London WC1B 3JH
Reprint 2002

© 1999 AVENTINUM NAKLADATELSTVÍ, s.r.o.

Text by Miroslav Hrdina
Translated by Jiří Krojzl
Edited by R. Elizabeth Novak and Zdenka Matysová
Photographs by Jiří Bašta (pp. 23, 60, 83),
Tate Gallery, London (pp. 8–9), and
National Gallery in Prague (pp. 10–19)
Graphic design by Vlasta Srbová

ISBN 1-84067-130-0
Printed in the Czech Republic by Polygrafia, a.s., Prague
2/15/03/51-03

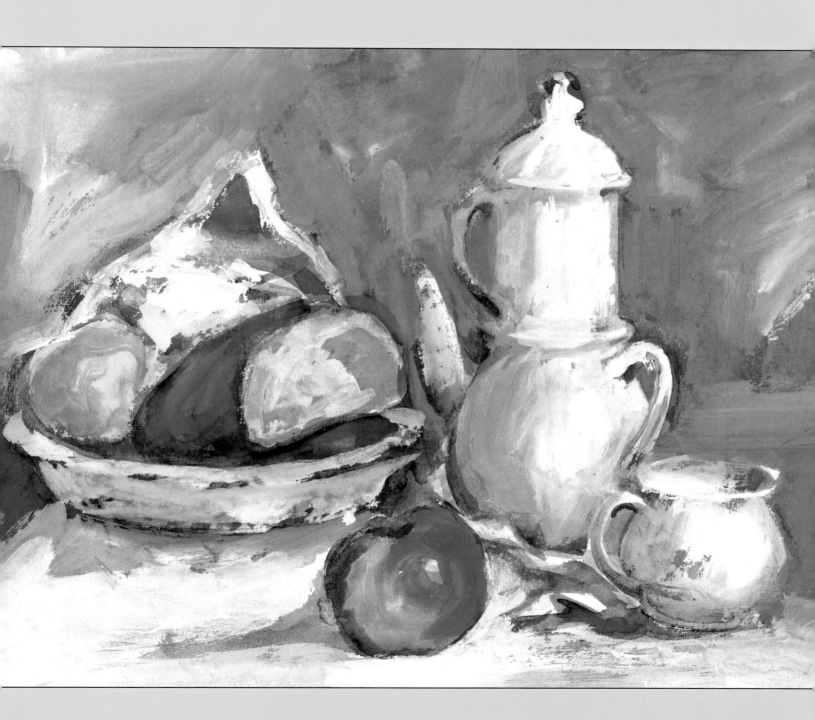

Contents

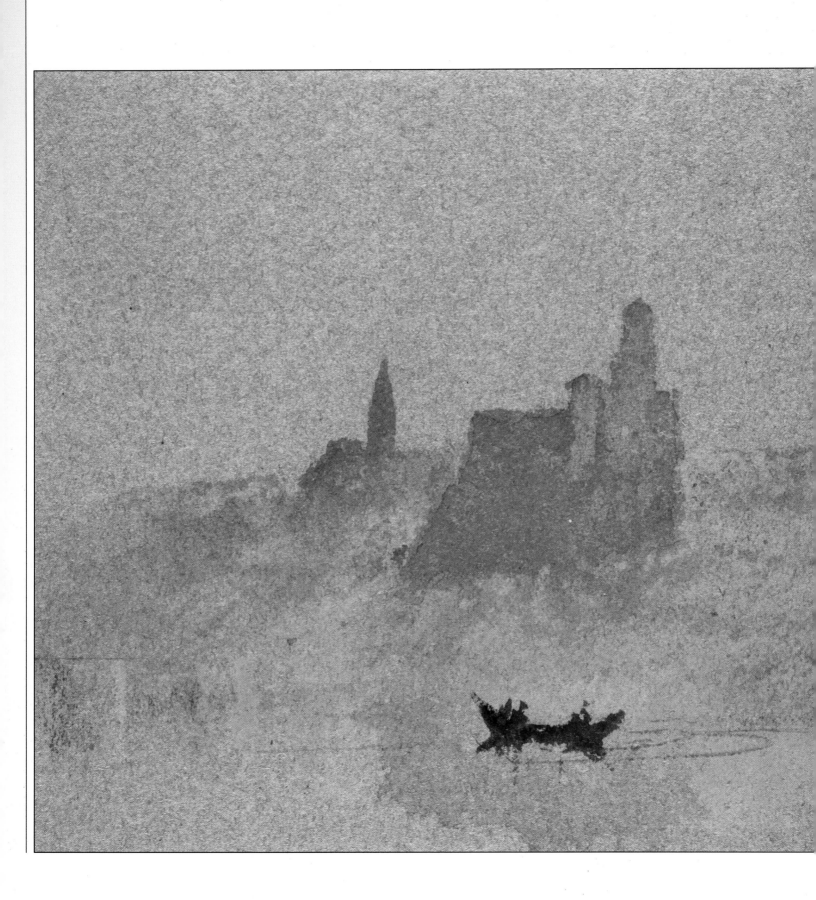

Introduction

When studying the works of great classical or modern watercolourists it is impossible not to be impressed by their consummate skill.

Large oil-paintings with more demanding compositions may overwhelm the viewer with their very complexity, yet a modest-sized watercolour often harbours such beauty and charm that the technique not only matches, but, in many cases, even outstrips the artistry of oil-painting.

Watercolour technique is perfect for depicting the transformation wrought by atmospheric effects, the weightlessness of passing clouds, fleeting images reflected on water or the apparent fragility of certain architectural features. The transparency and lightness conveyed by this technique is just as effective in painting flowers, plants or landscapes.

These are not the only subjects suitable for watercolour. Man himself, his face and his body in motion are all wonderful subjects.

Indeed, there is little that cannot be captured in a watercolour, but such paintings require a degree of experience and practice to help us comprehend the basic tenets of the medium. Choice of subject matter will probably be governed by the artist's practical ability and tastes.

Apart from colours, brushes and paper, the artist will need a certain level of commitment to succeed. Beginners may need to overcome initial disappointments, but as their skill grows they will eventually derive immense satisfaction from their work.

The aim of this book is to offer advice, suggestions and practical demonstrations on what to paint and how to go about painting it.

Watercolour technique has changed a great deal since the formality of the classical watercolour. In addition to references to conventional methods and techniques guided by strict rules, this book also covers freer, more spontaneous approaches to watercolour painting.

Personal commitment and a willingness to explore the subject beyond the borders of this book are critical to the artist's success. The reward will be found both in the sheer enjoyment of painting and in his ability to produce a much-admired watercolour.

JOSEPH MALLORD WILLIAM
TURNER (1775–1851)
ST. FLORENT
Turner, one of the most famous English artists of the nineteenth century, painted many watercolours of landscapes and cities in England and Europe. He demonstrated a surprising freedom of form which heralded the achievements of twentieth-century painters.

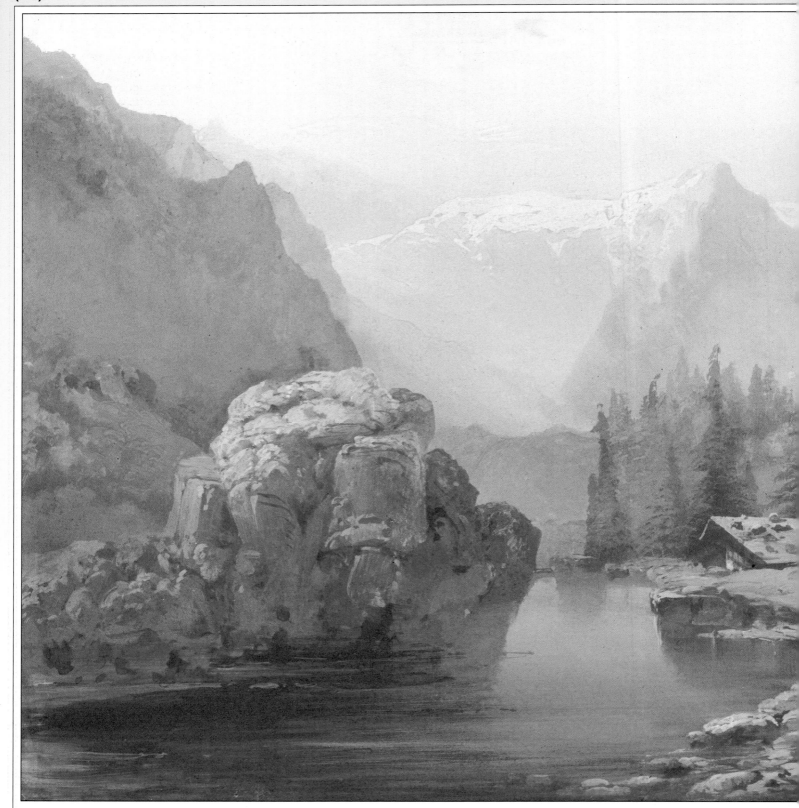

JOSEF NAVRÁTIL (1798–1865)
MOUNTAIN LANDSCAPE WITH
LAKE (43 × 53.8 cm)
*This painting is the work of an
outstanding nineteenth-century Czech
painter. He often used gouache, as in this
sensitively-treated alpine landscape.*

LUDĚK MAROLD (1865–1898)
IN THE STUDIO (51 × 36 cm)
*This prominent Czech painter achieved
world fame when working in Paris as an
illustrator. The light tones of the interior
as well as the bold expression of the
female figure and the drapery of her
clothes demonstrate his consummate
command of watercolour technique.*

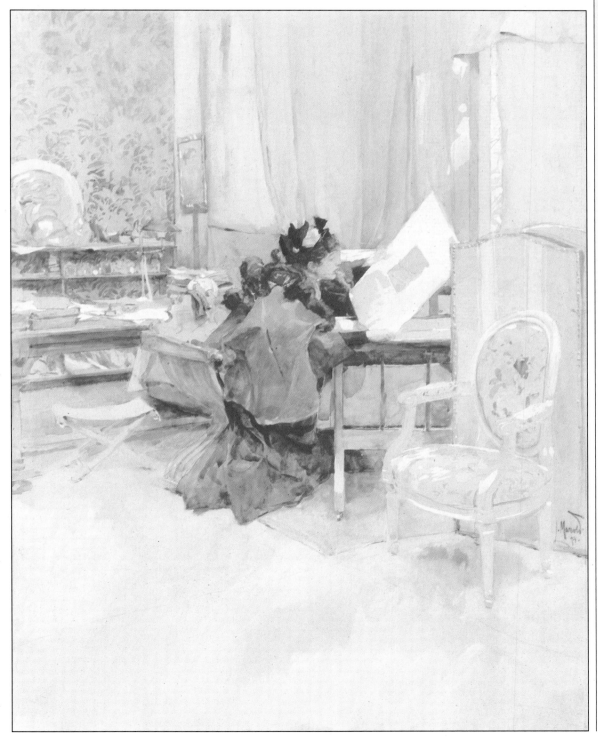

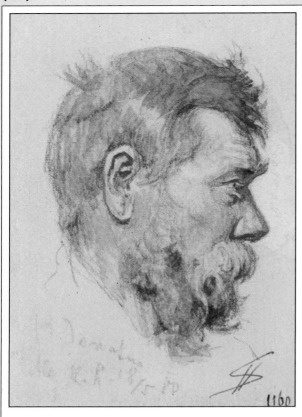

HANUŠ SCHWAIGER (1854–1912)
HEAD OF AN OLD MAN (8.3 × 5.9 cm)
*This watercolour-tinted pencil drawing is
the work of a Czech illustrator and
painter of the end of the nineteenth and
the beginning of the twentieth century.
The old man's profile reveals the artist's
outstanding feeling for form as well as his
ability to make sensitive use combining
drawing and watercolour.*

EUGÈNE BOUDIN (1824–1898)
CONCARNEAU (11.7 × 21.9 cm)
*This fairly small painting by the well
known French painter, a forerunner of
the Impressionists, is a brilliant example
of how watercolour technique can be used
to capture airy space in a coastal
landscape.*

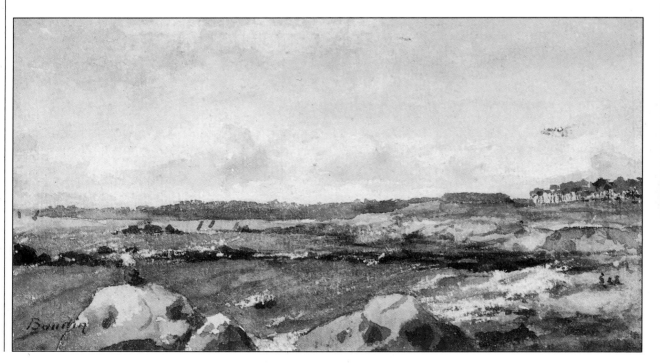

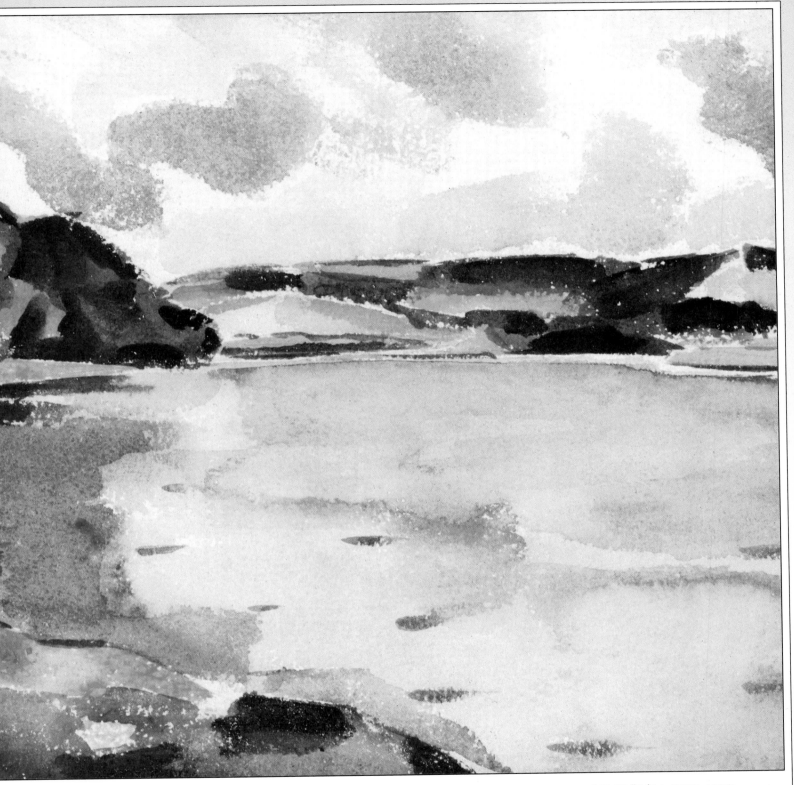

VÁCLAV ŠPÁLA (1885–1946)
SUMMER LANDSCAPE (27 × 32.5 cm)
Špála was a leading exponent of Czech
painting whose work has become popular
worldwide particularly in recent years.
His painting demonstrates a concise use of
watercolour technique producing a very
distinctive and individual rendition of
reality.

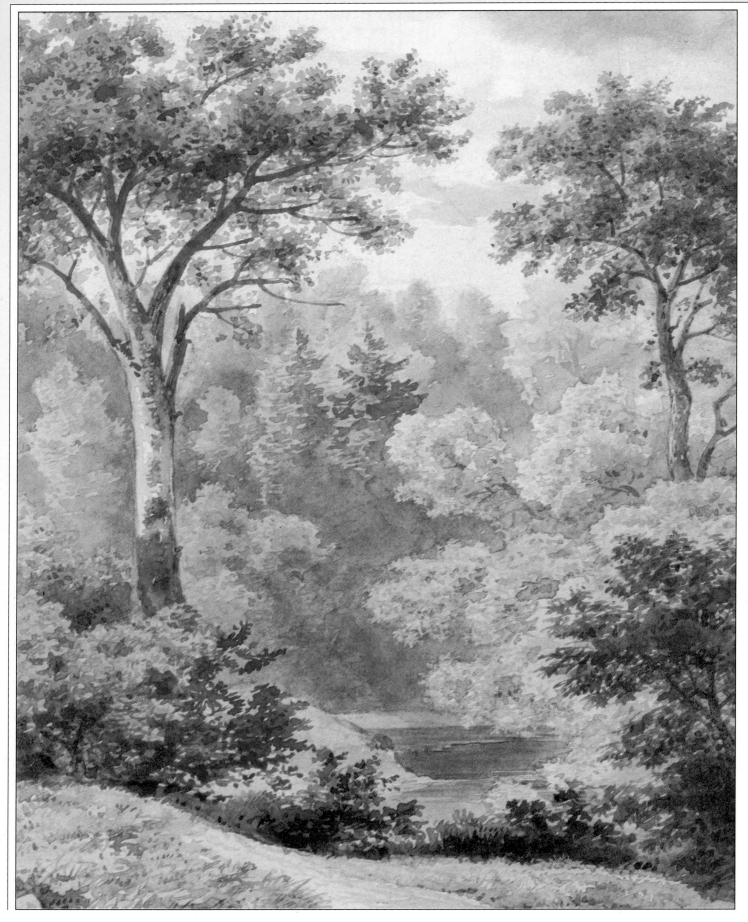

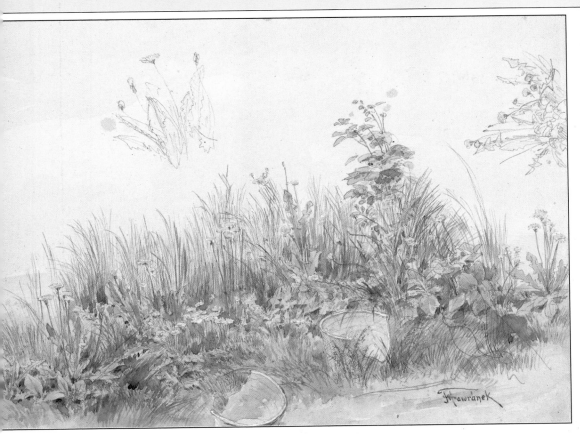

BEDŘICH HAVRÁNEK (1821–1899)
THE GRASS VERGE
(20.2 × 27 cm)
This delicate study in pencil and
watercolour produced by a popular
nineteenth-century Czech painter shows
his sensitive approach towards the
expression of natural detail so typical of
the period.

AUGUSTE RODIN (1840–1917)
NUDE (27.7 × 23 cm)
This pencil sketch lightly tinted in
watercolour is typical of Rodin's superb
approach to the depiction of the human
body.

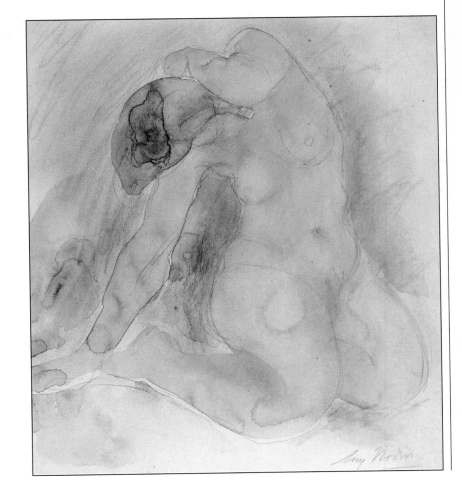

ANTONÍN MÁNES (1784–1843)
WOODED LANDSCAPE
(18.5 × 14.5 cm)
In this small watercolour, the founder of
the Czech landscape school and the father
of an outstanding family of painters
(sons Josef and Quido, daughter Amálie),
demonstrates one of the best facets of
nineteenth-century art, plain-air painting.

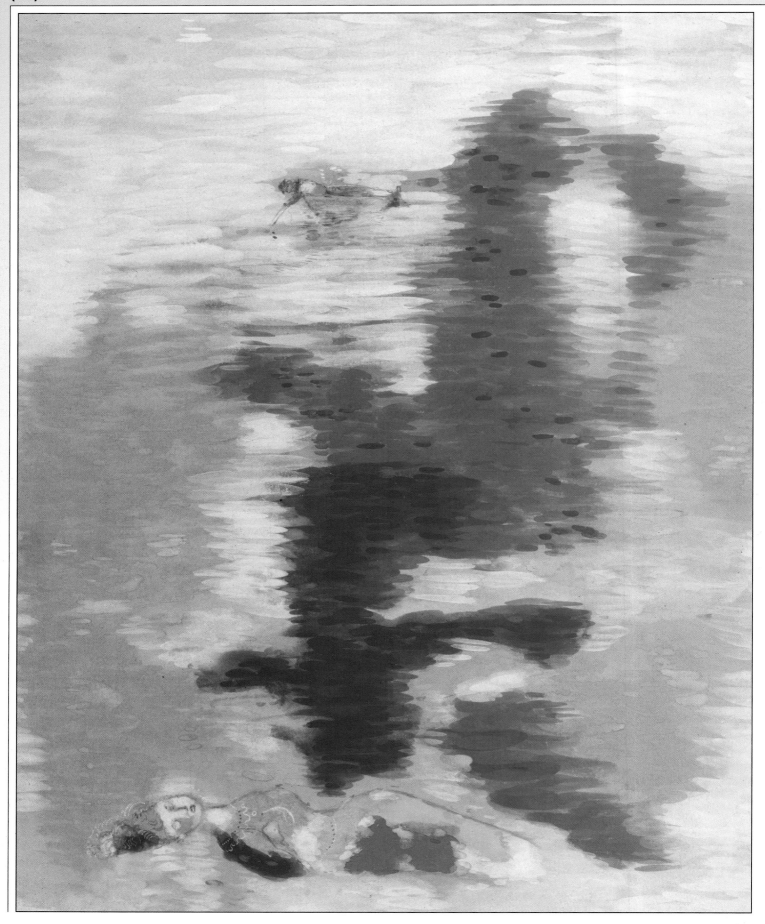

Left:
MARC CHAGALL (1886–1985)
DROWNED WOMAN
(51 × 41.5 cm)
This painting illustrates Chagall's
distinctive use of gouache.
The colours are opaque, yet their tones
remain delicate and light.

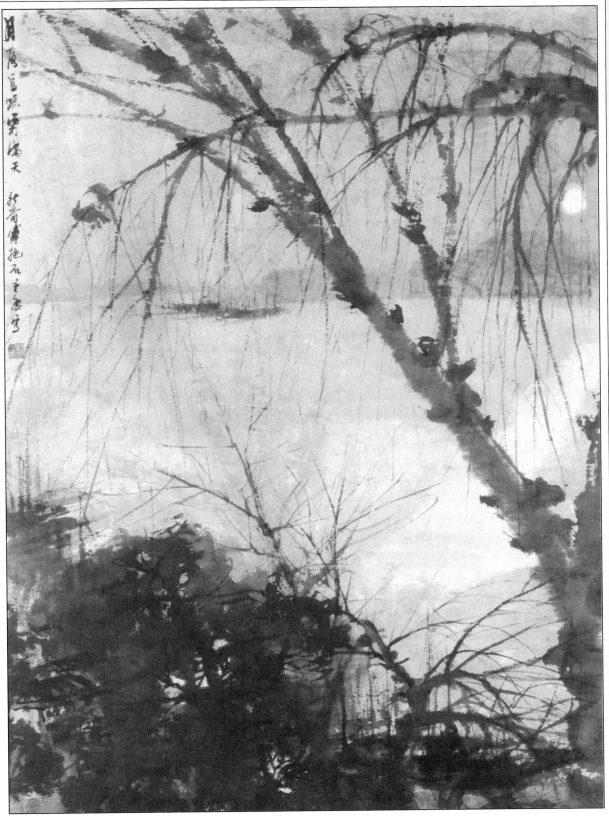

Right:
FU PAO-SHIH (1904–1965)
WINTER NIGHT
(89 × 61.3 cm)
No selection of watercolours would be complete
without an example from Chinese art.
Using light colour tones and distinct brush
strokes is an ancient Chinese technique.

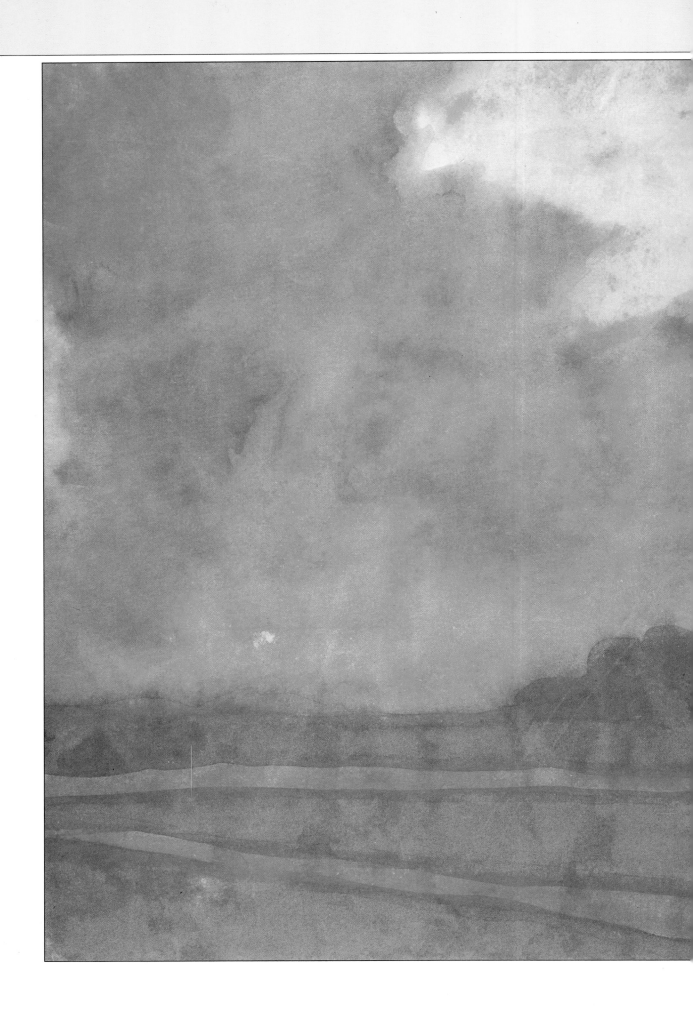

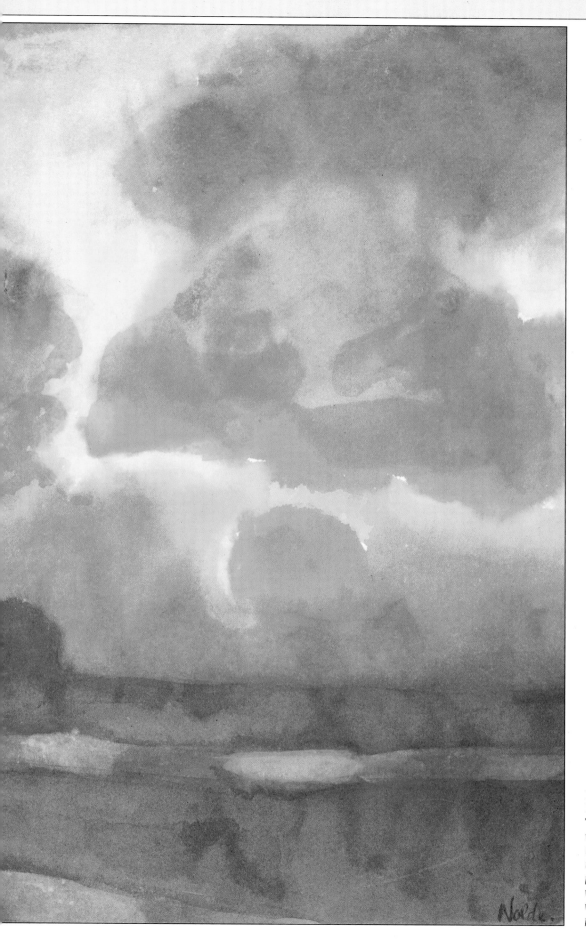

Nolde.

EMIL NOLDE (1867–1956)
EVENING SUN (35 × 48.7 cm)
*This German painter's expressive
watercolour shows the shift in the
understanding and use of watercolour in
twentieth-century painting. While
preserving the characteristic properties of
watercolours, the artist's primary concern
was the dynamic expression of a natural
phenomenon.*

Watercolour

Watercolours have long been known. Pigments blended into a coloured paste with water or fat were daubed by prehistoric painters on the walls of their caves many thousands of years ago. The ancient Egyptians also used a range of similar colours for murals and to decorate wooden sarcophagi or papyrus scrolls (Egyptian Book of the Dead). Watercolour paints were used on Chinese scroll paintings and on the paintings in early Christian catacombs. Watercolour art may also be found in medieval book illumination. During the Renaissance artists used watercolours for tinting and washing cartoons – preparatory drawings for murals and paintings.

The landscape studies of Albrecht Dürer (1471–1528) are perhaps the first paintings to have used all attributes of watercolours and gouache to create works of art. Dating from the fifteenth century, they are regarded as a landmark in the use of watercolour technique. During the sixteenth and seventeenth centuries watercolours and gouache were used more widely and even became popular among amateur painters.

It was not until the eighteenth century, however, that watercolour acquired equal status with other artistic techniques, largely due to the work of English painters. For some, such as Paul Sandby (1725–1809), it was their sole medium of expression, and Sandby's pupil, Joseph Mallord William Turner (1775–1851), is rightly regarded as one of the finest watercolour artists of all time.

The popularity of watercolours spread from England to France and Germany during the nineteenth century and was widely used in the work of the Romantic artists. During the twentieth century, their brilliance of colour, purity of expression and the ease and speed of use made them particularly popular with the Expressionists. The work of the German Expressionist Emil Nolde (1867–1956) is a fine example. Some of his paintings capture the charm and vibrant colours of flowers, others the dramatic beauty of the setting sun or of the sea beneath a cloudy sky. Pablo Picasso (1881–1973), although more famous for his work in other media, was also an accomplished watercolourist.

Apart from the Expressionists, abstract painters took delight in mastering this technique. Paul Klee (1879–1940) used watercolours both for grandiose landscape sketches, abstract figurative paintings and other genres.

Throughout history, there is hardly any painter who does not turn to this medium from time to time. Watercolour may be a source of inspiration and serve to record momentary impressions or ideas for later elaboration in the studio. The fact that watercolour painting requires little in the way of equipment or space makes it ideal for planning an overall conception or the initial ideas of a theme. Watercolours are usually fairly small, and can be painted on a table or, in plain-air, on one's lap.

Furthermore, watercolours have a number of intrinsic advantages which can only be put into fullest effect by understanding their essential nature and characteristics. Such a process calls for a high degree of patience and the willingness to work hard.

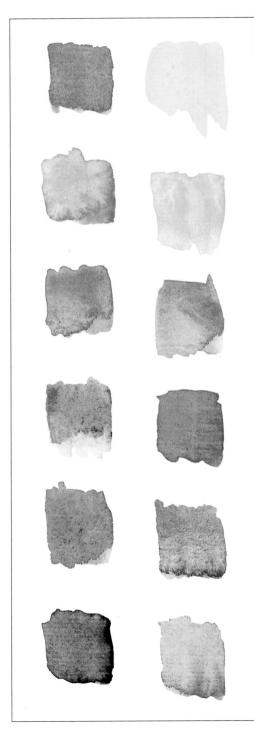

THE PROPERTIES OF WATERCOLOUR PAINTS

Before starting to paint it may be useful to become familiar with the physical and chemical properties of watercolours. This is the best way of finding out what and, above all, how to paint.

Watercolour is a technique which uses strongly bonded paints thinned with water. The binder used for the finely ground colour mixture is either gum arabic, or a mixture of this and tragacanth, a vegetable gum. Dextrose is used as a binder for cheaper colours. Glucose or sugar syrup is added for better solubility and ox bile to improve the flow of colour from the brush on to the paper, and to make the colours easier to spread.

Best-quality watercolours should not fade when exposed to light.

The following list gives the names of some fast colours:

Zinc White
Gold Ochre, light and dark
Mars Yellow, light and dark
Natural Sienna
Burnt Sienna
Natural Umber
Cadmium Yellow, medium and orange
Cobalt Yellow (Aureolin, sometimes substituted for Indian Yellow)
Iron Oxide Red
Burnt Ochre
Pozzuoli
English Red
Indian Red
Caput Mortuum
Mars Red
Cadmium Red, light and crimson
Madder Lake (Natural Alizarin; fades in the sunlight)
Cobalt Blue (Thénard's Blue)
Cobalt Violet
Cerulean Blue (Coelin's Blue)
Ultramarine Blue
Prussian Blue (Berlin Blue, Paris Blue, Antwerp Blue)
Green Earth (Terre Verte, Bohemian Green, Veronese Green)
Opaque Chrome Oxide Green
Viridian (Transparent Chrome Oxide Green)
Bone Black (Ivory Black)
Lamp Black

Additional whites used for gouache:
Barite White (Mineral White, Heavy Spar)
Chalk
Kaolin (porcelain clay, china clay)
Gypsum (Brilliant White, Lenzine)

It may be safely assumed that purchased paints will be fast, particularly those manufactured by reputable firms such as Windsor and Newton, Talens, Schminke or Lefranc. They are often supplied in boxes containing ten or twelve pans of colour, a selection sufficient to create a wide range of fine shades.

Colours are also manufactured in round or cube-shaped pans, tubes or bottles. They may be purchased either individually or in sets, enabling the artists to replace only used up colours. The use of some colours more than others depends both on the subjects being painted and on the preferences of the artist.

WHAT TO PAINT ON

The most common ground for watercolour painting is paper, which must be good enough to take colour well without detriment to its purity. The best brands of paper do not absorb colour too quickly, and must not be so smooth that the colour smudges.

Watercolour paper may be either hand- or machine-made. Hand-made paper is generally of first-rate quality and will react well with all the properties of good watercolours, leaving the pigments fresh. Although colour can be washed off to some extent, this is not easy if the colour layer is rather thick, so try to get the colour wash right first time. Paper should always be stretched before use (by fastening it to a frame) as it 'cockles' slightly when it comes into contact with water. The tendency to cockle depends on the thickness of the paper. Good-quality machine-made paper is for beginning watercolourists. Colours not only take well to it, but also can be washed out relatively easily. Harder, less porous types of paper are easier to work with.

Watercolour paper is also manufactured in blocks, with the page edges stuck together to reduce cockling in contact with water. Individual pages are easily torn off when the painting is finished and dry.
Well known brands of manufactured paper include Whatman, Zanders and Torchon. Illustrations in this book were painted on Italian FABRIANO paper, or on hand-made paper from the Velké Losiny papermills, Czech Republic.

It is best to try out several types of paper to find one that suits your needs.
Some firms even manufacture specially treated watercolour canvas.

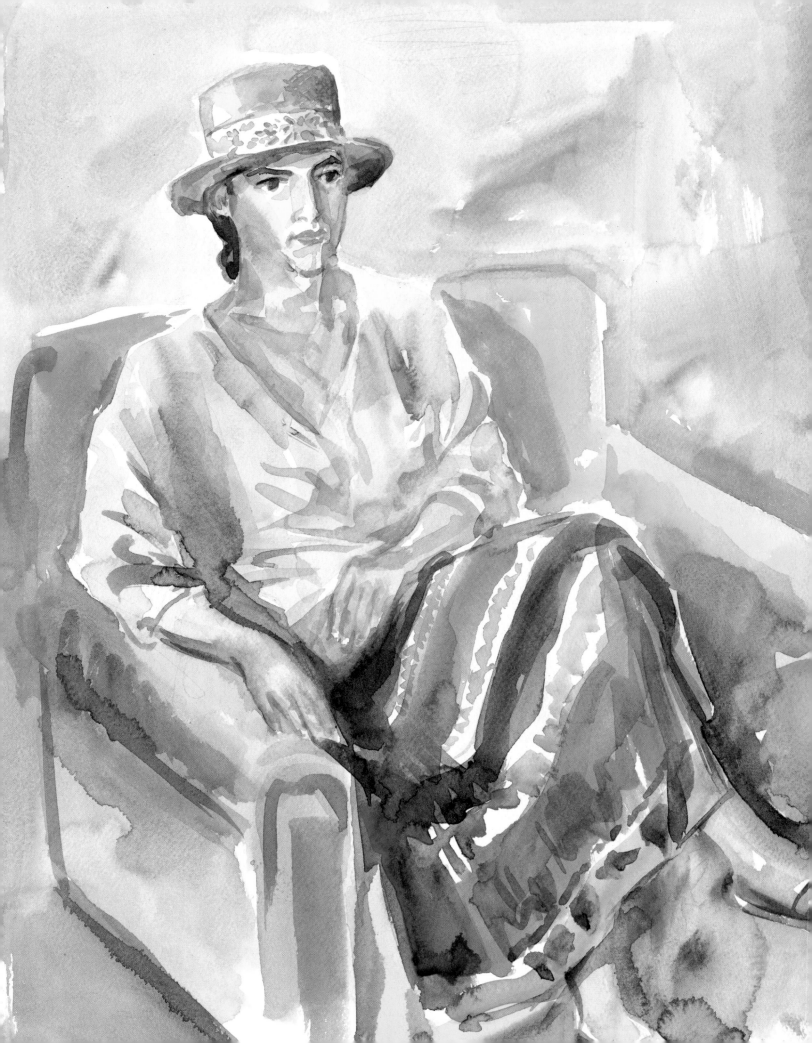

BRUSHES AND OTHER TOOLS

Besides colours and paper we also need good-quality brushes. These are usually made of marten, sable or otter bristles, which are harder and more flexible than cheaper soft-hair brushes. It helps to have a range of brushes of various sizes, depending on the subject to be painted and the paper format to be painted on, the longer side not usually exceeding 500 millimetres. Somewhat smaller formats should really be chosen.

Brushes come in various thickness. The author has found nos. 6, 8 and 10 to be suitable. These are round, pointed brushes which can equally be used for sketching and for coating with masses of colour. Flat brushes of larger size can also be used when working with larger surfaces.

Other tools include a sponge and a rag for dampening the paper or wiping excess water off. The beginner should also learn how to blot colour from the paper using a brush washed in clear water and wiped carefully on a clean rag. A brush dipped in clean water can also be used for washing or softening colour where appropriate.

The artist needs a fair-sized container for water, ideally a screw-top jar for painting in the open air, and dishes for soaking and rinsing brushes. A number of small containers will also be needed for working with colour tones made up in advance. One or two largish conserving jars are enough when working at home.

Colours should be mixed on a palette, ideally a white one. When working with tube paints it is best to use a palette containing hollows into which the required amount of colour can be squeezed. Palettes may be made of plastic. Ceramic dishes, though usually heavy, have also proved useful. When painting with colour boxes containing pans, the open lid of the box, often double-flapped, can be used as a palette. When painting at home, a small glass plate placed over white paper to make the colours stand out will serve just as well, or even a flat white plate.

A light-weight palette is useful when painting landscapes, as well as a light, portable easel on which to attach the board with stretched paper. A board can also be rested on one's lap, a stone, or even simply on the ground, although in this case dust stirred up by the breeze can prove a hazard.

Left: The girl in the picture was painted alla prima apart from some light colour glazing. The painting was intended both as a portrait and as a fresh expression of the drapery of blouse and skirt.

Below: Various types of watercolour papers.

PREPARING THE SUPPORT

Paper should be fixed to all four sides of the support with adhesive tape. It may also be dampened on the right side. When working at home a clean piece of fabric should be placed over the dampened paper to soak up any excess moisture evenly and achieve the ideal moisture level. The amount of moisture will effect the character of the patches of colour.

Everything concerned with preparing painting will become automatic with time. Making the best use of one's materials and organizing them properly takes considerable experience.

Beginners can practise painting on dry paper to familiarize themselves with the properties of the paints and the basic methods of work. By way of cartoons and sketches you may know how the colour "takes" to the paper, which colour tones are produced when layering or mixing various colours, or discover prospective advantages of the selected painting procedure.

THE SOLVENT FOR WATERCOLOURS: WATER

Water, the solvent, is one of the key components of painting. If you are out in the countryside, away from modern civilization, you may consider yourselves fortunate to find a brook from which to draw water. This should, however, only be a last resort.

Water used for watercolour painting should be as clean as possible to reduce the negative effects of pollutants on colour fastness. Water with too high acid or lime content is particularly harmful to some pigments. Distilled or preboiled water should therefore be used for tempering paints. At all events constant care must be taken to ensure that water and brushes are kept clean so that colour tones will live up to expectation, and do not contain any undesired admixtures.

In the course of time, having gained experience the artist will improve the records of his painting activities to such an extent that he will wish to preserve his works in their original form. This is where the good habits and preparation and the use of good quality materials come into their own.

CHOOSING THE RIGHT MOUNT

When the artist is pleased with his picture he may want to hang it and must therefore choose the right mount.

The simplest way of mounting a picture is using a passe-partout, a cut-out of hard paper slightly smaller than the picture format, and glass. The picture is placed back-size and fixed with gum strip in the corners, possibly also in the middle of the sides, but not all round.

Climatic effects, especially humidity, can have various effects on paper tension, so that backing a painting all round could lead to undesired cockling. On no account should glue be used as an adhesive.

To ensure that the picture is dust-proof, the passe-partout is then placed under a sheet of glass or in a frame with glass. The passe-partout should be thick enough to prevent the painting from coming into direct contact with the glass. Mounts can be made at home providing you have some practice.

The paper used for the passe-partout can be tinted to complement the hues of the painting, or make use of a dominant colour. These frames are available in such a wide range of sizes and materials that it is often more convenient to buy them ready-made at specialist outlets. The colour of a passe-partout can correspond with a less vivid, neutral colour, which is dominant in the picture. It can also be complementary to the most distinctive colour (e.g. light green to the dominant red). The colour of a mount should always be muted so as not to detract from the colouring of the picture. A white passe-partout is a safe choice, but it turns yellow with time.

The mounted picture should not be hung in direct light, especially sunlight, which causes some colours to fade.

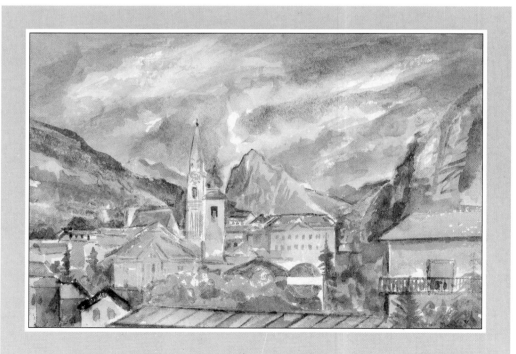

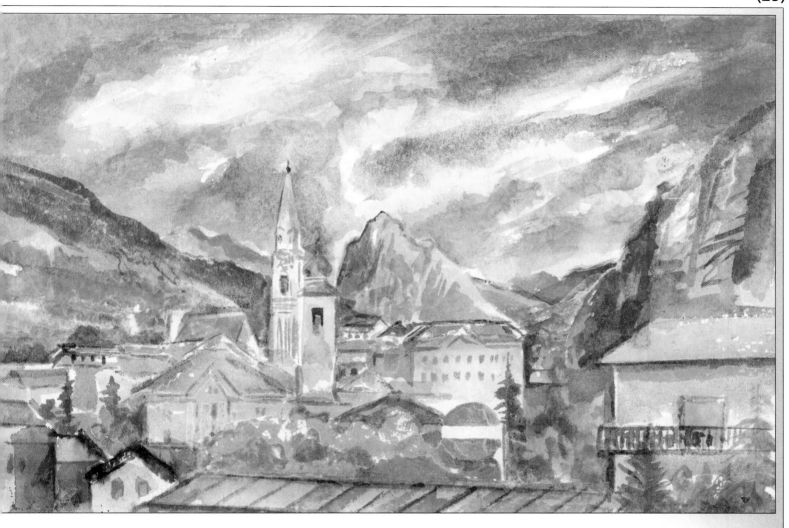

Above: This picture of Cortina d'Ampezzo (the Dolomites) was painted using a greater number of colours. Light hues created the distinctive atmosphere of this mountain landscape.

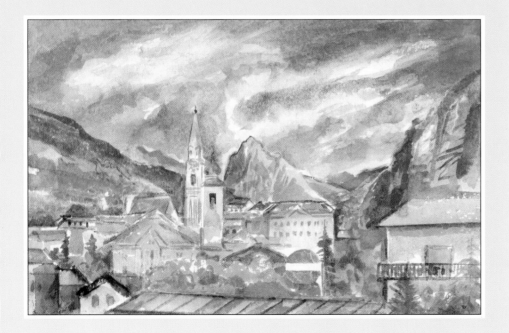

Left: A passe-partout is often neutral in colour, e.g. grey or ochre, depending on the warm or cool colour character of the picture. Its lower side is usually wider than the others.

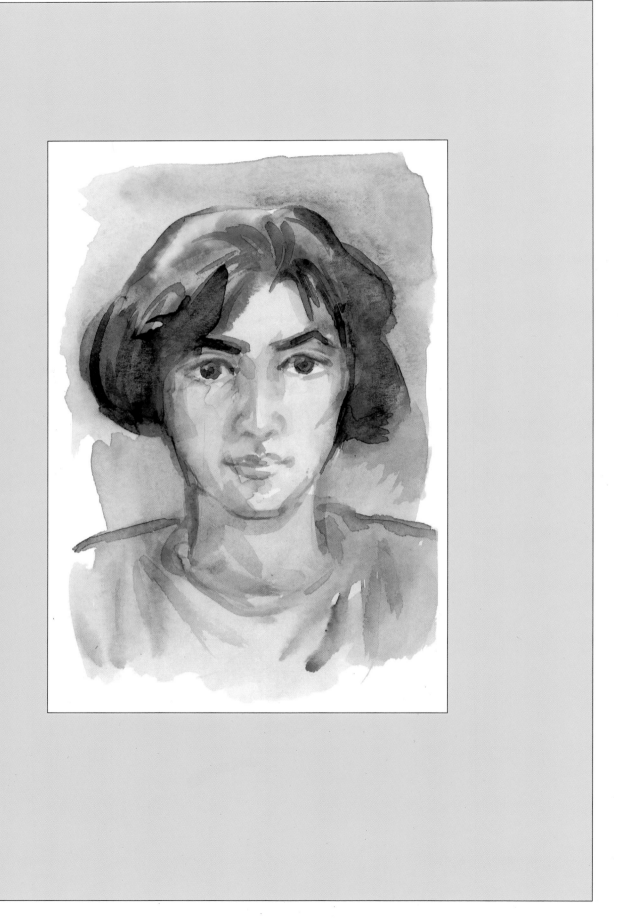

Left: A wider passe-partout is recommended for smaller pictures; a narrower one for larger pictures.

Below: The highlights of white rocks on the Black Sea coast (Balčik, Bulgaria) were left blank. Only the parts in shadow were painted in using light colour hues to create the luminous and ethereal effect of a landscape in the morning mist.

THE ESSENTIAL CHARACTERISTICS OF PAINTING WITH WATERCOLOURS

One of the chief characteristics and advantages of watercolour paints is their transparency and lightness.

Most watercolours have very poor covering power.

Only a thin layer of colour is put onto the paper. The degree of transparency is controlled by varying the degree to which colours are diluted with water. The final effect is light and transparent.

Use can also be made of the paper itself, which is usually white, but may be in any colour hue. In some cases this contributes to the unification of colour and may be a useful aid to creating various atmospheric effects (for example, a dawn atmosphere on light blue paper).

Another characteristic evident from the above is the limited potential of watercolour for overpainting. A procedure which requires this technique might be needed at times, but it is not a good

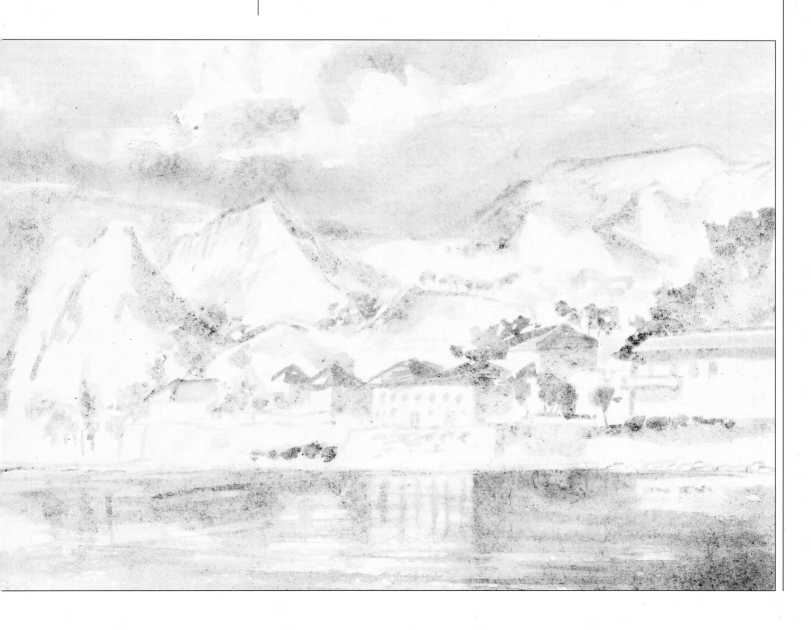

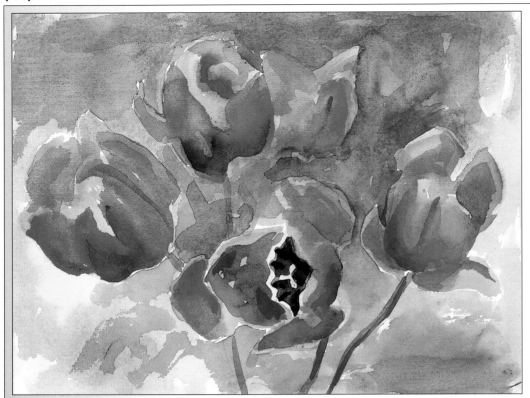

The picture demonstrates the use of various tones of one colour. Rich red was painted wet-in-wet into a light orange tint and spread into the shape of a flower with lightly indicated modelling.

idea to overpaint in an attempt to erase mistakes of form or colour.

Watercolours likewise preclude a reliance on limitless corrections, for example to degrees of light in a painting, as this causes the surface of the colour to lose its freshness and transparency, making it dull. This happens most often when the artist is trying to achieve the ideal correlation between illuminated and shadowy parts. Remember that colours cannot be made lighter by adding white. Although white exists in the range of watercolours at the present time it should not really be used in true watercolour painting. Its use alters the character of the painting and is more appropriate to gouache. In watercolour proper white is achieved by leaving the underlying white paper blank.

When overpainting, the artist must be aware what the combined effect will be when two colours are blended together;

e.g., yellow painted over blue will produce green. (These effects will be dealt with below.) Even here it is not a good idea to make over-frequent use of colour layers, as repeated brush strokes make paper fatigue, the colour loses its freshness and luminosity and the resulting effect is unsatisfactory. When painting flowers, for example, it is better from the outset to brush on a sufficiently strong tone alla prima in a single layer so as to bring out their brilliant red. Repeated brush strokes using red over red will tend to darken rather than intensify the tone. When studying painting it is better to start afresh instead of rectifying wrongly painted areas.

In view of all this it is advisable, as far as possible, to consider light and shade of colour scheme and establish certain basic degrees of lighter and darker colours beforehand, since it is difficult to make major alterations at a later stage of painting.

SOME BASIC INFORMATION ABOUT COLOURS

Finally, a few words on colours from the point of view of physics and practice including some terms occurring frequently in the text.

From the physical point of view colour represents light of a certain wavelength. When passing through a prism, white light refracts into the colours of the spectrum. These include both the **primary colours** – yellow, red and blue – and **binary** *or* **secondary colours** – orange, green and violet. The **spectral colours** can be observed in nature when a rainbow appears in the sky as a result of simultaneous rainfall and sunshine. Secondary colours are obtained by mixing two primary colours: orange is a mixture of red and yellow, green of yellow and blue, and violet of red and blue. In a clearly visible rainbow these can be seen at the points where the more intensified primary colours overlap.

The colours of the spectrum have been arranged in the form of a wheel, the best examples being those devised by the German poet J. W. Goethe (1749–1832) and by the German chemist W. Ostwald (1853–1932).

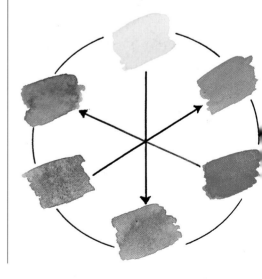

In Ostwald's system the colours are classified numerically on the basis of an arrangement of coloured lights, i.e. both warm and cold colours, complementary colours, and deep and dark colours.

THE PROPERTIES OF COLOURS

Colours are characterized by certain constant properties which are systematically used in painting. For example, secondary colours stand out more next to primary colours, e.g. orange next to blue. Orange is thus a complementary colour to blue, green to red and violet to yellow.

These and other natural laws pertaining to colour have given rise to a body of knowledge which painters make greater or lesser use of depending on their temperament and artistic intentions. An example are the Pointillists, led by the painter Georges Seurat (1859–1891).

While discussing the colour wheel, 'warm' and 'cold' colours were mentioned. Colours evoke a certain feeling of warmth: red is warmer than blue, yellow seems warmer than green. A particular shade can shift this effect in one or the other direction. Within the red group, which is warm overall, some shades of red seem warmer, others cooler. For example, light Cadmium Red is warmer than Crimson Lake, Prussian Blue is cooler than Ultramarine. Similarly, the lighter the yellow, the cooler its effect.

Above: ADDITION OF COLOURS
Secondary colours result when two primary colours are mixed together.

Below: A series of reds from warm to cooler shades (left to right), which also illustrates various shades of one colour.

Left: THE COLOUR WHEEL
The colours opposite primary colours are complementary colours.

Above: PRIMARY AND COMPLEMENTARY COLOURS
The intensity of complementary colours is enhanced by juxtaposing them to primary colours.

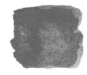

USING COLOURS TO CREATE SPATIAL EFFECTS

Red colour broken by adding green.

Knowledge of the relative warmth of colours and their effect is essential when the artist is trying to evoke spatial effects in landscape painting. Drawing perspective is of equal importance. It has for many years been a well-established canon to divide a picture into **three planes**:

The first plane, the foreground, has the warmest colour, and is thus painted predominantly in colours of red, brown, ochre, etc.

The second plane, the middle ground, tends to be green, as this colour is half-way between warm and cold.

Finally, **the third plane**, the background, the furthest away from the viewer, is usually the coolest, represented by various shades of blue.

There are many examples of this approach in the paintings of past centuries, especially of the Renaissance, Baroque and Romantic eras.

Obviously, this rule cannot be applied to all paintings. Modern painting, in particular, often intentionally dispenses with it altogether. But even here examples can be found of the systematic use of colour to create spatial effects. For instance, Cubist paintings, especially in its early period, make systematic use of the rule of alternating cool and warm colours to evoke shallow space. This is most evident in Cubist still-life paintings. Let us mention frequent terms used in relation to the properties of colours:

Shade, which means a minor change to any colour attribute.

Tone refers to the specific character of a given colour. For example, in the case of red, tones are light and dark Cadmium Red, light and dark Crimson Lake, etc. There are various different shades of red, that is of the same colour type. The wide range of differentiation in watercolour reds is clear from their various names, e.g. English Red, Indian Red, Caput Mortuum, Mars Red, Cadmiun Red, and Madder Lake. The terms for colours may change in connection with the development of the manufacture of watercolours.

Colour can also be broken. A **broken colour** occurs when its character is altered by adding any other colour. The resulting colour will be duller and less intense; it is used when the artist works towards a harmonious transition between two fairly bright colours which would otherwise have too strident an effect when juxtaposed. A process of trial and error shows the unsuitability of mixing some colours, where the result is a dingy, unusable tone. This is less likely to occur if the amount of additive colour is less than that of the original one.

A colour composition can also be made more harmonious by means of **neutral colours**, which are neither conspicuous when used, nor interfering with or affecting neighbouring colours.

A **rich colour** has no admixture of either black or white.

This picture painted freely after a Baroque original shows the classic approach to the construction of space based on three colour planes.

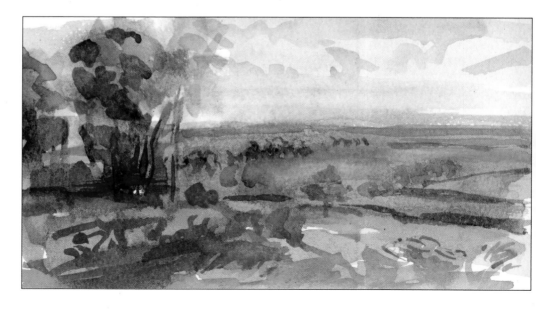

An example of the tonal values of colours used in the picture below.

A **dark colour** contains an admixture of black.
A **light colour** contains an admixture of white.

However, the lightness or darkness of colours need not depend on admixtures, namely when these properties are inherent to one colour in relation to another. Deep yellow, for example, is intrinsically lighter than deep blue.

The term **local colour** refers to colours which are unaffected by any extraneous factors such as lighting, a neighbouring object of a different colour which creates a reflection of the other object, etc. In other words, it is the intrinsic colour of a thing itself, unaltered by anything; an

Constructing space by means of tonal values.

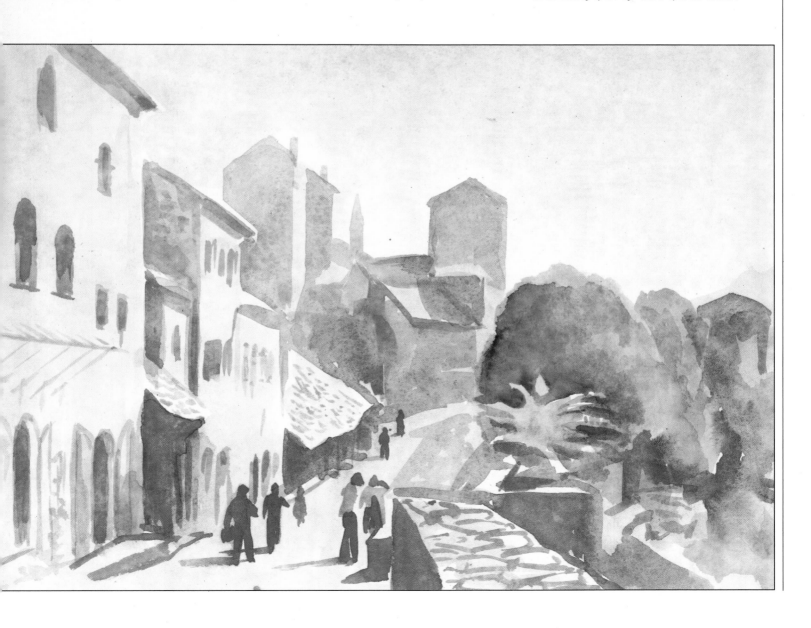

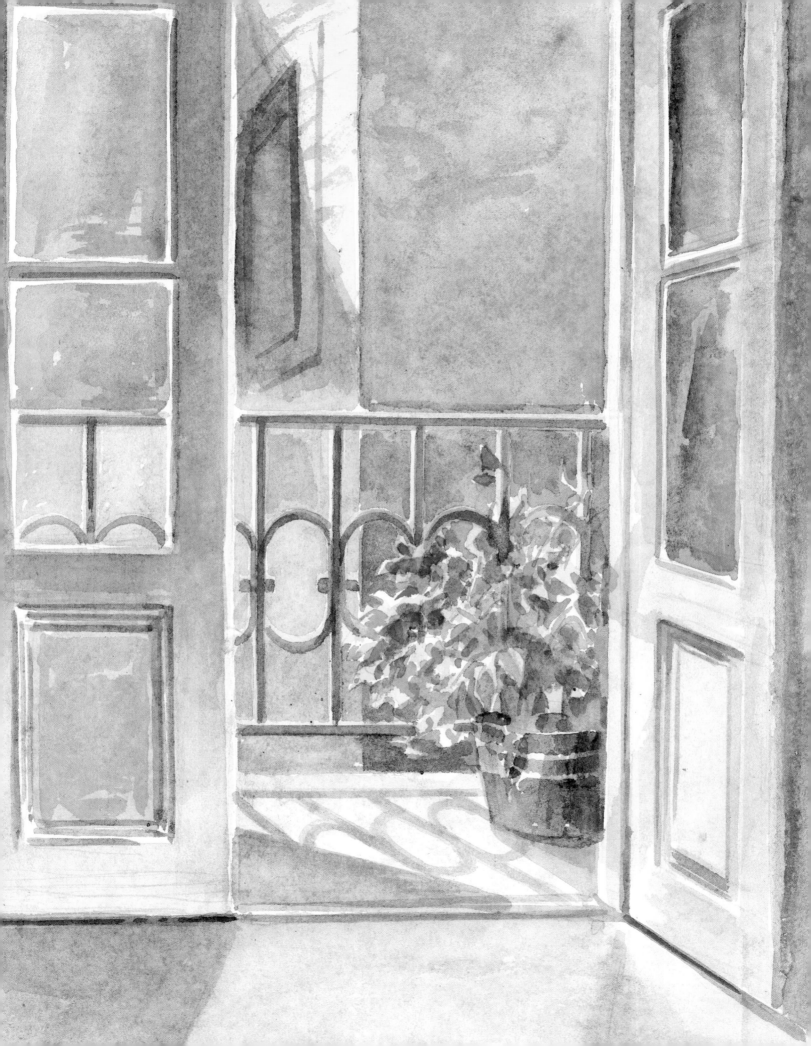

observable colour, as opposed to the actual one.

Light gradations of a given colour are sometimes known as **tonal value**. Whereas in oils and other colours gradations of colour tones are achieved by the progressive admixture of white to the basic colour, in watercolours tonal value is achieved by tempering colours with water.

Glazing is an application of a colour in a thin, translucent layer, which is typical of watercolour painting, especially when the harmonization of all colours in the picture is required. In some techniques, such as oil-painting, some colours are transparent (e.g. deep Crimson Lake, or Transparent Chrome Oxide) in comparison with those having greater covering power. However, all watercolours are translucent, both because of their nature and because they are water-soluble. Purity of colour tone is an essential prerequisite.

Colour glazing in watercolour painting can increase the intensity of the colour by repeated overpainting. When overdone, however, it can produce a dull effect. This method is best applied in the final stages of a painting when putting the finishing touches to colour and light contrasts, or harmonizing the overall colour conception.

Colour can be affected in a variety of ways. Making use of the properties outlined above, artists should also be guided by their own intuition, and, last but not least, experience. The world all around us comprises a huge range of colours and tints, compared to which the range of colours at our disposal for expressing visible reality is limited indeed.

Nonetheless, even these can be put to maximum use by applying what is known about mixing, refraction, shading, etc. so that they not only describe reality, but creatively express and enrich it with the artist's own impression and understanding. In the course of time the artist will learn how to use contrasts, the principles of colour relationships and when to exaggerate. It is a joy to discover that colours harbour unsuspected possibilities.

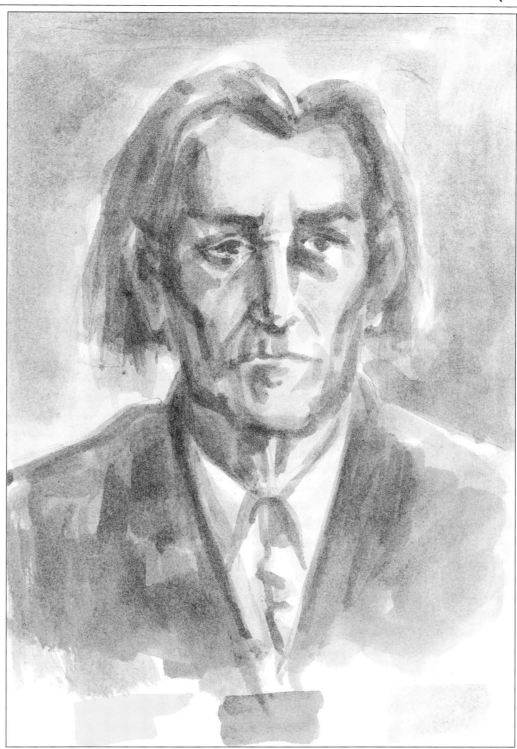

The clearly visible colour glazing in this portrait demonstrates how many new colour tones can result from blending three primary colours.

The picture opposite shows the use of colour glazing to indicate the subtle colour transitions of early morning light.

Practical exercises

Some fairly simple exercises or studies will serve to test in practice what has been said above.

Our first task will be a simple cloud in a blue sky. The paper has been dampened with clean water, followed by a free application of Cerulean Blue. A generous mixture of blue and Raw Sienna was then blended into the wet ground to create the shape of the cloud. This process of blending was repeated to intensify the dark shade of some parts of the cloud. The upper, lighter edges of the cloud separating it from the blue sky were left unpainted, i.e. in the colour of the paper. The exercise should be painted very quickly and from memory. The student can try some other variants of this simple task.

The second exercise is painted similarly. The shapes of bushes in rich opaque chrome oxide were painted into the background of the far river bank depicted in a far lighter shade of the same colour. A darker green was used to paint the soft outlines of bushes reflected in the river and ultramarine for the waves on the water surface. Dissolving the parts drawn in blue on the wet surface of the paper helped to create the illusion of water. To enhance the effect of the water surface the background part of the picture was separated from it by a brown bank (natural sienna with red, slightly broken when mixed with the original green). Below it a narrow band of the original paint was removed with a clean, dry brush. In the foreground the near bank was indicated by using fairly rich opaque chrome oxide.

This painting was done in free, quick brush strokes. When painting freely wet-in-wet – it is not possible to record details. Nor is exactitude the purpose of our exercises; they are to practise and verify some of the characteristics of watercolours.

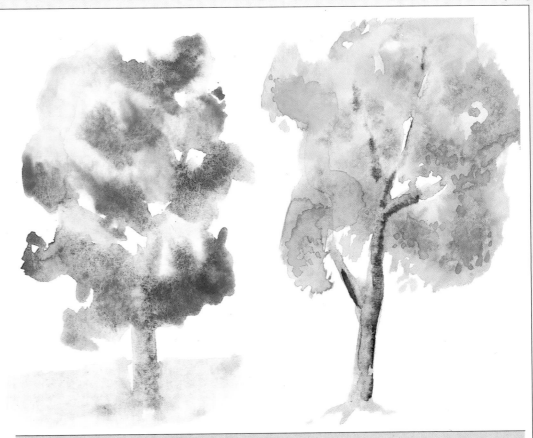

The next exercise is painting a tree. The irregular outline was painted in a pale shade of green, to which patches of a richer green (opaque chrome oxide with a minute amount of light green) was added. Where foliage catches the light, some colour was removed while still wet to express the volume of the tree.

The next exercise is similar but this time showing a tree in autumn colours. Dark orange dots were painted into the wet ground to create the impression of small leaves. The trunk was underpainted in thinned blue, the shaded sides in dark blue mixed with orange.

It should be clear from the exercises that while the range of colours used was very limited this detracted nothing from the colourfulness of the motifs. It is often easier to achieve a subtle and yet sufficiently colourful effect with the well-judged use of a few colours than by trying to use all the colours on the palette.

Mixing can also enrich colour effects by aiming to achieve the right shade rather than trying to create rich, striking tones. It is also worth noting that the richness of colour can be achieved by mixing only a few tones (see the colour changes in the cloud) ranging from various shades of violet to the darker and warmer shades of greyish-brown.

This knowledge is also employed in the next exercise, a mere sketch of a fictitious landscape with a few shrubs both in the terrain and on the horizon. Again, these are painted in dark green onto a still wet undercolour. The picture is closed on the horizon with a lightly hinted ridge of hills in light blue, tapering off into the distance.

A trace of brown added in the foreground suggests a slight hint of pink when painted in a clear wash. The picture also demonstrates the classic division of space into three colour planes: the warmest plane, the foreground, is in reddish-brown, the second one or the middle is in green, and the third plane, the background, is in blue.

Cultivating the art of selective vision is a basic prerequisite for the would-be painter, taking in only what is important and dispensing with any superfluous detail which would otherwise confuse and clutter the work of art and make it less convincing. This method is particularly important when painting more demanding themes.

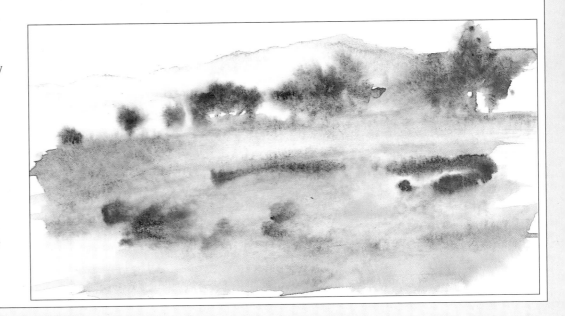

Such a kind of selectivity is by no means easy to achieve, and initial painting efforts are often marred by unnecessary detail.

Although the motifs suggested here are a sound basis for painting exercises, they are not intended as a hard and fast rule, either in their range of subjects or their number. These recommendations can quite easily be replaced to suit the tastes of the individual. The most important thing is the inclination of the student, whether towards descriptive, realistic painting, or towards expressing the inner substance of the subject matter, which is rather the product of an inquiring mind seeking to express feelings than the product of a curious eye.

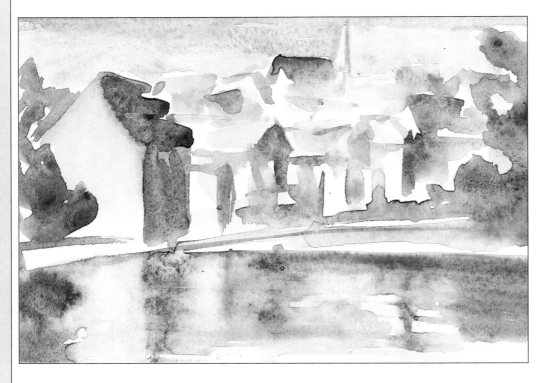

This exercise depicting a river with weir and terraced built-up area poses much the same problem as the painting of the river on page 34, as well as shows how to express the complex outlines of the houses by simply painting partly in a wet and partly in a dry ground. The free-standing trees at the edges help to enhance the sense of space and contrast.

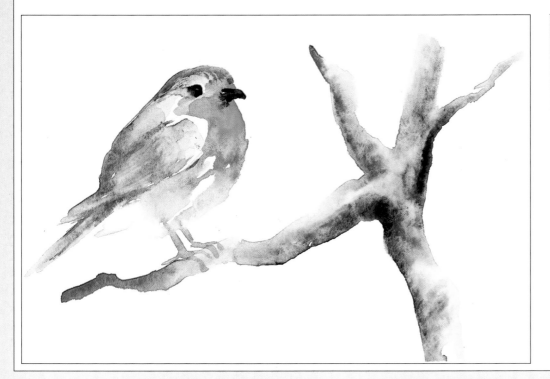

Another, somewhat more challenging exercise, the sketch of a robin, not yet aiming at a precise description, was painted with greater care than the previous pictures. It also makes extensive use of tempered colour but adds fine lines to outline the feathers.

The overlapping of tempered patches of colour in a wet ground expresses both the volume and the softness of the body surface. The twig on which the bird sits is painted even more freely, by indicating the shape in light brown with blue added for modelling. As the blue dissolves sfumato into the brown undercolour it forms random islets of colour to suggest the typical outline and structure of the surface. Such random effects contribute to the freshness and spontaneity of the painter's style.

Autumn leaves are an excellent subject, as they combine both a spontaneous and an organized approach. When painting leaves care should be taken to respect both their characteristic shape and their rib structure. At the same time one can also paint in more spacious areas of ground colour and then add other colours as required before the undercolour has dried. In this way one colour runs into another as they do in real life. Where the precise depiction of some detail becomes necessary the artist should wait until the undercolour is either partially or completely dry before touching the area again. In our picture this applies to the ribbing of the leaves.

Another technique which can be used in addition to dissolving colour into a wet ground is that of using a clean wet brush to remove colour as required, whether to lighten or soften the effect of a painted area.

A similar procedure was used to paint an orange. The surface structure is suggested by stippling, which partially blends into the wet ground. Painting the background and the shadow cast by the orange enhance the illusion of its volume and position in space. On the illuminated side of the orange the background is darker in colour, on the shaded part lighter. Unpainted paper left around the edge of the orange increases the spatial effect.

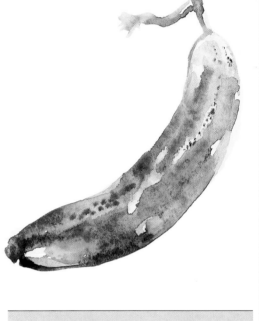

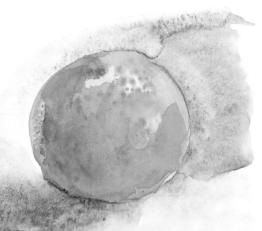

An overripe banana was painted in a similar way by gradually painting over wet yellow colour, adding first brown and then blue for the darkest parts. Painted from life, rather free than descriptive, the picture aims to capture the impression of overripeness.

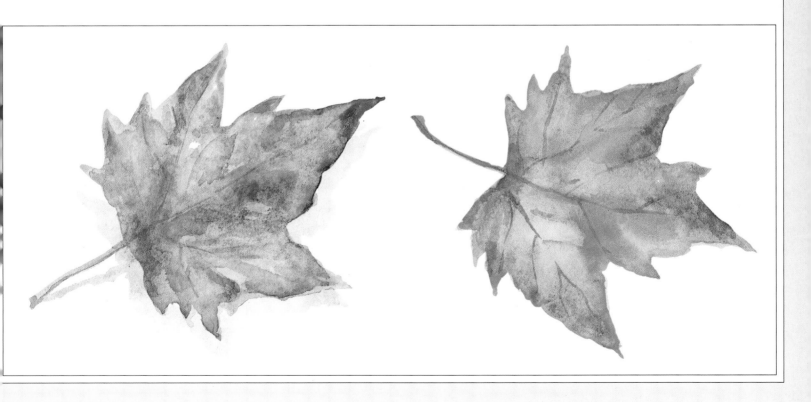

Painting flowers

Flowers are a singularly appropriate theme for watercolour painting. Colourfulness, lightness and fragility are qualities inherent to watercolours as they are to flowers, which are thus ideally expressed in this medium.

Provided one is prepared to dispense with the exact, scientific descriptive depiction of flowers found in herbaria, namely from the old days, he will enjoy using watercolours spontaneously to capture the transient beauty of the subject.

However, there are two working methods offering themselves. You can choose either the gradual method, carried out more slowly and in several phases, or the faster, alla prima, making for freshness of expression.

Right: A bouquet of dried flowers was chosen to practise the slower, gradual method. Since they do not change with time there is no reason to hurry. The economical range of paints used includes dark red, ultramarine and yellow with golden ochre. Lateral lighting enhances the sense of space, indicated in individual flowers by glazing. This also softens the petals and helps to provide a spatial setting for the flowers. The thin stalks of small flowers on the left had to be omitted, care being taken to colouring the background. On examining the overall colour and spatial effects, the artist decided to add richer colour accents where necessary.

Below: This is an example of the free, alla prima, wet-in-wet painting technique when light colours were painted in the ground. The somewhat darker colour glazing indicates the structure of the flowers.

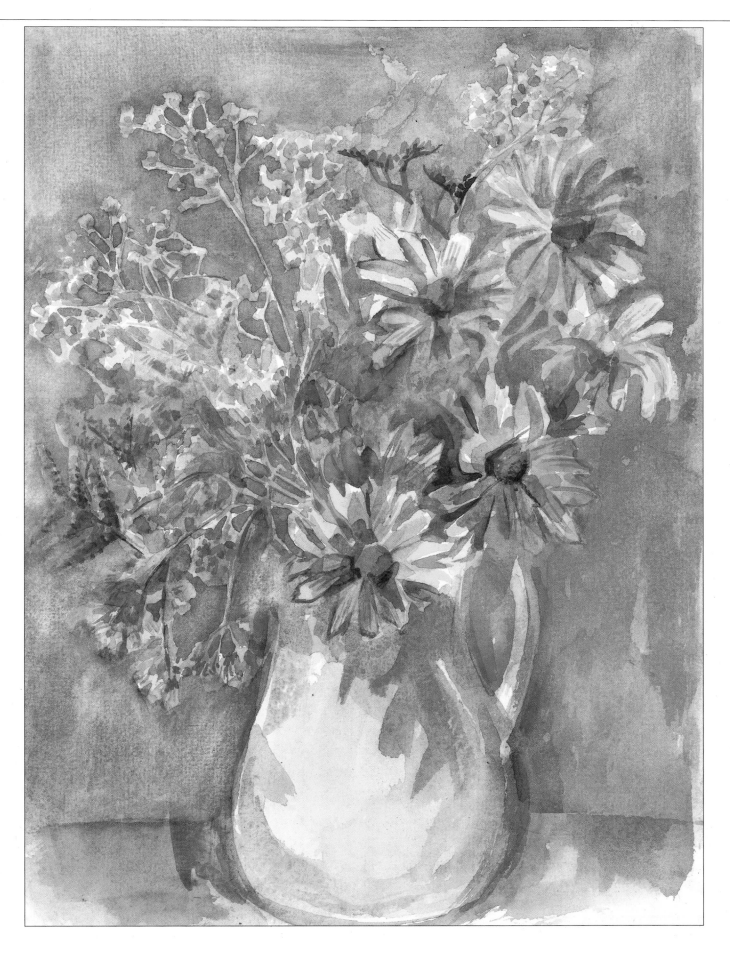

The **gradual method** is based on an overall colour scheme carried out in light tones. The painting is then completed with gradually adding rich colours where colour and light stand out in the real subject. Light areas are left in their original colours, dark areas are colour glazed in appropriate tones. (On the contrary, alla prima painting calls for experience and sound judgement in appraisal of the subject, the selection of colours and when applying them to the paper. Colours are applied to the sketch in the same degree of richness and shades as they occur in the subject, with no subsequent overpainting.)

In case of painting a more colourful bouquet, the relative intensities of colour must be assessed beforehand. The shades should either be applied in large areas, or drawn with colour, depending on whether a flower is to be characterized in patching or colour drawing. The light effects on various flowers should also be observed, and where appropriate, the colour made richer or paler. The creation of inner volume also must be observed before expressing it by applying darker colour into a wet ground. Flowers placed irregularly on the format of the painting will sometimes overlap. The shadows between the flowers will often also blend in with the edges of the flowers, which calls for a soft, somewhat blurred method of execution. These areas can be painted by applying colour to a wet ground. Wherever the illuminated parts of the flowers, especially their edges, contrast with the background, the transitional areas can be painted more solidly. A good spatial effect is achieved by painting the background in a deep colour and then giving solid outlines to petal edges.

If you like to depict a flower more emphatically, in more detail or in bolder colour while this has become dry, the area should be lightly wetted with clean water. The required degree of richness and appropriate outline can then be painted in. The overcolour will deepen the modelling of the flower by blending in with the undercolour, whereas colour applied to a dry undercolour creates more sharply defined outlines.

Although the **alla prima** painting is more demanding, it is still the best and most suitable method for painting flowers. It calls for good powers of observation and a sound appraisal of the mutual effects of colour and light in the early stages. This enables the artist to work with a sure hand and apply rich colours that will not require any subsequent adjustment. (See ill. of gladioli on p. 41.)

Here the brush, richly watered with colour, was applied to the paper to cover substantial areas while also outlining the shapes. Dark colour accents at the edges of the flowers, or where it was necessary to indicate modelling or overlap one petal with another, were applied to a still wet undercolour. The sharp outlines of the flower edges were left untouched, especially where they bordered on the background; the latter, in light blue,

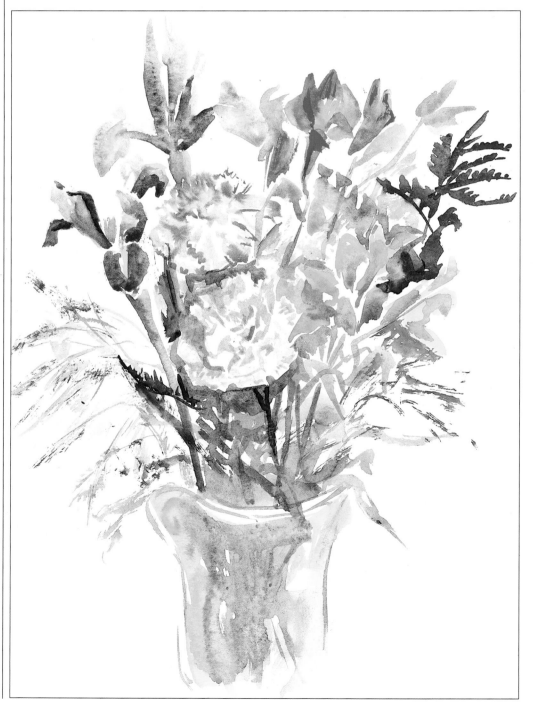

is painted over with green in some parts. Where greater contrast in colour or shade was called for the particular colour was applied a second time or even repeatedly, always into a wet ground to ensure a soft blend with the undercolour. The colours used were vermillion, crimson lake, terre verte, violet, cobalt, ultramarine and lemon yellow.

In the course of work, which was too fast, several tried-and-tested principles concerning the use of colours were confirmed particularly how to mix them. For example, violet straight from the tube seemed too hard and was therefore softened by adding violet mixed from blue and red.

Appropriate colour combination can be achieved by glazing over a dry undercolour, or by dissolving colour into a wet undercolour and, if necessary, brushing it out into the required shape.

MIXING COLOURS

Colours mixed from two primary or also other colours are highly recommended. The mixing of suitable colours results in some magnificent and harmonious shades which have more distinctive effects than those obtained from commercially produced paints. Knowing which shade to choose to produce a beautiful result calls for experiments and practical exercises (not every blue mixed with any red will produce a pleasing violet tone).

As with any other genre, success depends on how hard you work, or, as a matter of fact, how often the artist paints flowers. If they are to be only one among many other subjects, the few hints offered above may be enough as basic information and to whet the appetite. Many artists have a particular penchant for painting flowers, and no doubt these enthusiasts will in time acquire experience and skills far beyond the scope of the basic instructions and recommendations offered here.

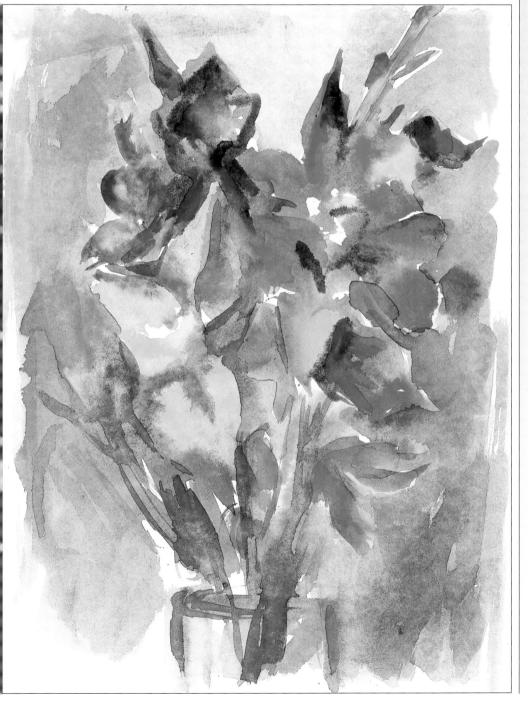

Opposite: The painting of a mixed bunch of flowers exemplifies the technique of painting alla prima without subsequent adaptations by overpainting or glazing. It was painted on dry paper. Only some parts were wiped with clean water, into which colour was then painted and spread to achieve the required shape and lightness.

Left: This small painting of yellow, red and violet gladioli is an example of painting alla prima.

Practical exercises

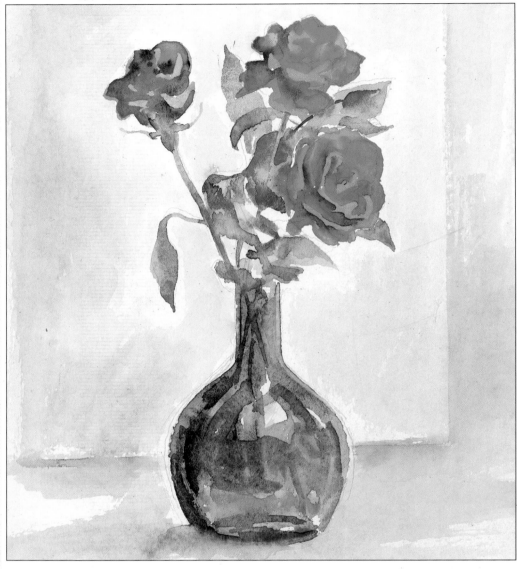

The picture (right) of red and yellow tulips with light and colour contrasts shows the use of a wide range of means of expression: painting wet-in-wet, glazing, tonal values and colour drawing. The picture was painted freely and quickly to express the vibrant colours and the velvety surface of the flowers.

The final example in this group is a painting of a pink aster flower with some small leaves. The ground of the flower was painted in a darker colour. In some places this colour was first removed using a clean dry brush. Other parts were darkened still by overpainting the dry ground.

A combination of alla prima painting with simple glazing over dry paint to emphasize the construction of the flowers.

The detail (left) shows how colour glazing emphasizes the structure of a flower.

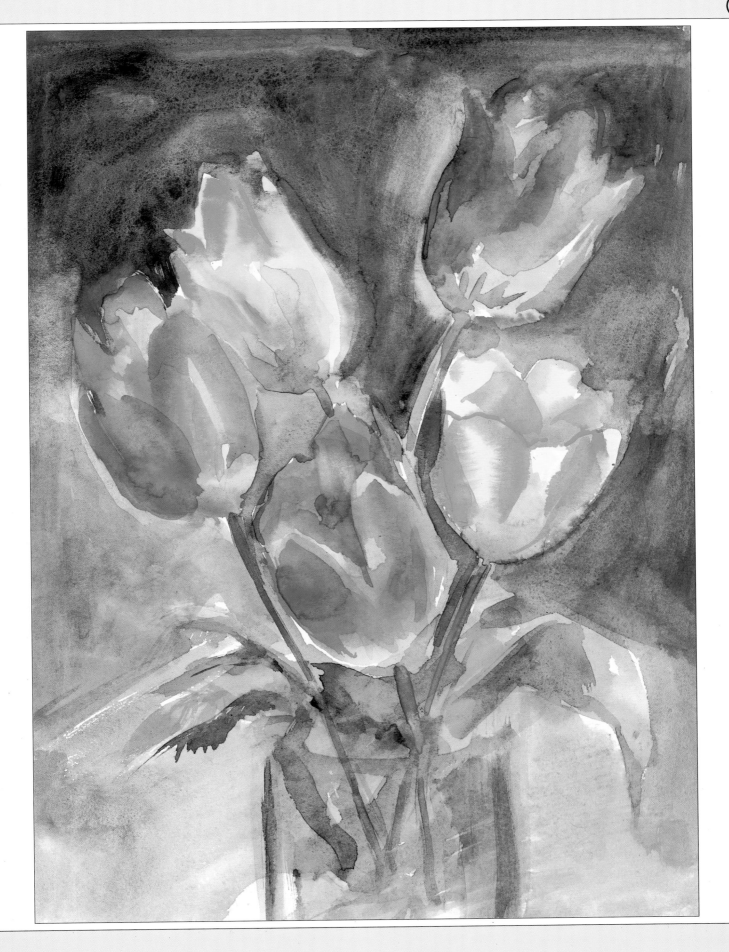

Painting motifs from nature

Thanks to the ease with which flowers, plants, animals and birds may be portrayed in watercolours, this technique has long been popular for use in this genre. Waterecolours represent a unique method for the illustration of scientific and educational publications.

Thus they have continued to hold their own despite the invention of photography, which has often replaced them due to its accuracy, speed and authenticity.

Watercolour illustrations have indeed one advantage over the objectivity of photography. In addition to a description of the object they can also make use of objective knowledge of it. This helps to clarify its nature and to generalize information about it as best as possible.

The illustration in watercolour can deliberately exaggerate and emphasize the characteristics of the given object. It can counteract the distorting effects of light and thus lead to a more precise depiction by deliberately and consciously combining objective knowledge with imagination. It reconstructs objects and phenomena which ceased to exist long before the invention of photography. Watercolour illustrations of architecture enable us to enjoy views of buildings and nooks and crannies of old cities which have fallen victim to the housing requirements of recent years and disappeared from the face of the earth. Watercolours are also important for the documentation of folklore, both depicting whole scenes as well as many important details, thus providing important material for study and conservation.

As for us, however, we are not only concerned with the utilitarian function of watercolours as a means of information, but rather trying to find pleasure in portraying something that has caught our attention in nature.

Watercolour painting from nature may also serve as preparation for artistic expression in other genres. The methods and procedures employed in the detailed and meticulous depiction of visual reality can stand artists in good stead whenever they seek to express themselves coherently and informatively. This also applies to situations where they are seeking a freer, more creative and more subjective mode of expression – just as the quality of the interpretation of a piano composition depends on the degree of the pianist's command over the keyboard.

Consequently, where are we to start? – With the simplest things.

They are all round us in abundance and most of the time we scarcely notice them at all. More often we are interested in attractive and spectacular phenomena. At the zoo most of us will admire birds with their beautiful plumage, or beasts of prey, which have proved a happy choice of subject for many artists (E. Delacroix, 1798–1863). But what about a dead pigeon lying in the street, with its delicate feathers in finely nuanced colours? Too depressing a theme? All right then, try a snail. A snail can hardly run away, and even if it does we will at least find its shell to use as a model. Obviously beginners are advised at first to choose immobile subjects facilitating peaceful, systematic work.

It is better to choose some easily accessible models. Beginners with a fancy to paint a bird with beautiful colouring will just have to make do with a stuffed animal, providing one is available. Similarly, they can try their luck with an interestingly shaped stone. Thanks to its simple colour scheme one can concentrate on getting the shape and the interesting surface right. Other suitable models include tree

bark, part of a branch, or various nuts and berries. The leaves of trees, especially in autumn colours, are preferable to all other models.

The examples given here show several such subjects: a stag-beetle, a stone, conches, the shell of a crustacean, a walnut and a fly, small dried flowers and a twig.

The object to be painted should be placed on a table so as to be viewed slightly from above, but not from too far away. Lighting is best kept natural and diffuse. Avoid sunlight, which changes.

Prior to painting, the object should be lightly sketched without details but with a well-defined outline, inner dimensions and good overall proportions, particularly when painting animals. Spots of light or lustre may be sketched in and carefully avoided at the painting stage. Correct modelling calls for light and shade to be placed as accurately as possible. Errors lead to distortion of visual reality. Sketching should be light, with a hard pencil, which is less smudged by subsequent painting than a soft pencil. In order to capture the true colours of the object as faithfully as possible it is essential to aim for unadulterated colour. You should also keep in mind that with this kind of painting some parts will be glazed several times.

The size of the brush is another crucial factor, which should change according to the size of the model.

Underpainting starts with a ground in a light tone corresponding to the colour of the strongest lights. Multiple glazing is then applied over this ground.

All the preceding sections have acquainted the reader with watercolour techniques in loosely designed studies. These do not call for a high degree of one's experience, concentration and care, which cannot be said of the range of themes to be dealt with in this and the following sections.

The methods used in painting motifs from nature we have just described call for close observation, patience and meticulous care though the demands put on creativity are less than those called for when painting landscapes, heads or figures.

The above-mentioned painter's objects are more or less simple and isolated in nature. Up to here, the artist need not have thorough knowledge of the principles of creative expression such as concept of form and colour, composition as well as his/her own perception of reality.

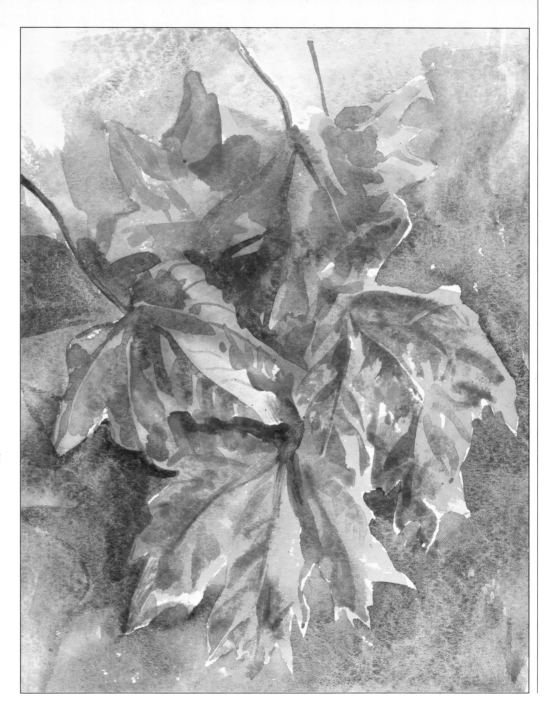

This composition of dried leaves shows, step by step, the methods described above. Their application and further elaboration is apparent in the lower part of the picture, where the leaves are finished, whereas the upper part was painted in large surfaces omitting details.

Practical exercises

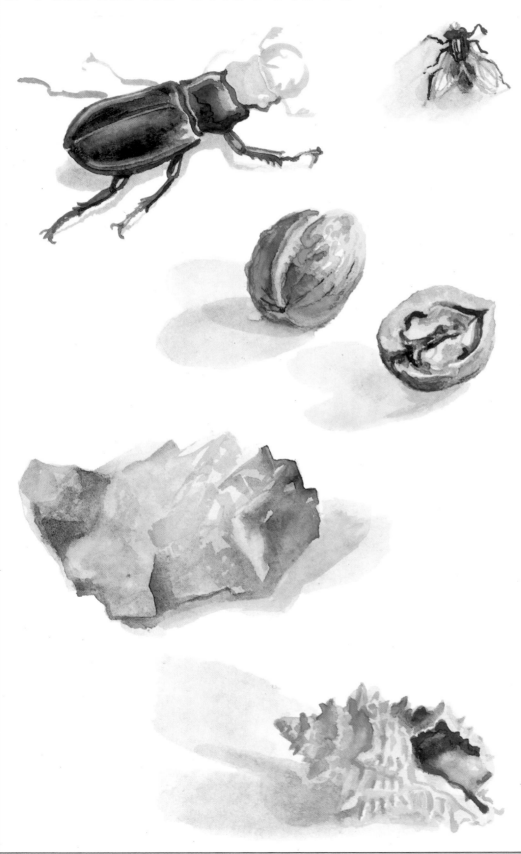

This painting of a stag-beetle has deliberately been left unfinished to illustrate the procedure used. The light ground has been left untouched around the head, mandibles and legs on the left side of the body. The brown wing-sheaths have been overpainted in brown and dark red with an admixture of black, omitting the light patch in pink along their axis. The thorax was painted using a similar procedure. The highlights here are light blue. Light pink has again been left out at the wing-sheath edges, and where necessary some of the upper layer of brown was gently washed with a brush.

Soft and hard transitions were used to create the impression of the hard surface and structure of the walnut.

The ground used for this stone was greyish-blue into the centre of which, while still wet, thin ochre was brushed. Some parts were overpainted wet-in-wet, some into partially dried ground. This evokes the structure of the surface of the stone. Parts expressing and emphasizing the hardness of the stone, particularly at the sharper edges, were glazed in a darker shade on the already dried bottom layer. This created sharper, distinct contrasts between light and dark colours. The procedure used is particularly noticeable in the upper right part of the model.

This intricate shell structure was underpainted in light ochre. The left side in the shade was painted while the ground was still wet, thus somewhat softening the spiky surface. The part exposed to light clearly shows the shell surface with the distinct spikes painted in over the light ochre ground with well defined brush strokes. The darkest place is the exposed inside of the shell, where dark red contrasts starkly with the light upper edge of the shell.

The leaves on the twigs were painted in a similar way as the following examples, except for the one on the left which was painted wet-in-wet suggesting rather the inner modelling than describing it accurately.

The following illustrations show the method used for gradually painting the inner modelling of small dried flowers and part of a lavishly shaped twig with the knots removed.

The upper part of the twig has been unfinished to highlight the procedure employed. The first step was to paint in the various parts of the twig in light shades of the relevant colours. These were then gradually shaded and drawn in to achieve the desired modelling, spatial effect and some indication of the surface structure.

In the painting of the conch multiple layers of colour glazing were used both for the artistic expression of the cup shaped depression and to evoke the contrasting mother-of-pearl part inside.

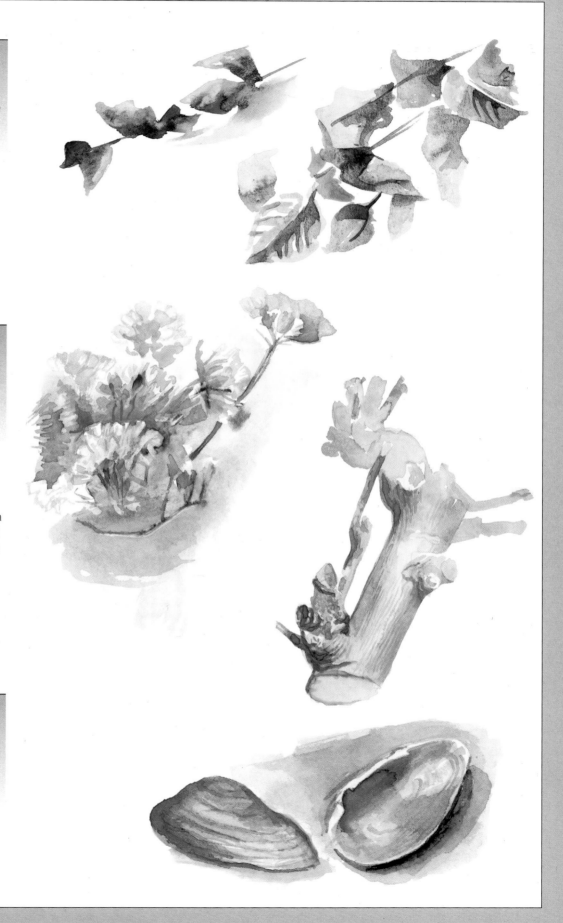

Painting animals

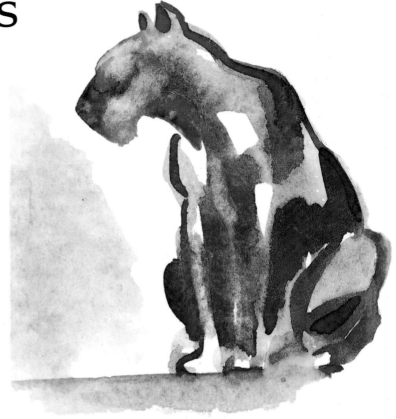

Painting animals calls for careful preliminary sketching and knowledge of the anatomy of the animal in question. Many budding watercolourists wish to immortalize their favourite pet. This is more likely to be successful when the animal is asleep or if it is possible to keep it in the same pose for the necessary span of time.

The illustrations (exemplifying what has been just said) show a black panther. Its characteristic postures are expressed generally by means of light and shade alternating in large areas. The horse and dog were painted in a similar way.

The outlines of the animal were painted in a light tone on dampened paper and then the shaded parts of the body added in rich colours. Darker shades were applied either on a wet, or a semi-dry undercolour. Here the highlights were unpainted, but this effect can also be achieved by removing some wet undercolour parts with a brush. The painting can be finished when the undercolour is completely dry by applying economical brush strokes to add the

Some of these pictures were painted freely from live models, the guinea pig and the cat from photographs. This facilitates the expression of details and the animal's fur. The working procedure can be combined — the animal (from a live model) is captured freely and in large colour planes, then details (from a photograph) are added.

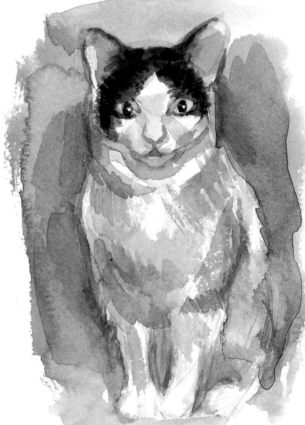

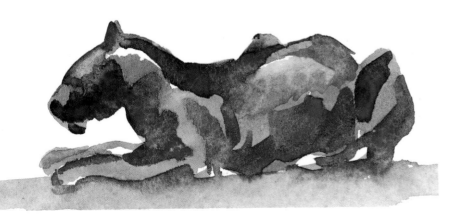

necessary details of shape or indicate the animal's fur.

Painting from nature, at the races or at the zoo, will always be of higher quality than painting from a photograph, although the latter cannot be refused entirely.

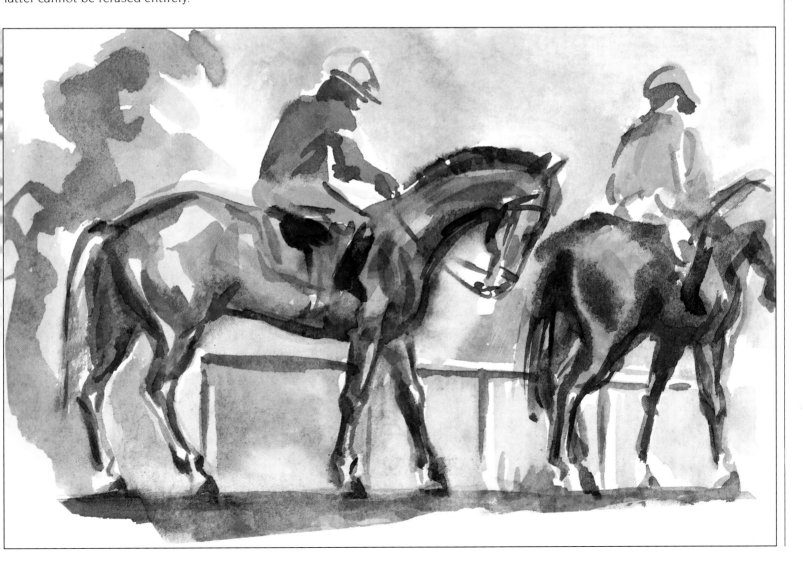

Painting still-lifes

Still-lifes should be included among the genres for watercolour paintings.

The most diverse objects encountered on a daily basis, whether on the kitchen table or elsewhere, can be turned into a still-life when arranged in a pleasing way which inspires the artist to paint them. The

arrangement may be a random one, but for painting purposes it is more often carefully arranged.

Still-life has a number of advantages which make it invaluable for painting studies. Since it is static, changing only with changing light, it can be studied as

long as the artist wants, which is impossible when painting a head or, all the more so, landscapes. Arranging it the artist can influence the complexity of the subject, its composition, colour scheme and lighting, depending on the objective he has in mind.

Still-life first appeared as a separate genre in Dutch and Flemish paintings of the seventeenth century, although it had been used earlier in some figural paintings. There, however, it had served as an accessory or decoration with the aim of enlivening and adding to the authenticity of the surroundings. With increasing interest in everything concerning food, drink, table settings or hunting, still-life became a much sought-after genre, soon achieving a remarkably high standard and popularity.

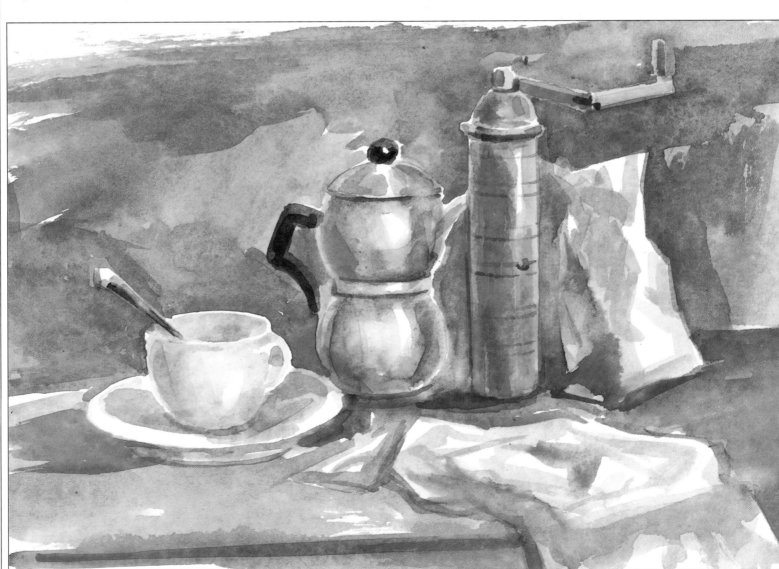

At first, the aim was nothing but capturing faithfully the character and material of those various objects, usually porcelain or pewter, plates and glasses. Soon, however, painters concentrated on composition. Both the content and the mode of expression were improved along with the quality of the painting which gradually acquired such a consummate level that still-life painting became a genre in its own right.

In the course of time the range of subjects expanded to include flowers and a wide range of animals from land and sea.

Baroque still-lifes increased in format. In contrast to the small proportions of the first Dutch and Flemish paintings, the size of the pictures approximated to those of the figural compositions of the period.

The unchanging, objective character of still-life has led modern painting, notably of the Cubist period, turn it into a quasi laboratory for discoveries in the realm of shape and form.

Still-life has remained a genre combining a whole range of elements for basic studies, from proportional and spatial relationships of objects to the expression of their inner modelling in colour or with the aid of light and shade.

This is why still-lifes are a useful aid in the study of watercolour painting.

STILL-LIFE COMPOSITION

In addition to the elements for study mentioned above, still-life painting can help the artist to verify the rules of composition and its characteristics. The advantage lies in the fact that the artist can adjust the composition in advance depending on the particular problem he is interested in. At the same time a still-life also allows for a deeper investigation of the nature of things to which we often only pay cursory attention. These objects, particularly when in their new arrangement, lead a quiet inner life of their own which the artist can try to capture and express in paint. It is irrelevant whether we juxtapose decorative objects, although these will be more difficult to paint, or simple objects of everyday use placed at random on a writing or work desk.

It is best to start with a simple still-life arranged of ordinary things with simple shapes. There should not be too many of them to begin with. This will enable the watercolorist to concentrate on coping with the relations of colour, proportion, space, shape and light. The very process of setting up the composition helps to develop a sense for it. Things should

be placed in an irregular arrangement. In the case of three, for example, this would create an irregular triangle. The ideal compositional effect can be appraised by viewing it from various sides, not forgetting to notice the effect of the general outline. In a still-life there tends to be more complexity of outline in the upper part of the composition. The lower part, where the objects rest on a support (a table or some other solid board which has the advantage of being portable) tends to a less complex outline, particularly if the support is at eye level. This makes it difficult to observe the spatial arrangement of objects at their base, and hence to create the illusion of space using linear perspective.

Here the artist can create the effect of spatial arrangement using tonal values which depend on the distribution of light and shade on the objects. Volume is created in the same way.

Where a more articulated outline of the still-life is desired it is better to view it from above, so that the lower outline may also be observed.

This situation often occurs in modern painting. The still-lifes of Georges Braque (1882–1963) are full of variously shaped objects, which, viewed from non-perspective, create a complex, two-dimensional composition.

Viewed from above, a still-life looks flatter, and should be painted as such. Unlike in the preceding example, colour shades less broken and gradated are applied here.

Left: Depicting the material of various objects.

Below: Still-life composition constructed according to the rule of the 'Golden Section'.

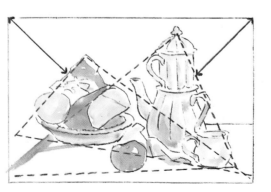

Left: We begin with a simple preliminary sketch paying attention to the correct placing of various groups of items within the format. The rule of the 'Golden Section' or 'Gate of Harmony' (discussed in detail in the section on landscapes, page 62) can be used here. Geometrical shapes, triangles framing things in the painting were subsequently applied to it. The fact that the areas of the triangles are almost identical proves the well-balanced surface. The abscisses running from the upper right and left corners of the format to the outer edges of the objects are also of the same length.

This still-life with bread and coffee pot
(deliberately in the classic style) illustrates
several principles of composition.

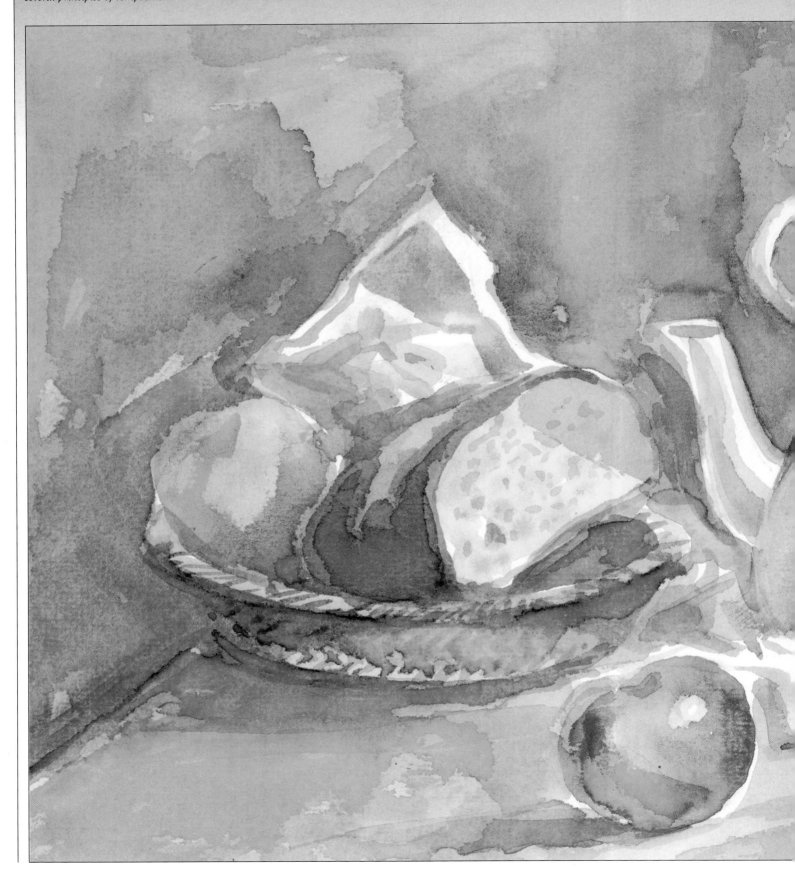

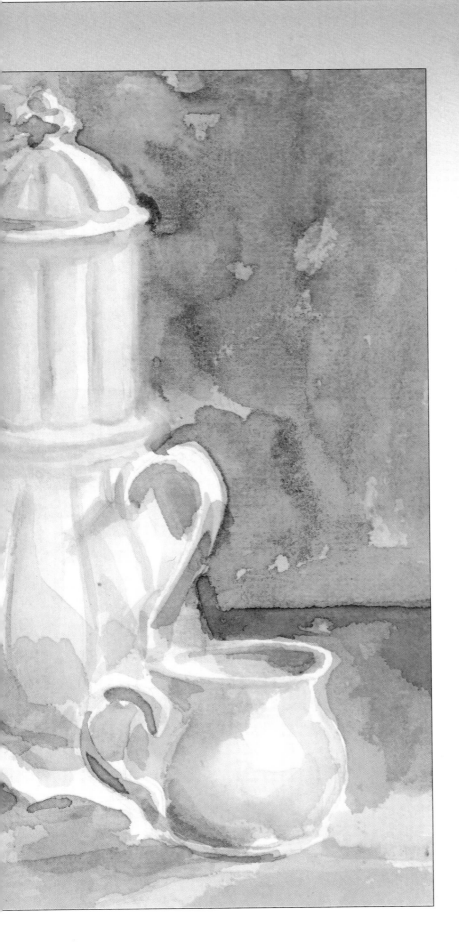

LIGHTING STILL-LIFE

Suitable lighting is important for still-life painting and can be adapted to our need and intention.

Lateral lighting shows the three-dimensional character of objects and allows the artist to concentrate on volume and space. The relationships between objects are more strongly differenciated. Local colours are affected by light and shade so that their intensity decreases by using broken colours and shading techniques which gives the whole a somewhat muted colour effect.

Direct lighting falls on the still-life vertically, which is then painted from the same direction. This brings out local colour; shadows are weaker and cover a smaller area. It means that the outlines of objects are accentuated. They may be drawn in cooler colours, such as blue, so that the outer edge is darker than the inner surface of the object. This approach permits the artist to respect the spatial element, although a still-life in direct light will appear flatter and can therefore be dealt with in a simpler, two-dimensional way, which is done by employing more colourful and purer style that is lighter and airier than the style used for a laterally-lit still-life.

The choice of lighting will depend on whether the artist prefers a three-dimensional, or two-dimensional type of colour painting. It also depends on the character of the objects. Those with more decorative and complicated surfaces should be lit from the side to bring out their characteristics.

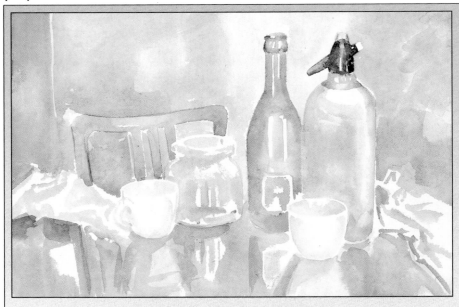

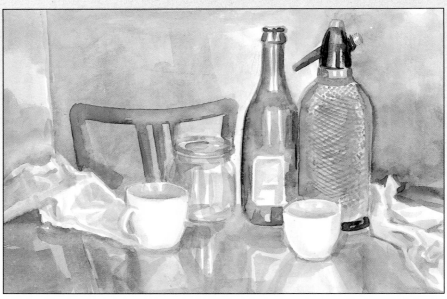

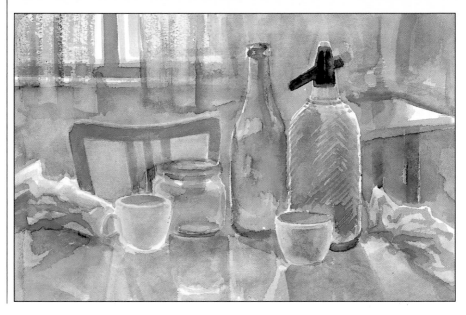

The final possibility is **counter-lighting**, where the still-life is lit from behind; the artist standing in front of the still-life views it from the shaded side. Colours fade considerably when the objects are in shade, particularly in a contrasting light. The observer perceives rather the outlines of the still-life than its internal colour arrangement. Still-life lit in this way is often employed in a painting together with other equally or even more important components, for example as part of an interior, placed against a window. This provides an opportunity of freely using larger areas with colours merging without need for a more definite differentiation in shape or colour of the various objects.

Lighting creates contrasts not only in light but also in line and colour. **Contrasts** are to be found in perpendicular, horizontal, sloping or rounded lines, as well as in the distribution and correlation between colours and light. The sensitive use of contrasts helps to harmonize a composition, to locate objects in space and to make a painting interesting and live.

From top to bottom:
In this still-life lit from the front the colours are not influenced by highlights and shadows (to make it clearer, a sample of the initial colour scheme is added).

The still-life lit from the side has a more three-dimensional effect.

The still-life lit from behind is darker and has more muted colours. It is here enlivened by the colour effect on the glass of the light coming through the window.

SELECTING MOTIFS / MEASURING PROPORTIONS

As we have seen, it is not always necessary to arrange a still life. It is often worth taking a good look at a random collection of items, such as the mess in the kitchen before the dishes are washed, or the apparent chaos on a writing desk. Try to walk round this group of items and look for the best viewing angle. This can be done by using a "viewer" formed by the index fingers and thumbs of both hands through which to observe the collection of items. The size of a "shot" can be adapted by bringing the hands closer to or further away from the objects. Or a view-finder may be made by cutting an oblong out of a piece of cardboard and attaching a holder. The oblong can be made shorter or longer, or changed into a square by attaching a strip of paper to one side of the cut-out. (More of this in the chapter on landscape painting.)

Painting begins with a light drawing of the whole still-life. You should pay attention to placing the items onto the format paper to be painted on, and to the fact whether the still-life is situated vertically or horizontally, according to which the paper format should be chosen; and if it is oblong you must decide whether the long or short side is to be the base of the picture.

It is important to learn to see the items in a still-life as a whole, shown in its outline

A still-life viewed from above concerned mainly with colour as well as the inner structures and contours of items. The distribution of items is random.

as a geometrical shape. This helps in correctly placing the whole group on the paper format.

Checking the proportions of the individual items also helps to practice correct assessment. The height, width and dissimilarities of the objects should be ascertained and indicated at the sketching stage.

Measuring is done by holding a brush, pencil or spillikin between the index finger and thumb with the arm outstretched towards the object being assessed.

The dimensions (e.g. height) are demarcated on the brush handle between its tip and the thumb. This measurement is then transferred to the paper. The brush can be positioned vertically or horizontally, or placed parallel to a particular line to be measured in the still-life. The same technique is also used when painting landscapes, architecture and, above all, figures.

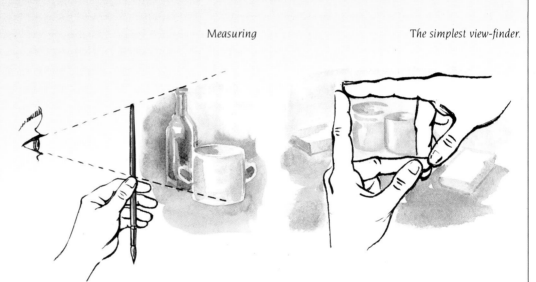

Measuring *The simplest view-finder.*

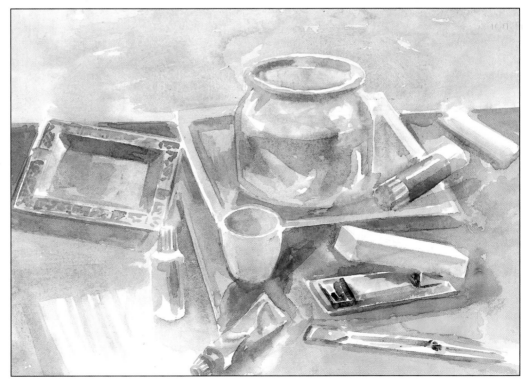

Practical exercises

Preliminary sketch for a still-life.

The illustration given here shows a bottle and beside it a light ochre milk jug which forms a transition between the vertical bottle and the low, horizontal bread basket. A tea towel falling in free folds over the edges of the table was used to introduce slanting lines. (The tea towel can be replaced by any piece of fabric which will form folds expressed both in volume and lines.)

Fabric in complicated and interesting folds is known in painting as **drapery** and was once a frequent object of study for the great masters, chiefly on account of its occurrence in figural painting. It has also become a common and significant component of still-life painting.

The softly draped tea towel used here counteracts the abrupt vertical and horizontal lines thus helping to harmonize the overall distribution of the components of the picture. At the same time its soft structure creates a contrast to the hard material surfaces of the other objects. Distinguishing the materials of which objects are made has always been one of the outstanding features of still-life painting.

Finally, there is a round, yellow-and-red apple in our illustration; its vivid colouring and shape add a piquant note to the resulting effect.

The **working procedure** for the still-life described above is as follows:

First make a simple pencil **sketch** (charcoal can be used for larger formats). The sketch should be light and only indicate the essential elements for

orientation. (An exception is allowed to a more complex drawing coloured in watercolours.) The sketch may also be done with the tip of the brush using a light, best would be a neutral colour.

Sketching is followed by planning the distribution of colours. The application of large areas of light colour shades leads to an overall view of the composition of colour and light. The largest highlights are left blank, but may be lightly indicated during sketching when accurate placing is required.

The volumes of objects (the milk jug on the left, the metal coffee pot) are painted by applying a light colour and taking it from the strongest light to the edge of the vessel and then modelling it there with a darker shade of the same colour. This can either be applied into the wet ground or for glazing at a later stage. Reflections on the metal jug appear in a different tone. These are applied in a similar way, but they must not blend with the adjoining colour creating the shade. In the case of items which reflect the colour of neighbouring objects (metal, shiny ones), the placing of colour and light must be carefully observed to prevent distortion of the basic modelling of objects.

The drapery – here the tea towel – is flat at first. Folds in the fabric are indicated later in a darker colour applied either in wet, or in a semi-dry ground colour.

The next phase uses glazing to intensify the modelling and spatial relationships of objects. These are accentuated, where necessary, by exaggerating the light contrast wherever objects touch or

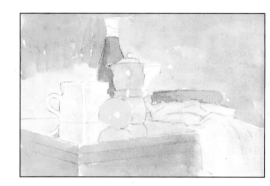

Above: Determining colours are painted in larger blocks into the simple drawing. The colours are light because they are to be glazed at a later stage. The whole appears flat without the use of tonal values. There is no modelling and spatial effect has not yet been solved.

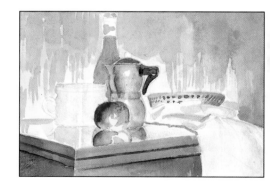

In the following phase, modelling and the spaces between objects have been achieved by glazing. At a later stage – not represented here – glazing in cooler shades will be used in the background. Modelling of the vessel on the left will be enhanced, the colour of the bottle deepened and the pattern on the tea towel completed.

overlap. The same applies to the spatial relation between the still-life and its background.

Depending on the distinguishing features of the model and its components, practical knowledge acquired during painting flowers or natural motifs can also be employed here. These include overpainting, combining colours, the hard edges of glazing, or, alternatively, softening the transition between adjoining colours in wet-in-wet painting.

In the final phase of painting the overall colour harmonization and the distribution of light and shade are corrected and accents of colour and richness added. As has been said, different colours have different spatial effects. Since this knowledge cannot always be fully put to

good use when setting up a still-life it is sometimes necessary to adapt the colours of certain objects in a picture in a way to prevent complications from creating the illusion of space.

The working procedure for the still-life described above is a case in point. The background is in a warm colour, whereas the still-life itself has been painted in cooler tones. Spatial separation between a still-life and its background can be achieved by making the background lighter wherever it comes into contact with the still-life outline.

Alternatively, the background colour can be modified in the final phase by applying a cooler glazing in at least a few places (see the same still-life painted freely alla prima).

An example showing the same still-life painted alla prima. The gradual method is replaced by one not based on underpainting, but expressing colours, volumes and shape simultaneously. This method is faster and facilitates a lively and fresh approach, but calls for considerable experience and a sure appraisal of colours and their richness. The picture also illustrates the likely result of using the gradual method.

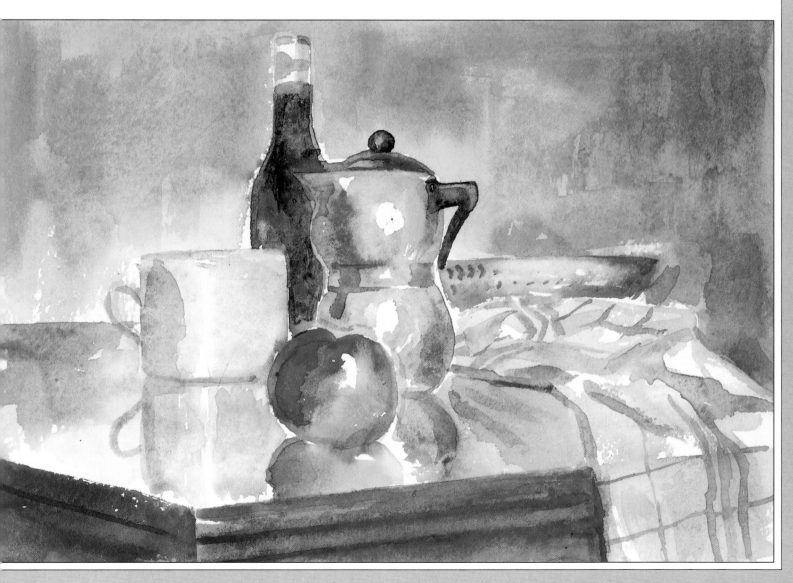

Landscape painting

Apart from painting flowers, landscapes are – for a variety of reasons – an excellent subject for watercolours. Watercolours are appropriate for creating coloured landscape records which can later serve as the basis for further work on a larger format, perhaps in oils. A watercolour sketch is fast, enabling the artist to capture the essential features of a landscape in a vivid and interesting way.

Without claiming to be a study of details, watercolours are a relatively fast way of capturing an overall impression based on a certain harmony of colours whose individual, combined and well-considered shades express the mood of the landscape.

Together with a more detailed drawing or even a photograph, a quick sketch can serve as a useful basis for further, thorough work at home.

Apart from sketching, watercolour can also be used in painting landscapes more sophisticatedly, using a certain method of approach.

In the history of watercolour paintings both methods are documented by the works of major painters, some of whom have already been mentioned (e.g. the later works of Turner give an overall impression without descriptive details). There are innumerable different methods of approach in painting landscapes using the watercolour technique, especially in modern art, with its emphasis on the simple application of rich colour planes unaffected by light and space.

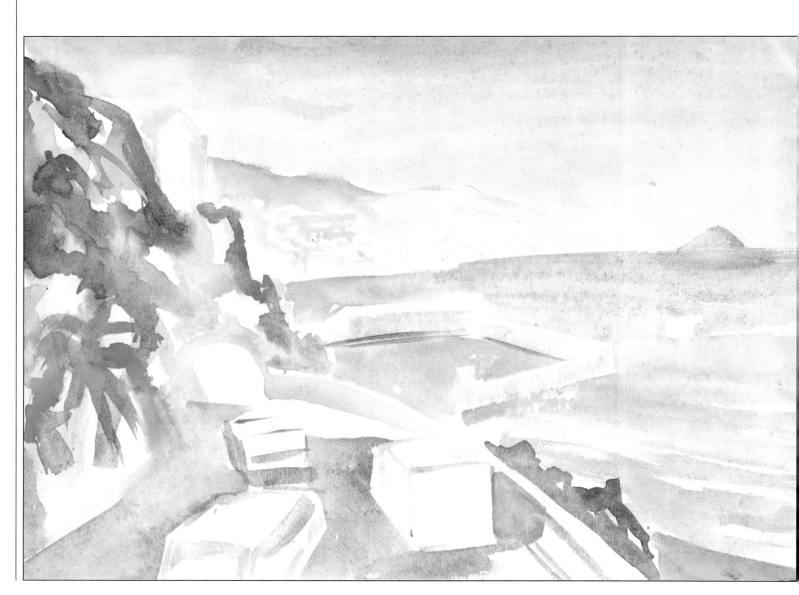

SELECTING SUBJECTS AND MOTIFS

Certain rules which are valid also for other genres apply to landscape painting though playing a specific role.

This is, first and foremost, the rule connected with the choice of a motif which, in turn, affects the mode of creative expression.

The beginner is advised, at first, to choose simpler motifs uncluttered by an excess of detail.

One such subject is a landscape panorama, provided its composition of colour and shape is obvious and clear. A good example is a terrain divided into various colour planes of fields and meadows, viewed slightly from above to bring out this articulation. Such a motif provides more opportunity to paint larger surfaces of colour than one with a low horizon, which calls for a more spatial approach with the aid of drawn elements such as a path trailing off into the distance, or an avenue of trees.

Another suitable subject is a section of a landscape panorama, containing elements of shape and colour permitting full concentration on a relatively small number of observed objects. These may be various nooks and crannies where attention is drawn by a major interesting detail that stands out in the simple, calm surroundings. In this sense a motif resembles a still-life and can be dealt with as such (for example, an interestingly shaped branch of a tree lit by the sun, a shrub in a shaded corner of a garden or in a courtyard against the tranquil surface of a wall, or a tree silhouetted against the darker background of a forest).

Left: A colour sketch expecting later completion.
Below: The completed painting is richer in the raggedness of the rocks and the expression of space.

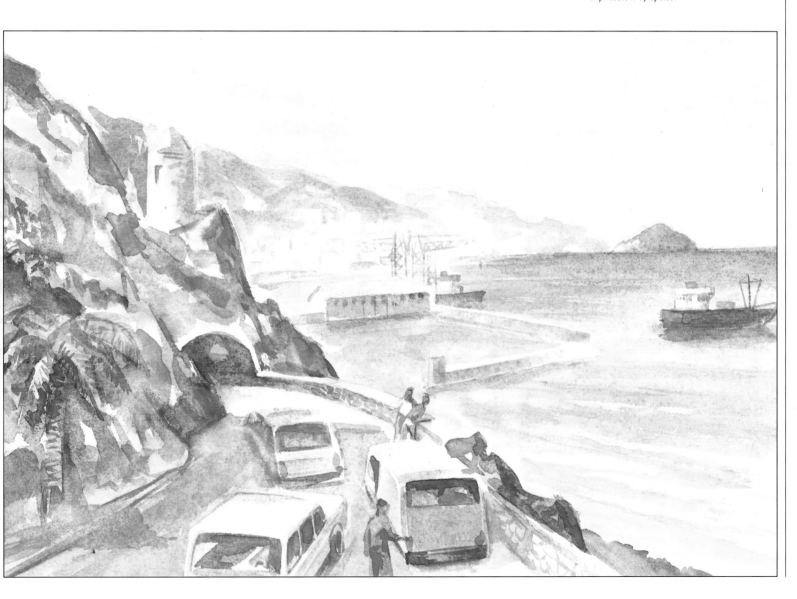

USING A VIEW-FINDER

Artists are often guided by their feelings when selecting a motif. A view-finder is a useful aid to the choice of the most suitable section of the landscape, to a clearer understanding of the composition, and speedy orientation.

If the view-finder happens to be left at home the index fingers and thumbs of both hands will serve to form a viewer quite easily.

Some painters have no need of either of these aids and are simply guided by their feelings, which strengthen with experience. Even so, these aids are by no means superfluous as they help the artist in the early stages to weigh up calmly all the various compositional aspects of the motif in terms of colour, form, light and space.

Where there is a particular concern for accuracy of expression, especially with regard to proportions (the need for accuracy depends on the character of the motif and is particularly important when architectural features figure in a landscape), it is advisable to attach a network of fine string to the viewing-frame. The horizontal and vertical lines made by the string serve as an orientation net through which to observe the landscape. The squares formed between the strings also help to ascertain quickly and accurately all the lines, shapes and proportions of everything contained in the view. The same network, adjusted appropriately to suit the format, can then be drawn lightly onto the paper.

In this case the view-finder, equipped with a handle, needs to be attached to something such as a stick and stuck into the ground to ensure a fixed viewing angle and prevent the distortion of visual information. This is more difficult to achieve with a hand-held view-finder.

This study aid was used more widely formerly than nowadays, when the faster pace of life is accompanied by impatience as well as a search for a different meaning in painting. Nevertheless, to cultivate discipline and method of our approach to painting it is worth working with a view-finder and learning from the experience thus gained.

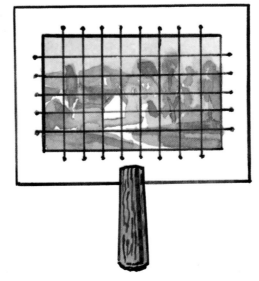

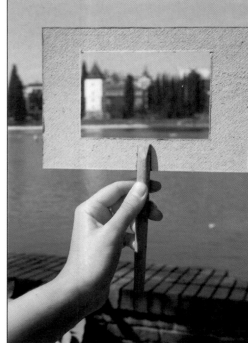

Above: A view-finder with a net.

Right and below: A view-finder and measuring proportions.

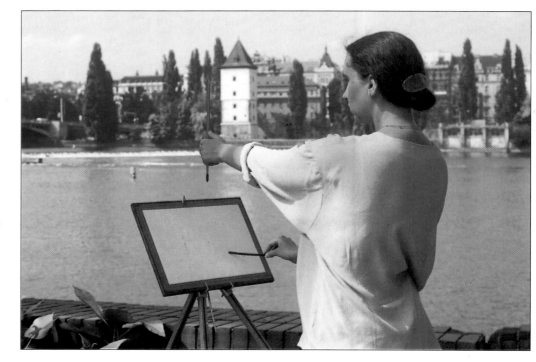

A high horizon line stresses the monumental character of the mountain landscape. This picture also exemplifies the kind of fast alla prima painting often made on artists' outings.

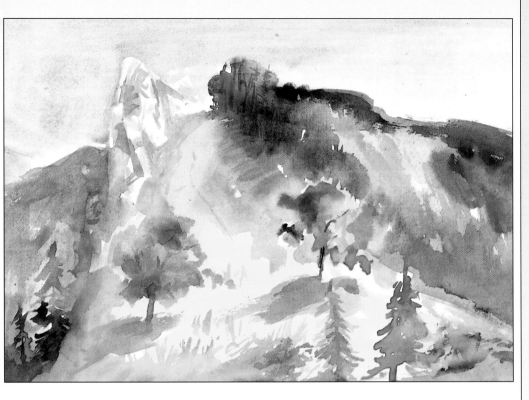

A low horizon line.

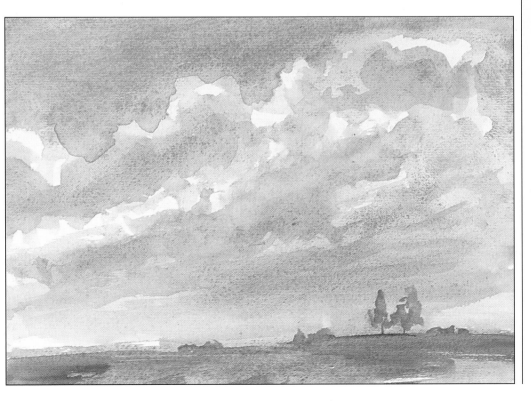

COMPOSITION IN LANDSCAPE PAINTING

Composition is a major factor in all spheres of painting and has always featured in all of them to a greater or lesser extent. Since its importance increases with the size of the format, it might be supposed that its importance for watercolour is rather limited, as opposed to, e.g., oil-painting. In many cases, however, you will see that particularly in landscape painting the meticulous choice of composition at the outset is a prerequisite for a good result. This is because watercolour technique does not lend itself to substantial subsequent alterations or corrections, and because the final result is expected to give a fresh and unique impression.

Landscape painting and composition have always gone hand in hand. The landscape was sometimes artificially composed; composition, especially in the early years, was set up according to hard-and-fast rules which changed only little over the years. Until the nineteenth century many landscapes were painted in the studio and experience with plain air painting did not begin to make any real impact until Realism (the French painters Gustave Courbet, 1819–1877, Eugène Boudin, 1824–1898, etc.).

Prior to this, as in the case of still-life, the Dutch painters of the seventeenth century were already interested in landscape painting.

Besides light and shade and their influence on landscape there were other principles which gradually came to shape basic composition, and it was this schema that in some variations penetrated all artistic styles of the nineteenth, and sometimes even the twentieth century. Considering composition in relation to

format means to think over and solve the problem of how to convert visual reality into an image in a two-dimensional picture with the aid of lines, shapes and colours. The sum total of these components has to be taken into account in the very first stage of selecting a landscape panorama when the artist must decide the ratio between the sides of the format and whether to use the longer or shorter one as the base of the picture.

Another crucial decision conserns the dominant features in the landscape; for example, an interestingly shaped tree in the foreground, the location of which will determine the character of the picture, i.e. also the distribution of other, less important elements.

It is the artist's decision, depending on the feelings to be expressed, which features are to have priority and to what extent. If our attention is drawn, for example, to a tall expanse of the sky with an interesting cloud formation, the horizon line will be lowered in order to give the sky enough space. If, on the other hand, the landscape is of particular interest because of its shape, colour or perspective, space allocated to the sky will have to be reduced.

Initial orientation proceeds from at least a general knowledge of the rules of the "Golden Section" or the "Gate of Harmony", which have been used since the Renaissance. The construction of both is shown in the diagram.

The **Golden Section** is such a division of a given distance that the relation between the smaller and larger sections is the same as the relation between the larger part and the whole. The numerical expression, *c*. 1.615, is derived from a ratio of *c*. 13 : 21.

The **Gate of Harmony** expresses the ratio between one side of a square and its diagonal. This is expressed numerically as 1 : 1.14.

The correlations between these two rules not only represent the ratio between the longer and shorter sides of the picture format, but also determine the crucial points in the overall compositional scheme.

Though these correlations will not always be found in ideal form in all pictures, an examination of a substantial number of paintings will reveal their presence, more or less, in classical painting as well as in modern art.

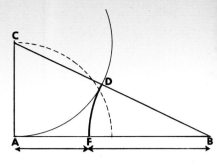

GATE OF HARMONY
$a : b = 1 : \sqrt{2}$
Constructing the proportions.

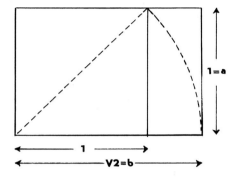

A circle with a radius equal to the diagonal of a square describes both the length of the longer side of the format at the point of intersection of the base line, and the ratio between the shorter and the longer sides. This ratio occurs frequently in landscapes.

GOLDEN SECTION
This proportion is a division of a given distance so that the smaller section stands in the same relation to the larger as the larger does to the whole.
Here: AC = 1/2 AB
 BF = BD
 AB : BF = BF : AF
Construction:
Draw a circle round point A with a radius half the length of AB. Then draw another circle with the same radius round point C, joined to B by a straight line. From point D where this straight line intersects the above-mentioned circle describe another circle with B at its centre. Point F, where this circle cuts through AB, defines the proportions of the Golden Section.

Below: The Golden Section applied to a painting by the Czech artist Adolf Kosárek (1830–1859).

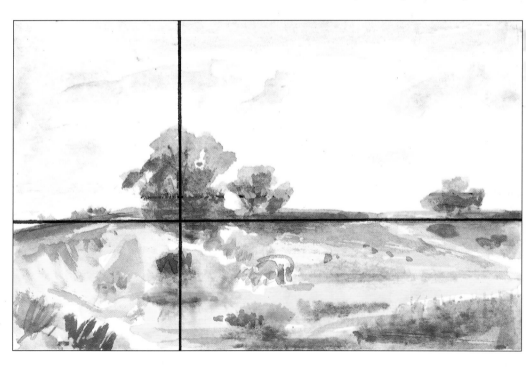

IMPORTANT COMPOSITIONAL ELEMENTS

Besides the above-mentioned rules of composition which play a part both in choosing the format and in the internal arrangement of the various elements which will make up the picture, there are other compositional elements with characteristics and distinctive effects of their own.

Horizontal lines in a picture have a calming effect. This is affirmed by our sight of a surface of water, which generally gives the observer a sense of quiet and pleasant stability. The use of several horizontal lines one above the other increases this calming effect.

Perpendicular lines have an uplifting effect, evoking a sense of stability and elation. This may take the form of a lone tall tree dominating the picture within other than perpendicular lines.

Oblique lines, which evoke a sense of movement, a change from tranquillity, have a different effect. Depending on where they are placed they may evoke feelings of either rise or fall, thus

introducing an element of excitement or even tension. Oblique lines may alternatively be used to counteract the austerity of horizontal or perpendicular lines and to harmonize the overall linear structure of a picture.

Lastly, **rounded lines** can evoke a feeling of excitement. Depending on the nature of the subject, they may have an optimistic, dynamic, or even dramatic effect (e.g. ocean waves, rocks, or a spreading tree).

Combining these lines and determining their relationships and importance, we may influence the effect of the picture as a whole. Alternating and repeating colour

A landscape panorama showing the colour gradations of the spatial planes.

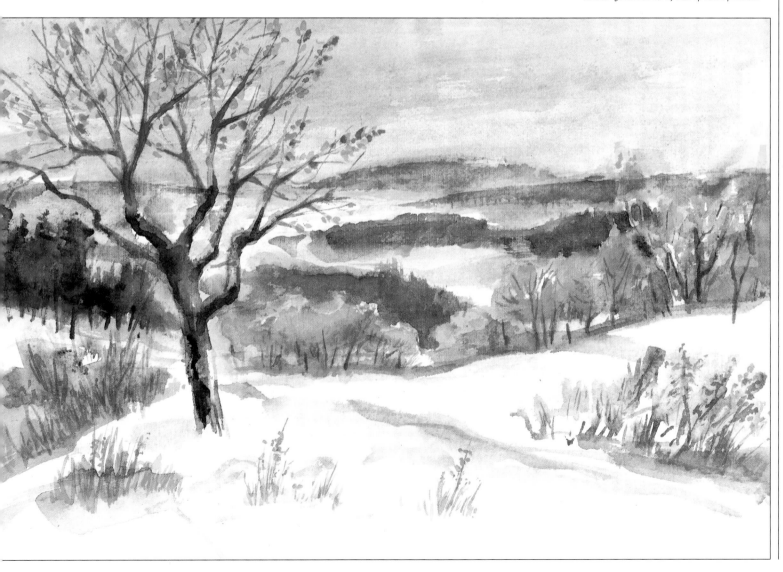

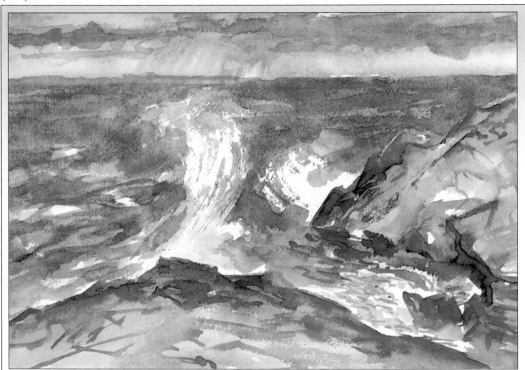

tones as well as lines and the shapes delineated by them result in either a harmonious effect, or the opposite. Thus the picture is enriched with something entirely subjective, which is much more difficult to convey than reality.

The above information on the Gate of Harmony, the Golden Section, and linear composition can be seen in some of the illustrations here. Note that the optical centre of a picture does not usually coincide with its geometric centre.

Left: A rough sea, breakers and jagged rocks in this example produce a stirring composition marked by expressive colour and spirited execution.

Below: The vague horizon line and the unbroken surface of the sea evoke a tranquil effect.

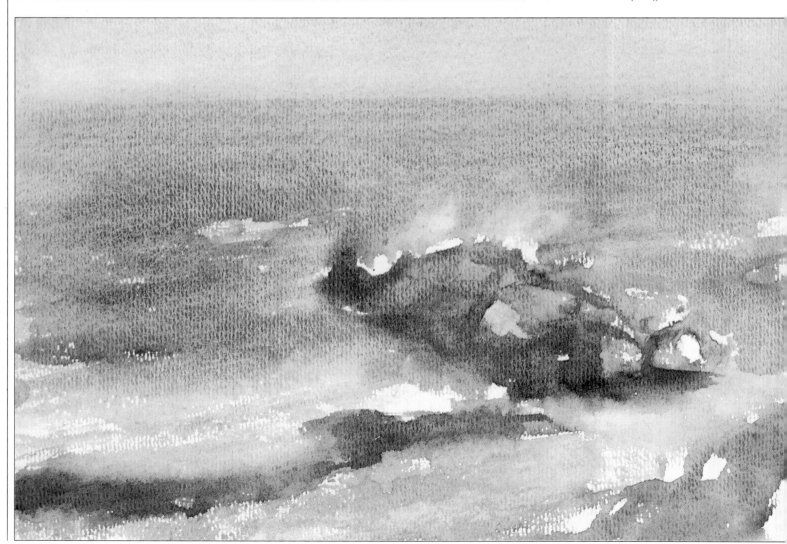

COLOUR COMPOSITION

Since colour is the main means of artistic expression, its role in composition can hardly be overlooked. **Colour composition** is influenced by a number of other elements, such as light or aerial perspective; colour alone is used in the case of two-dimensional compositions. The distribution of colours over the picture obviously depends on the subject. Even so, it is still necessary to consider how a colour can be modified, both with respect to the subject matter and the purpose it serves. For example, where the essence of a landscape is its spatial construction (in large, long-distance views, namely panoramas), colour selection has to be guided by the requirements of aerial perspective, which makes use of various colour shades and tints to create the illusion of space (see the section on colour planes, page 30).

Colour harmony is governed by certain laws just like harmony in music. It derives from the properties of colour described earlier and makes use of a range of facts concerning complementary colours, the breaking of colours, colour contrast, etc. If red is juxtaposed to a complementary green, for example, the result is an intense contrast. This can sometimes be put to good use, or else the effect has to be moderated by breaking one or both of the juxtaposed colours. When a certain colour should be made particularly striking the surrounding colours are broken.

Alternating bright colours with broken or neutral ones in areas of certain sizes according to a deliberately planned rhythm enhances the harmonization of the composition. The functions of warm and cold colours has already been mentioned in the section on colours (page 29).

SPACE IN LANDSCAPES

Although contemporary painting respects space to a lesser extent than that of previous eras, it is still worthwhile to mention at least the basic principles of creating spatial effects. Some of these have already been drafted in our handbook.

Constructing space in landscape painting depends on the correct appraisal of tonal values, the degree of richness used in the foreground, the appropriate use of placing warm and cool colour tones (the classic landscape construction dividing the picture into three colour planes has already been mentioned on page 30), as well as on drawing prominent components of the model for a natural **construction of perspective.** The latter may take the form of an avenue of trees,

a path, or the edge of a cornfield vanishing in the distance. Many such space-constructing elements are usually observed; others may be constructed (as in the picture below).

In addition to colour perspective (the spatial distribution of warm and cool colours), landscape also involves drawing perspective. The picture illustrates how this is constructed. An avenue of poplars, a path, a row of bushes and the edge of a cornfield converge at a vanishing point on the horizon.

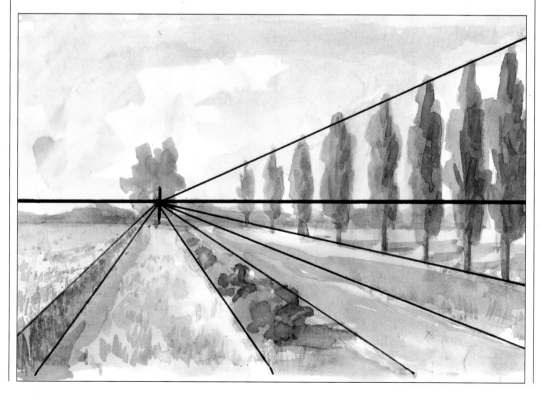

PAINTING TECHNIQUES: THE GRADUAL METHOD

While the method alla prima is more spontaneous and can be often found in modern painting, paintings created by the gradual method used to have specific rules. We can learn from them, but they need not be taken as strict dogma which cannot be broken.

In order to find a mode of artistic expression to suit us, we first need to try out a few procedures based on these rules, the application of which will open up the huge potential of watercolour painting.

One such method can be explained using the following example, a simple, not too extensive landscape with a river, as shown in the illustrations on the opposite page. An important focal point on the left bank is a spreading tree; the bank is also bordered by small bushes. The bank on the right hand side of the picture features two poplars, with a larger tree in the foreground. The two motifs are linked by a low range of hills on the horizon.

The landscape is flooded in early morning sunlight from the left, modelling the tree branches without creating too stark shadows.

This picture was painted in three phases and exemplifies the procedure for painting on a dry ground later to be covered by glazing. The **first phase** was to apply only the shaded parts using pure deep ultramarine (dark blue). The shades define the basic structure of the trees, bushes and the whole landscape. At the same time they represent the compositional scheme of the whole picture. The rounded contours of the trees form a linear contrast to the straighter, oblique lines of

the two river banks, while the gentler line of the far bank is balanced by the more oblique but shorter line of the near bank. The layout of the most shaded parts thus reveals from the outset the overall composition of the picture and is the foundation of the work to follow.

The **second phase** is the application of green indicating medium light, and light violet (ultramarine and red cadmium) for the hills and river banks. Light brown with an admixture of orange is used to brush in the tree trunks and branches. The green colour was applied in large blocks following the shape of the leafy branches. It was somewhat thinner and covered the shaded parts as well, so that it blended and softened the two colours. Then light cobalt was used to paint the sky and the river surface, as yet without the dark reflections of the bushes. Light blue glazing intensified the colour of the hills on the horizon.

In the **third phase**, yellow is used to indicate sunlight on the tree edges, and green to glaze again the colour of the trees and the field on the far river bank. On the trees the deeper green models the branches more clearly and indicates the outlines of the bushes on the far river bank thus enhancing the spatial effect. Shades were accentuated where necessary for the same purpose.

The colour of the sky was glazed again, this time in Cerulean blue, to accentuate the yellow edges of the trees and to deepen the tone of the sky.

The river surface was dealt with in the same way. The reflections of the bushes and trees were painted wet in wet. The slight diffusion of the colour at the edges enhanced the impression of the water surface.

The use of colours in the series of pictures shown here has deliberately been kept to stress the difference between the two-dimensional second phase and the third phase in which colours and spatial construction are deepened. For the sake of clarity this phase is presented here as the last, but there is nothing to prevent the painter from continuing. The three-phase

approach is not a hard-and-fast rule that must be kept at any cost. On the contrary, it is better for beginners to aim at the most particular observation of their subject which will lead to an increase in the number of phases. It is worth doing this even if the first pictures you paint will be lacking in freshness and colourfulness. But you will have learned the usefulness of layering colours.

The artist learns which colours cover more (ochres, reds) and which are more translucent and therefore may often be glazed. The acquisition of this knowledge reaps its rewards in time. The student will realize at the very outset of work which procedure is most suitable in any given situation.

It should be pointed out that the method described above, beginning with the painting of shaded parts, need not be the only one.

It is possible to start with applying large blocks of medium light colour (in this case light green to represent the mean between light and shade). These could be complemented by shading in the darker parts during the second phase. In any case, the highlight should be omitted. Even here, however, it will be necessary to make some minor colour modifications at the end. We soon learn that pure white rarely occurs in a subject. Parts of the pure white ground which are left unpainted help to create the necessary contrast. Since our colour scale is restricted by comparison with the vast scale of colour shades that occurs in nature, the artist has to make allowances for a certain degree of exaggeration and reduction. This approach must be implemented at every stage in painting in order to capture the colour and light correlations as faithfully and effectively as possible. It must always be borne in mind that painting is a combination of visually perceived objective reality and the artist's ability to appraise and express it.

There are numerous other techniques in addition to the above, which we shall mention in short. One of the classic water-colour techniques was to lay a single neutral colour, usually grey, over the

whole picture. The contours, modelling and space were then indicated in this single slight tone. The advantage of this method is obvious: the grey layer of **underpainting** facilitates completion by overpainting in bright colours. This is a lucid, organized approach permitting sound execution. Compared to the more spontaneous alla prima method, however, it is rather outmoded. The first phase of this working method recalls that of applying a colour wash to drawings in which ink thinned with water was used to create tonal values. The underpainting must be light so as not to distort the overall colour effect. (Classic watercolours were fixed to prevent smudging of the underlayer.)

This technique is best-suited for rather complex motifs which call for precise delineation.

Any beginner interested in mastering this method is advised to test the effect of glazing over grey underpaint on samples to make sure that the richness of the underpaint does not disturb the effect of the glazing.

It is not essential to use this classic underpainting method exclusively in grey. Depending on the overall range of colours in observed reality, underpainting can equally be carried out using such a shade which predominates in the landscape or which evokes its mood (an overcast landscape, for example, can be underpainted in pale blue, whereas a sun-drenched landscape might be underpainted in light orange). Some situations would suggest painting on tinted paper, as J. M. W. Turner used to do.

In the first phase, blue was used for the most distinctive shades.

In the second phase, medium green and light blue were added to the larger areas.

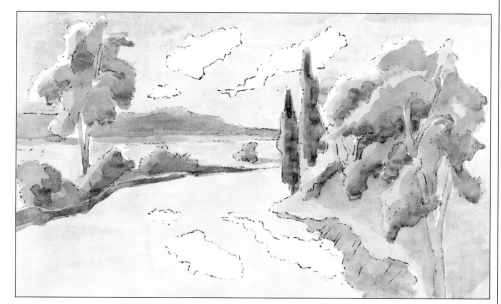

The last phase – the deepening of modelling and space by glazing.

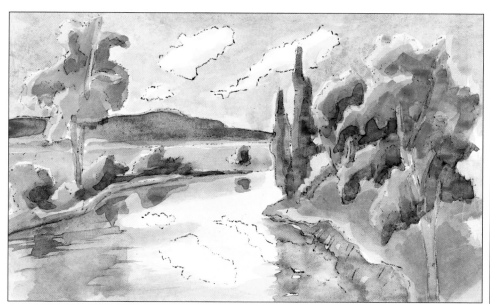

Practical exercises

Having first decided which components are the most important, lightly sketch the motif in pencil. This avoids overloading the subsequent painting with too many details which would impede the work.

The **preliminary sketch** depends on the nature of the motif and on the way it is to be painted. More complex parts of the plan will require sketching in more detail, for example an intricate piece of architecture in a landscape. Even a landscape itself can sometimes have a complex architectural structure, e.g. a group of trees and bushes which is to play an important part in the picture. Less detailed sketching is required for landscapes made up of larger, flat units (fields, meadows, the crowns of large trees, the walls of buildings, etc.).

The **colour scheme** can be indicated using the tip of a brush dipped in a light tinge of the predominant colour to be used. Stronger colours can be used depending both on the subject of the motif and on whether the drawing is to remain an essential part of the painting. Where the character of landscape permits, and after some considerable experience has been acquired, the colour scheme may be indicated in larger simple blocks without pre-drawing.

Above: Drawing the basic composition of a picture.

Above right: A preliminary sketch in a very light, neutral tint.

Right: A scheme executed in blocks of colour.

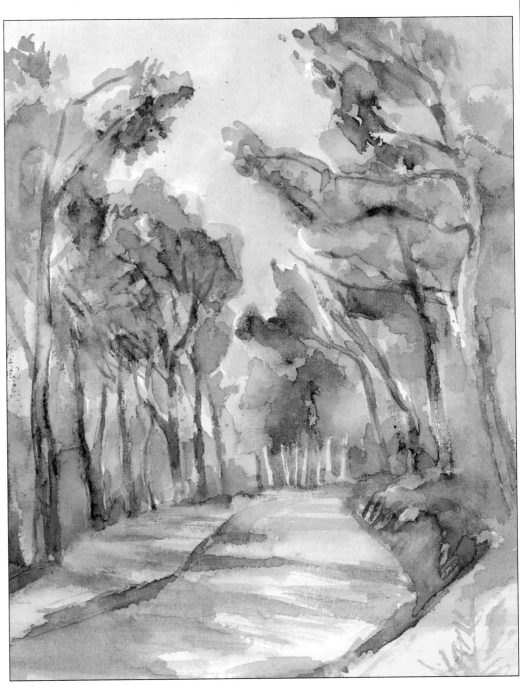

A similar theme (as in the previous examples) at an advanced stage – just before completion.

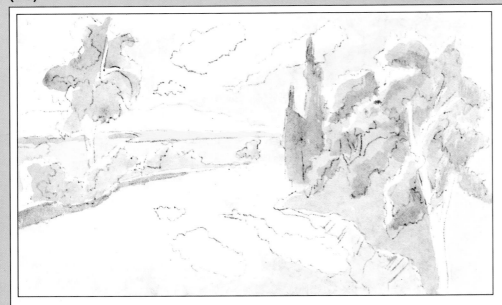

Another method is in many respects similar to the first, but uses colours throughout, beginning with the preliminary sketch. The overall structure of the landscape is lightly drafted and the created shapes filled with colours just as they are seen in the landscape to be painted. This method entails getting the colour and light correlations and light and shades right from the very beginning. Where shades occur in the landscape (in a sunlit landscape), these are brushed in concurrently with blocks of medium rich and light colours, thus gradually covering the whole surface of the picture. To be able to go on with the painting you should prevent abrupt map-like borders, the premature drying of the edges of colour blocks. Various degrees of drying can similarly be exploited wherever soft transitions are required. Alternatively, more richer glazing can be used where clearer and more obvious contrasts are needed.

Having accomplished the basic colour scheme, the second phase is to deepen colours, contours and spatial effects according to the model. The first phase of the technique was more or less two-dimensional. Blocks needing greater differentiation of either colour or contour are dealt with by several layers of glazing to darken, model or shade them. It will be clear from this that unlike the first example this method frequently involves shading or darker areas added in the course of work, not at the beginning.

The overall construction of the landscape is based primarily on the distribution of

From top to bottom:
Another way of painting is to apply the medium light colour tones to the whole surface of the picture at the beginning.

The underpainting in grey is similar to a washed drawing. It can be seen on the left side of the picture. The right side is influenced by colour glazing. In the past the underpainting was fixed to prevent smudging in later stages.

In the first phase the colour scheme was carried out in large blocks.

colour surfaces, which gradually change with the differentiation of form and colour in the various parts of the subject being observed. The number of working phases will depend on one's experience and can diminish because with increasing skill the student learns how to suggest and express various features as soon as the basic colour scheme has been established.

This is a more complex method which enables to gain a general idea of the final form of the picture at an early stage.

The beginner is advised to try out several painting methods. This is the easiest way of finding the best one for his style. It also protects him from becoming too fixed on a particular technique.

Above: The second phase is the application of glazing for the detailed drawing of a rocky seashore.

Below: Completion. Tonal values obtained by glazing help to create distant space and mass.

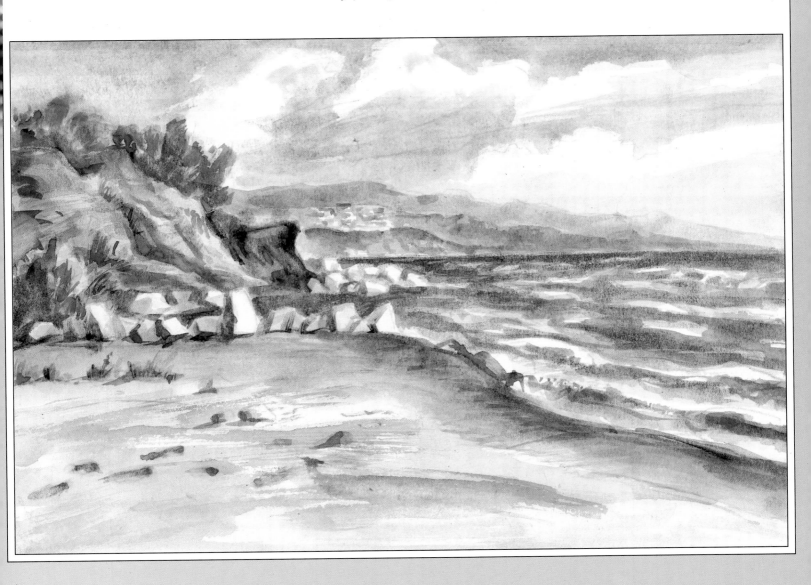

PAINTING TECHNIQUES: ALLA PRIMA

Alla prima, a generally known painting technique, is entirely in keeping with the properties of watercolours. Colour is applied in blots, in definitive form and required degree of richness, without subsequent modification. This technique calls for considerable experience and confidence in the selection and application of colour shades. It also calls for meticulous care when laying colour where different colour planes meet. If the motif needs to be expressed with precision, there should be no fusion of colours at these points. However, colour planes should not be too sharply delineated either. This sometimes occurs when a wet colour is applied to already dried colour (alla prima painting can be used both on dry and dampened paper). This problem may be turned to good advantage, particularly when working on a motif it is necessary to accentuate contrasts of form, light or colour.

Softer colour transitions can be expressed on dampened paper quite easily. A softer approach depends not only on the motif, but also on the artist's own way of viewing reality.

Paper should be dampened to such a degree that the colours when applied will not fully diffuse. This means that colour combinations have to be chosen to comply with the known properties of colours to avoid muddy tones caused by the mixing of colours.

Painting alla prima wet-in-wet alternating with painting on dry paper.

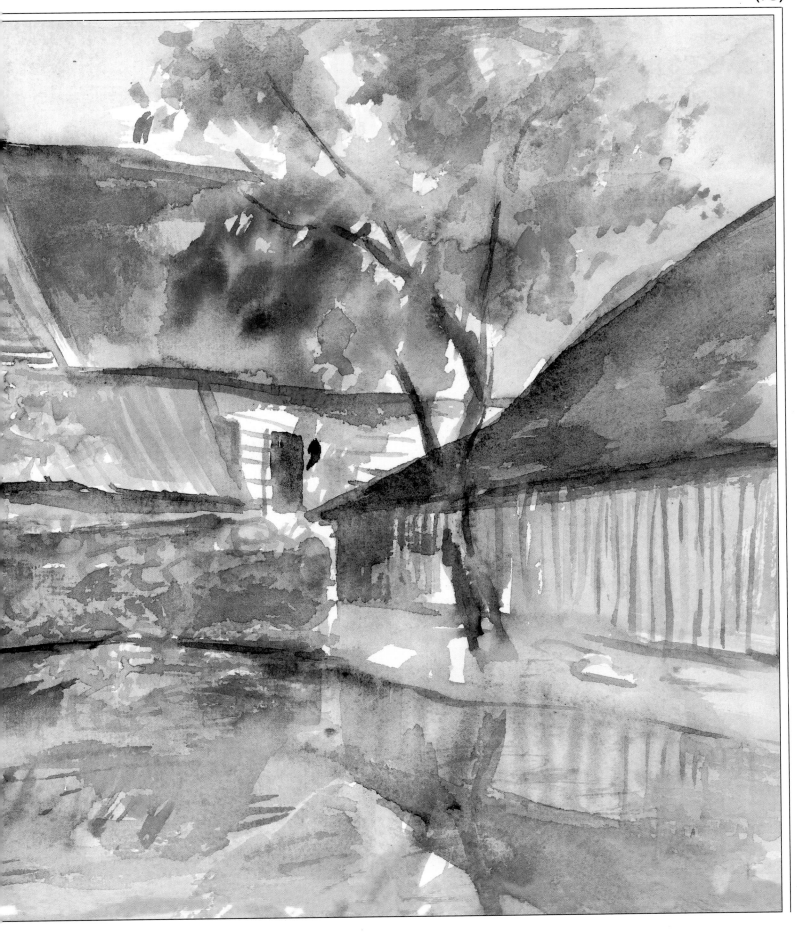

MOOD IN LANDSCAPE

Motifs with strongly emotive qualities occur frequently in landscape painting. The mood of the landscape may be affected in many ways. Some landscapes have an intrinsic mood of their own, evoked either by their structure, colour or vegetation. A lowland landscape extending far into the distance evokes a different mood than the landscape enclosed by hills.

Landscapes are also strongly affected by changing light at different day times and in different seasons. A landscape in the midday sun has a reduced range of colour due to the contrasts between light and shade, whereas a landscape at twilight has greater richness of colour and tranquility.

The sky and the amount of the picture it covers also strongly affect the landscape mood. The sky may have a generally calming, or alternatively, dramatizing effect, if, for example, it is full of fantastic clouds, which are particularly suitable for watercolour painting.

Other mood-affecting features include rain or mist, sunlight shining through mist, the rising or setting of the sun and a range of other climatic phenomena with such a marked effect on the landscape that they demand a completely different working procedure. The intention to evoke the mood of the landscape and thus express our own feelings can often prevail over the effort to describe reality (see the example of the expressionist painting by E. Nolde on pp. 18–19). Spontaneous work with brush and colour based on feelings is very close to watercolour technique. This helps the painter very often not only find effective means of expression, but also fully enjoy his work.

The sky is dominant in this picture.

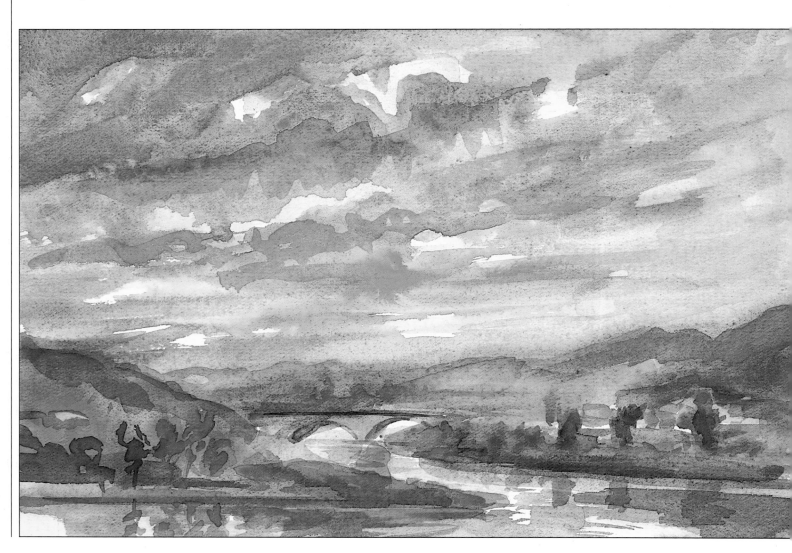

WET-IN-WET PAINTING

Atmospheric features may dominate a landscape and determine its general mood. Then the concrete features which previous painting procedures were at pains to capture become of secondary importance. This enables us to try a freer approach.

Wet-in-wet painting, a method already mentioned on some of the previous pages, is one of such possibilities.

The paper we shall paint on is fixed with adhesive tape onto a board and then dampened with a clean broad brush or sponge. The degree of dampness varies according to the motif which is to be painted and which affects the extent to which the paint is required to diffuse. As work proceeds the area to be painted on can be redampened where necessary with a brush dipped into clean water.

Paper can also be stretched using a special artist's frame (used for stretching canvases for oil painting) and the reverse side dampened during the course of work. This is particularly suitable for gouache. Broad colour blocks are then applied to the dampened paper in accordance with the subject, omitting the lightest parts.

Where necessary these can be covered immediately in a light shade. Colours applied wet-in-wet can be quite rich.

Spreading them over the wet paper you can reduce colour intensity and create various transitions of tonal value to indicate space, structure of terrain, etc.

Where appropriate a deeper colour shade may be applied before the undercolour is completely dry. This modifies the contrasts of adjoining colours.

The paper was first toned in light green using a broad brush. Painting was executed while the green underpainting was still wet.

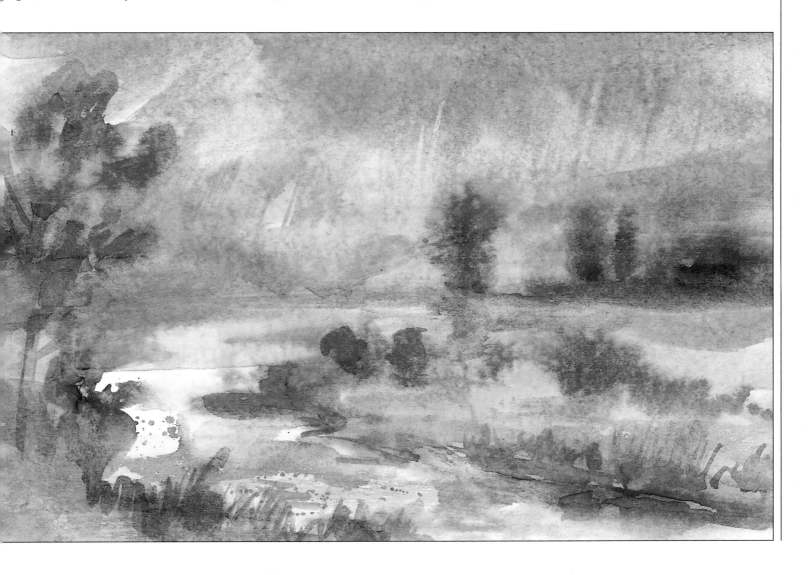

The colour intensity of bushes, trees or other focal points in the landscape can be accentuated in a similar way. Their shapes and location can be enhanced by applying colour to a partially or completely dry ground. The more defined treatment of certain parts of a painting in contrast with their surroundings helps to create the illusion of space.

Where some elements of drawing have to be included in the painting (tree branches, more conspicuous bushes or grass), they may be added at the conclusion of the work by drawing in to the dry ground. These features should be used predominantly in the foreground. Drawing helps to enhance the overall effect of the painting by introducing a contrasting and enlivening component into the soft planes. But the intensity of the drawing must not overwhelm the other areas. It should not monopolize the attention, but should be light and naturally introduced into the whole. This is not always easy for beginners.

In the case of a rainy or misty landscape the paper could be thoroughly dampened and painted in a single tone to indicate the basic colour of the painting. The shapes which loom out of the rain or mist, trees, bushes, undulations in the terrain and hills, are then painted over the basic colour while it is still wet, blend in with it and lose their solid outlines, just as they do in nature. More distant outlines are blurred, those closer to the observer can be pointed up by a further application of the same or a similar colour, again wet-in-wet. This helps to produce a convincing illusion of space.

This method can be enhanced by removing some colour with a brush rinsed out in clean water and then squeezed out with the fingers or a rag. Alternatively, larger areas of colour can be washed with a smaller piece of rag or a sponge squeezed nearly dry.

Paint was applied alla prima, freely and quickly, to dampened paper. This created a number of random colour and light effects.

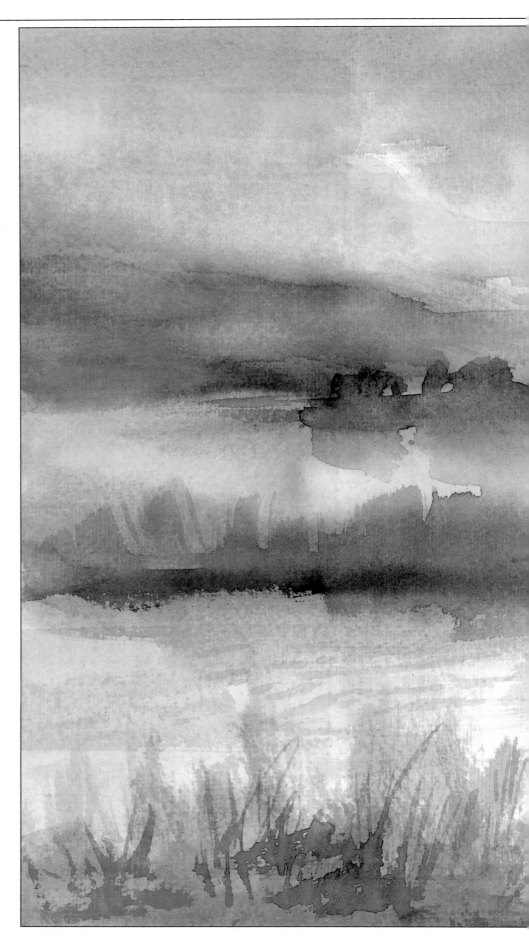

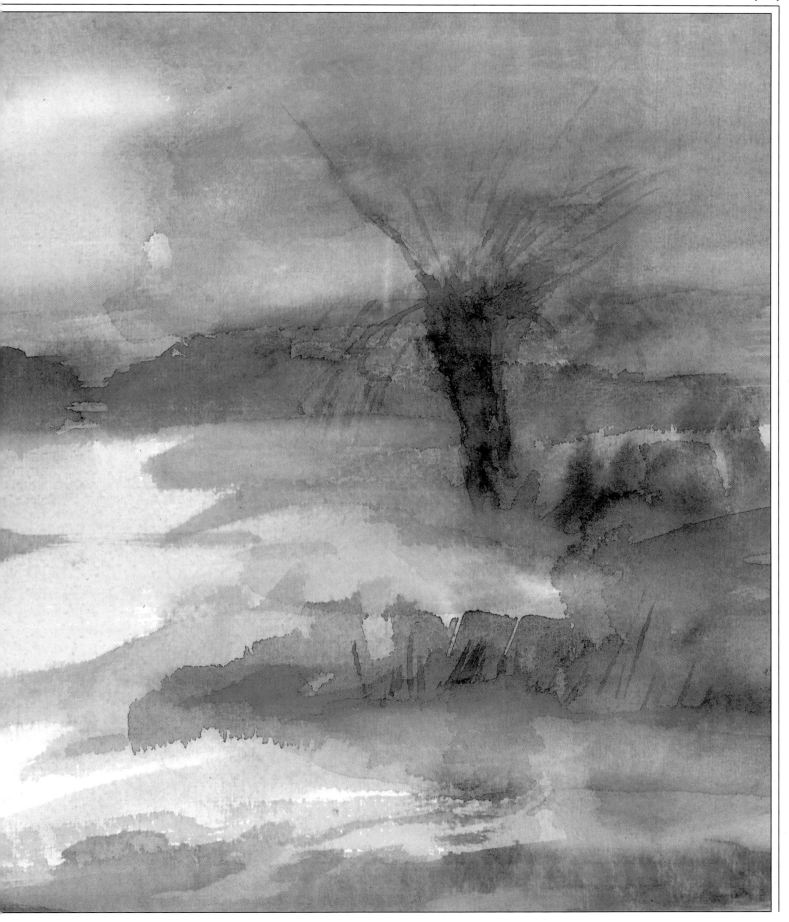

This method should be used deliberately and systematically for all themes calling for a dream-like, ethereal treatment, such as morning mist over water, or sunbeams in a woodland interior.

In a **washed watercolour** the motif is painted alla prima onto dry paper and then the whole surface is washed under running water when finished. Depending on the properties of the paper (paper that does not absorb colour too much is easy to wash), the colour that has been applied washes off leaving only traces which preserve the original structure of the painting in a very weak and blurred form. While still wet the picture will be stretched again if it has been removed from the support before washing (which is not always necessary) and then finished with a few small brushstrokes. The final effect is highly interesting and attractive. Used for motifs suited to this treatment, it is very suggestive. Because of its appeal this method is easily used to excess; its application is a matter of the personal style and signature of the artist.

In some cases the combined use of **washed and normal watercolour** is possible. Imagine a woodland interior in which the more distant tree trunks are more indistinct in form and colour compared to some clearly defined object in the foreground, such as a sunlit leafy branch. This might suggest treating all the distant features, even the whole background, by washing them. This achieves a most striking effect, especially with the contrasting branch in the foreground, painted in detail.

Washed watercolour. After drying the rich colours were rinsed under running water (a shower is best) and then wiped with a sponge. This helped to create the impression of evening mist over an illuminated river port.

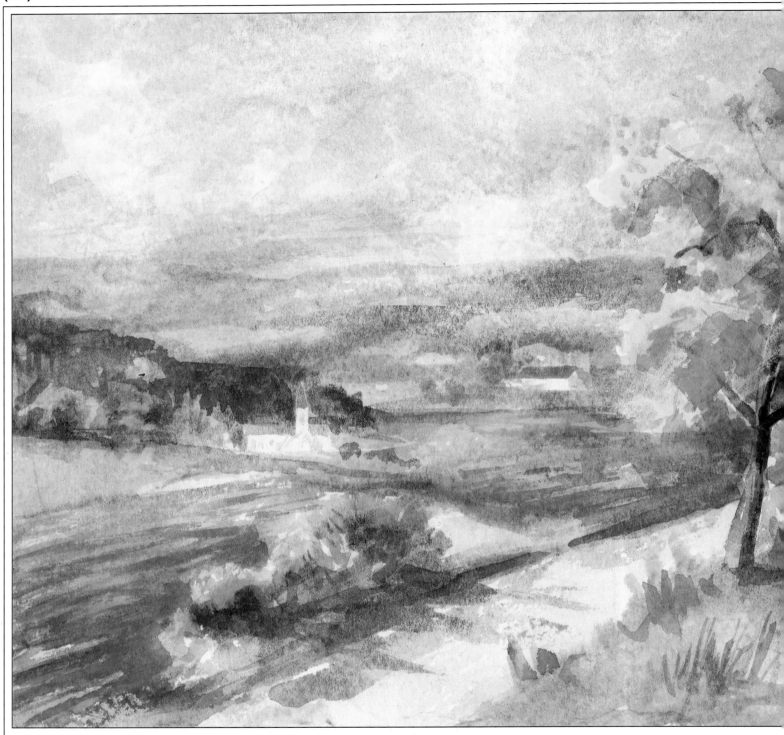

After drying the washed watercolour was completed with spots of colour in the tree crown, in the bush, shades and the ridge of the nearest forest. This combination of techniques helped to create the illusion of space and to capture the mood of a lovely autumn day.

Right: A detail showing context of the two techniques.

In conclusion, let us note some components which are essential to landscapes and the painting of which can cause initial problems.

Objects which appear two-dimensional, although their colours may be shaded because of their location in space, are not

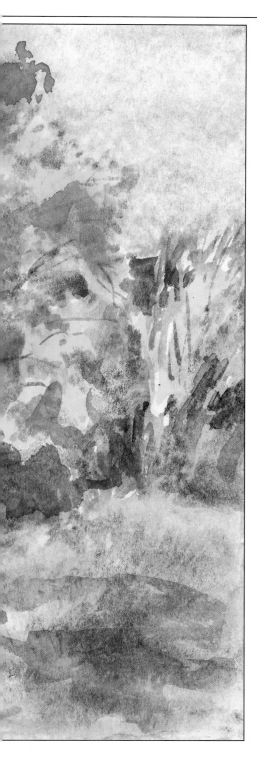

and distinguishing large colour planes usually avoids an excess of detail that is difficult to organize. Painting a tree, however, is a different matter. With its shape and volume it is a complex organism and to capture this complexity artistically often results in error. However, a tree is often an important element in the landscape, and you should pay necessary attention to it when painting, which requires a sound knowledge of its structure and modelling.

The inside of the forest was painted in the same way as the autumn landscape.

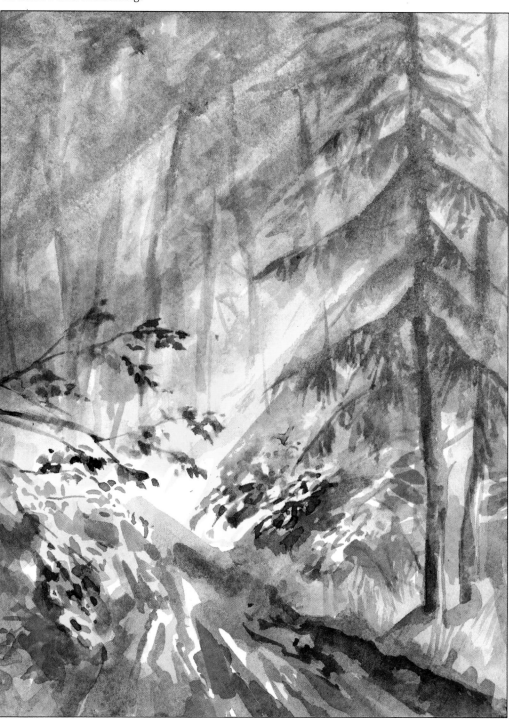

too difficult to paint. They include fields, meadows, and stone walls or stands of woodland. Here the brush has a certain freedom of movement and colour is applied to the paper in larger, not too complex areas. Colour applied two-dimensionally in this way has always a certain composing effect. Alternating

Painting trees

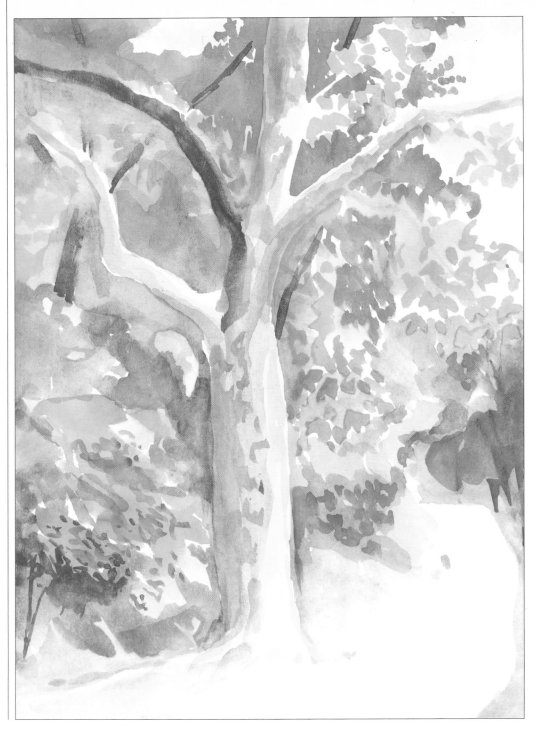

Let us recall still-life for a moment and consider a tree as an object of a definite shape with something in common with a pyramid, a cone, a sphere, or their combination with some other geometrical shapes. This is how a tree appears from the standpoint of modelling, which is shown through illumination as a geometrical volume shaped by light and shade, albeit somewhat more complex due to the variously shaped branches and the quantity of foliage.

A tree must be regarded as a whole ignoring at first the many details such as the lighter and darker spots among leaf clusters of all sizes, the open spaces between them where the light shines through, or the structure of the branches.

First let us attempt to express its volume by roughly indicating its light and dark parts. This is best done by looking at the tree through half-closed eyes to reduce it to a general shape without too many details; it clearly reveals the basic outline and the most striking shapes of the leafy branches. The next step is to try to represent this impression in colour and to capture the distribution of light and shade. A tree standing in the foreground will require treatment in greater detail, such as showing a cluster of leaves caught by the light. The foliage and leaf shapes can be indicated by drawing them in detail in selected places. This helps to bring out the contrast between the illuminated shapes of leaves and their shadows.

This unfinished picture of a plane tree in the park shows how space is suggested with large areas of colour (left of the tree-trunk) and how these are worked in detail (right of the tree-trunk).

These parts should be omitted when putting in the overall colour scheme so that they can be dealt with in more detail later.

The general sketch should be painted using a fairly large brush to indicate the big shapes and masses. Where necessary the more marked areas of shade can be darkened by applying more colour in to the still wet undercolour. The fact that trees are located at various distances from the observer does not mean that the nearest tree will be dealt with in greatest detail. Nevertheless, some interesting detail can be used on it to make it more plastic and its colours more striking. Different kinds of trees require different painting methods. An old, solid-looking tree with a full crown has to be painted in some other way than a birch, in which the crown gives a transparent, almost two-dimensional impression.

Basic modelling of a tree.

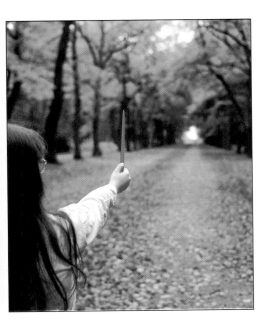

Left: Measuring results in establishing the whole arrangement of the avenue (view, perspective), not the proportions of the individual trees.

A tree painted three-dimensionally and two-dimensionally.

The distinguishing of the character of different types of vegetation by means of painting, for example with different brush work, helps to record the diversity of nature. Depending on the subject some parts of the picture can be painted in thicker colour. This leaves traces stressing the structure of the paper. Other parts can be dealt with by spattering colour off the brush or over the index finger of the other hand, held at various heights above the paper.

Combining these methods with the more conventional steps, the watercolourist broadens his repertoire of expression. Bushes and clumps of trees can be painted in a similar way.

Grass-covered areas pose a similar problem for the painter. The character of grass can be suggested by dissolving a darker shade of green into a still wet undercolour. Instead of drawing individual blades of grass in the manner of the naive painters, only the most conspicuous spots in the terrain are drawn.

No complete list of instructions of how to express various landscape features can be drawn up, though one general rule does emerge: artistic transcription of reality must be in harmony with the technique chosen and furthermore based on the assumption that artistic characterization of the phenomenon is more important than a naturalistic, detailed description. It thus makes sense to select and emphasize those aspects of reality which are of primary importance and to suppress, or even completely eliminate, aspects of secondary importance or all superfluous detail which would otherwise tend to overshadow the meaning and central idea of the theme.

In this woodland interior light, shade and tonal values are used to differentiate clusters of leaves and their spatial distribution.

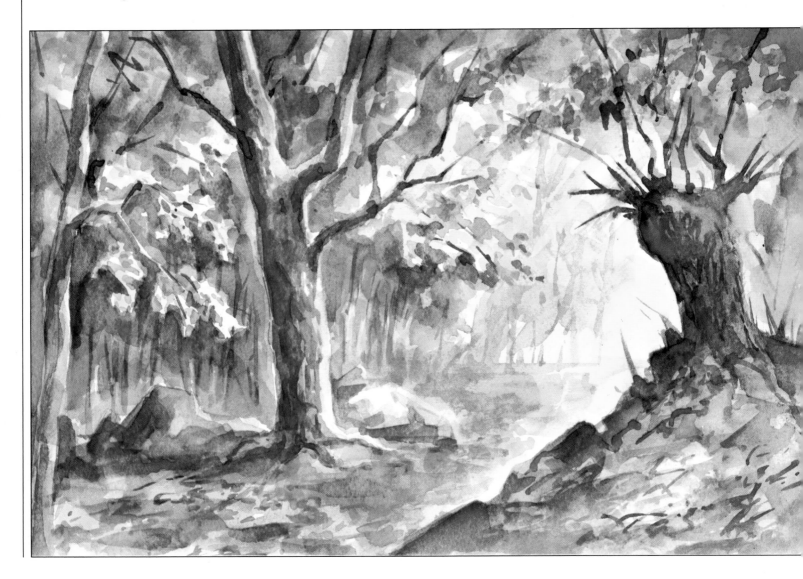

Right: The colour scheme of this clump of trees has been carried out in large surfaces of colour merging in some places and clearly distinguished in others.

Below: A completed similar motif shows how the surface of trees can be suggested by using the contact of the brush with the structure of the paper (see especially the foreground).

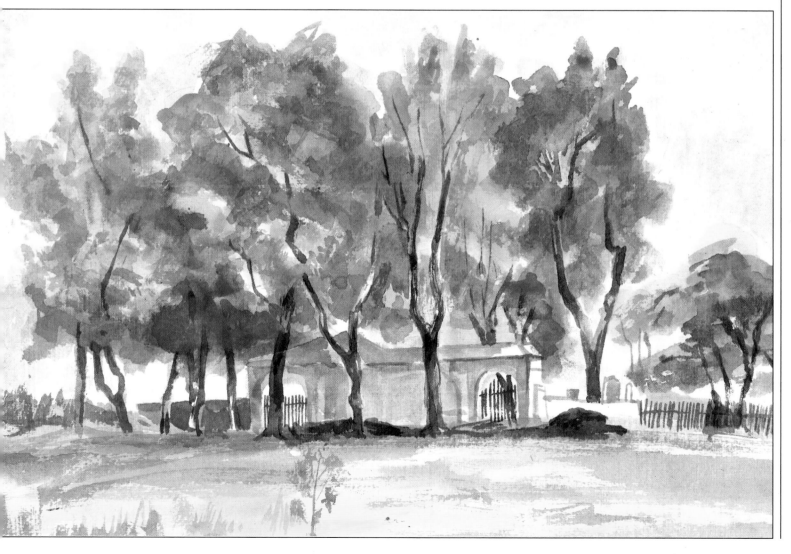

VARIOUS SHADES OF GREEN

Nature offers a plethora of different shades of green. Although there are several shades of green on the palette, we shall mix some more tones. New shades of green can be created either by adding another colour to the basic one, or by mixing two colours together to create a green tone. Green obtained from mixing yellow cadmium and ultramarine, for example, differs from the tone obtained by mixing Neapolitan yellow with cobalt.

In the illustrations first note the greens available in pure form in various water-colour sets. Next to them are examples of mixed colours.

Larger or smaller colour surfaces are more frequently found in nature, but motifs with prevailing drawn components are present

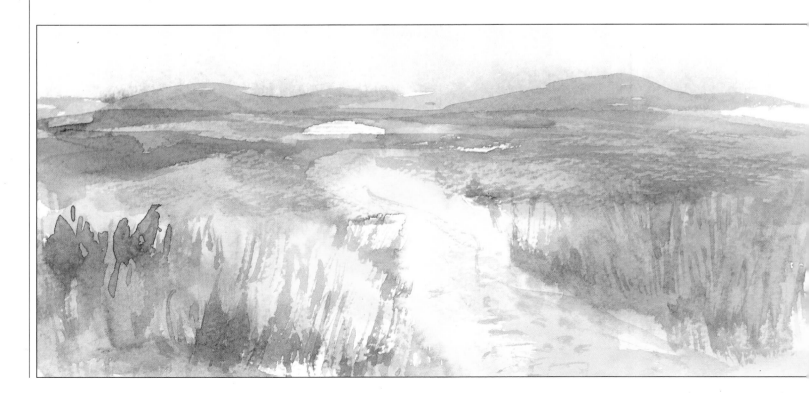

as well, such as dried grass, reeds on the banks of rivers and ponds, leafless trees or spray from breakers. When the motifs are light in dark surroundings, they have to be omitted or colour carefully applied around them in later working.

The upper row shows from left to right Opaque Chrome Oxide, Transparent Chrome Oxide and Permanent Light Green. The lower row shows shades of green created by mixing or glazing.

Below: Various brush strokes: thin, flat, parallel lines, spattered colour, the structure of the paper showing through diluted colour, stippling. Different brushwork is illustrated in the example on p. 86.

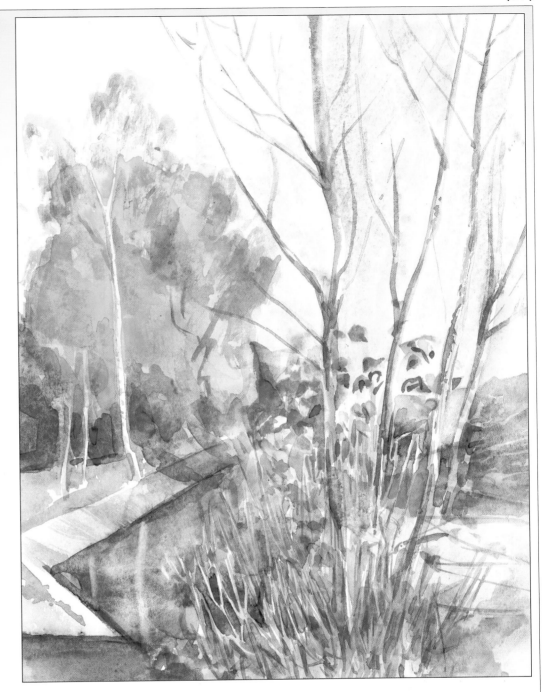

Above and on the following page: Examples showing the importance of drawing in colour.

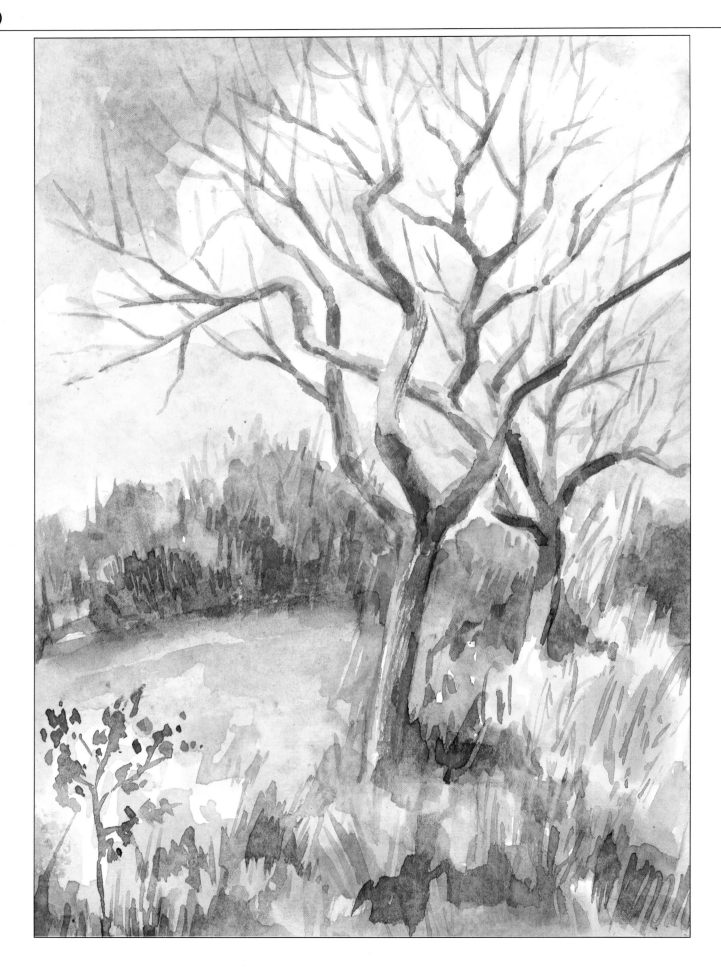

Painting architecture

When working with watercolours, one, sooner or later, comes across some architectural features which call for a far greater knowledge of at least the simple rules of **perspective** than landscape painting.

Some students will have the advantage of a talent for close observation, imagination and a grasp of the properties of perspective. The accompanying illustrations will help others to become aware of the basic relationships when constructing perspective. All artists will benefit greatly from the frequent observation of objects which cannot be expressed without at least a basic knowledge of perspective. These may take the form of a number of boxes piled up on top of each other and pointing in various

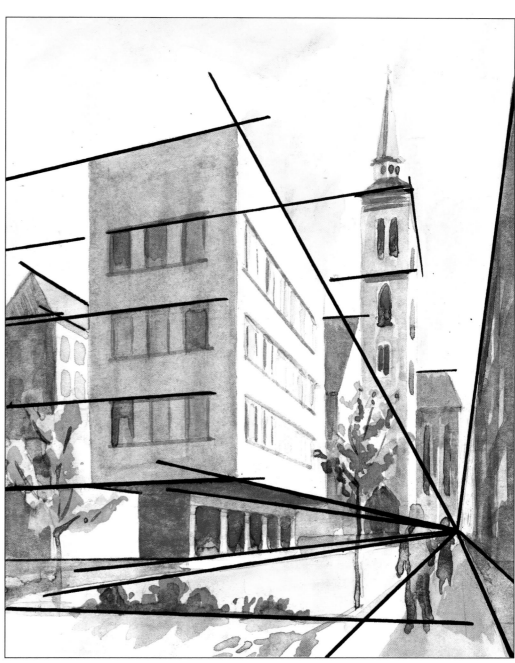

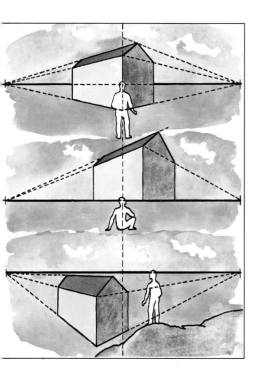

Left: The perspective of the house differs in relation to the horizon and the viewer.

Above: A network of lines merging at the vanishing point helps to achieve a better idea of architectural perspective.

directions, or converging window ledges or roofs in the street.

Landscapes with architecture, views of cities or groups of interesting and picturesque buildings were frequent subjects as early as the seventeenth but mainly in the eighteenth and nineteenth centuries.

This kind of painting is called a **veduta**. The common techniques for vedutas were oils, engraving, coloured or washed drawings, gouache and watercolour.

Watercolours are suitable for painting architecture, among others, because of the simple and easily portable equipment.

Above and left: A quiet corner of Čertovka (the Devil's Mill Race in the Lesser Town, Prague) shows work done from a black-and-white photograph and a simple sketch with some notes on colour. This is a suitable technique when there is not enough time to paint a subject that has attracted the artist's attention. It is also a way of learning how to appraise colour and colour combinations accurately.

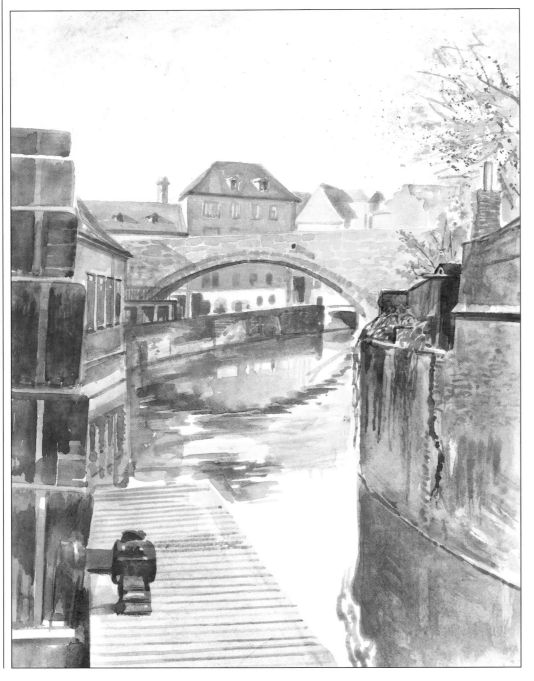

Right: This quiet corner of a small town in Dalmatia (Trogir) with its diverse architecture provides an opportunity for demarcating the shapes and spatial effects of architectural features using ethereal shades and colour differentiation

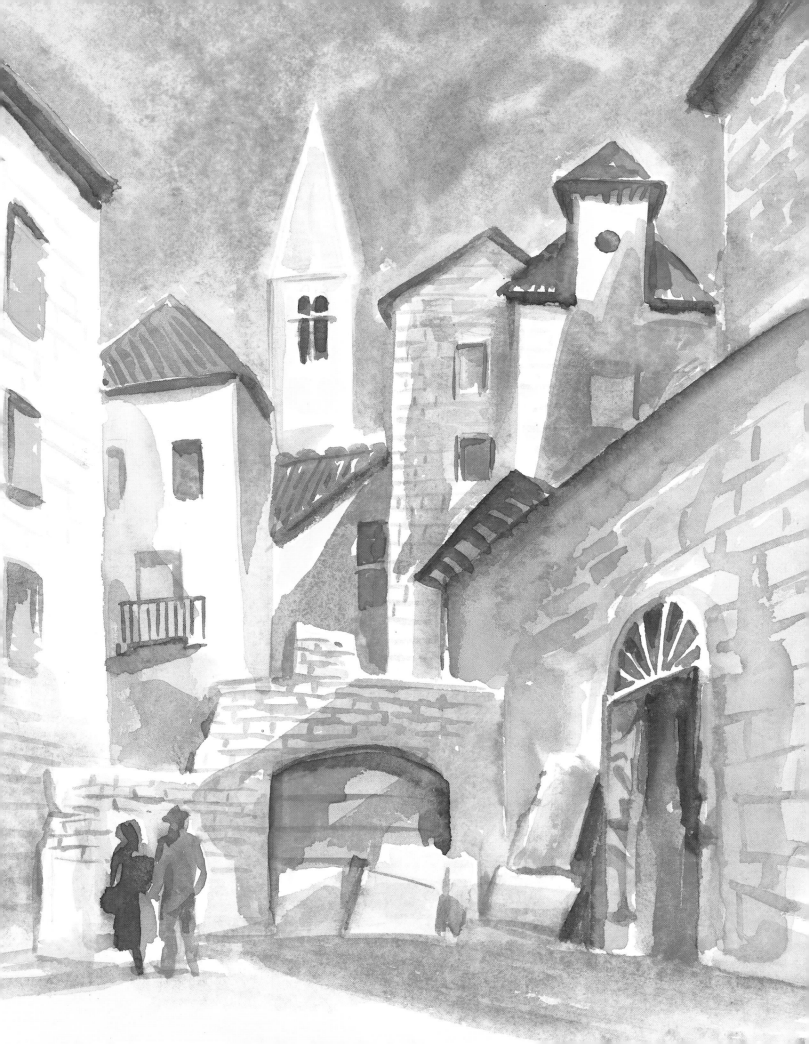

Painting figures

The human body has been a subject for painting since time immemorial. It occurred sporadically in prehistoric painting, painted in colours mixed with water.

As time passed, interest in the human figure increased, but the artistic expression was stylized according to the canon of the period. This holds good for ancient Egyptian paintings in water-colours.

The later Romanesque and Gothic periods produced stylized figures in illuminated religious manuscripts, again painted in watercolours.

In the Renaissance, figures and figural compositions worked in watercolours occurred in washed sketches for frescoes and paintings. Figures were painted from live models, often portrayed in motion showing a sound knowledge of anatomy.

Unlike the Middle Ages the new period encouraged painting nudes as well.

Artists often complemented and enhanced their landscapes or the popular urban vedutas of the eighteenth and nineteenth centuries with figural motifs. The twentieth century also offers numerous instances of watercolours being chosen for expressing figural motifs and portraits.

In keeping with the general search for artistic expression, the distinctive signature of the individual artist has come to the fore while still respecting the specific character of watercolour painting. Paul Cézanne (1839–1906) and his figural watercolour compositions may serve as an example. Figures painted in watercolours also feature in the work of Georges Rouault (1871–1958), Paul Klee (1871–1958), and many others.

Freely painted reclining nude.

Before starting with practical study we must acquaint ourselves with some general and indispensible laws of the depiction of the human body.

Some rules are even more important in figural than in landscape painting. In the latter, proportions may sometimes be distorted deliberately in the interest of composition.

When painting figures, however, a successful result depends on thorough drawing preparation, which is not possible without a basic knowledge of anatomy.

Since a large format is rarely used for watercolours, errors are rather less conspicuous. Even so, the artist should learn enough about the human body to avoid unnecessary mistakes.

First of all, we shall examine certain basic rules of anatomy, or of proportion, which apply to all human types in spite of their diversity. They are the principal guidelines facilitating the early stages of work.

Let us start with a standing figure. The height of the head has always been the primary criterion for working out and checking the proportions of the human body.

The height of the head is known as the **module**, a key measurement for working out the height of the whole human body. The head accounts for roughly one eighth of the body height in an adult, and about a fifth in the case of a small child.

The axis of the figure (a model is essential particularly when first embarking on a study) runs through the centre of the

STANDING FIGURE / CONTRAPPOSTO

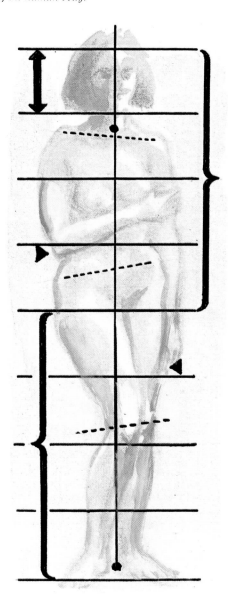

Female nude in contrapposto. This picture shows the basic proportional rules of the human body.

length of this axis from the top of the head to the feet is about eight times the height of the head. The determination of the height of the figure is important for its position in the format.

The following constants are also important in proportional orientation, easily checked on our body.

The crotch divides the figure into two halves. (Some proportional schemes divide the human figure into four equal perpendicular parts. The first lies between the top of the head and the nipples, the second between the nipples and the crotch, the third between the crotch and the knees and the fourth between the knees and the feet.)

When the arms hang along the body the finger tips reach approximately half-way down the thighs.

The distance from the foot to the middle of the knee is almost equivalent to that from the middle of the knee to the waist.

Some horizontal proportions are equally important. These include the width of the shoulders, which in the male is about double the height of the head, and in the female slightly less.

In men the width of the hips nearly equals that of the shoulders. In women the hips are usually wider.

Numerous artists have studied the proportions of the human body. One familiar study will be that by Leonardo da Vinci of a male nude standing with spreading arms. The proportions are demarcated by a square and a circle.

body in a perpendicular line from the point between the heels, up between the legs, through the navel, depression between the collarbones, the axis of the nose and up to the top of the head. The

If we prefer studying proportions, as it should be, it is best to start with a standing figure, ideally in **contrapposto**. This is the natural position of a human standing with the weight of the body resting on one stretched leg while the other is held loosely at rest, bent slightly forward at the knee. The foot may be placed either slightly forward or to one side. This posture brings about certain alterations which are discernible primarily at the hip joints and shoulders. On the side of the weight-bearing leg the pelvis protrudes slightly upwards, on the other side it points downwards. This alteration is connected with by another concerning the position of the axis between the shoulder joints. Where the pelvis points downwards the shoulder becomes slightly raised, while the other shoulder slumps slightly. We can speak of a contradictory process between the axes running between the shoulder joints and the pelvic tips respectively; and, further, the knee of the loosely held leg will be lower than that of the leg bearing the weight of the body.

Painting nudes

Right: A quickly painted sketch on dampened paper.

It is clear from the preceding information that a live model is indispensable for painting figures. Since human proportions can be distorted by clothing this should ideally take the form of a nude. Such an opportunity should be exploited.

Painting nudes occupies a key position in figural painting, chiefly on account of its aesthetic merits, and has been made famous by such artists as Giorgione (1478–1510), Michelangelo Buonarroti (1475–1564), Velázques (1599–1660), Francisco Goya (1746–1828), as well as Pablo Picasso (1881–1973), Edouard Manet (1832–1883), Amedeo Modigliani (1884–1920), and countless others.

Painting nudes not only offers an opportunity for practicing how to appraise proportion and body movement correctly, but also enables work with tonal values.

The colour correlations and transitions of the skin are very subtle, which facilitates the use of non-contrasting colour schemes based on a restrained use of colour. All this is in keeping with the nature of watercolour technique.

Simple colour distribution of light and shade in a sitting nude.

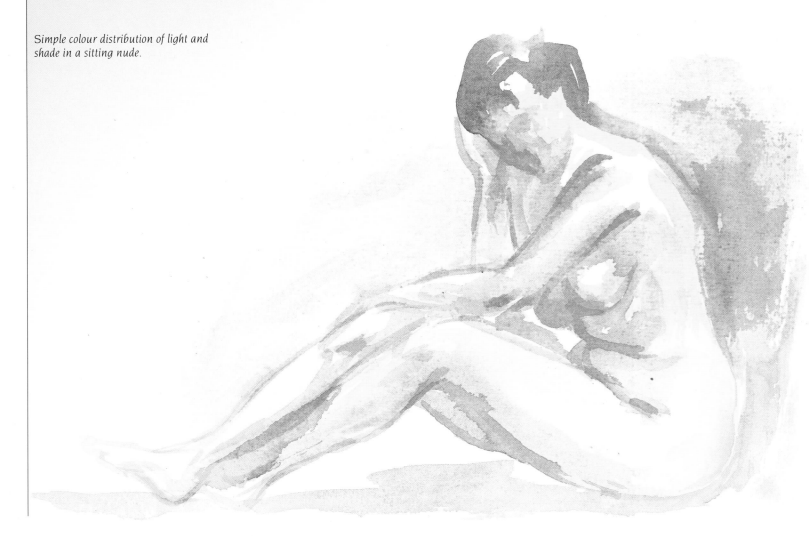

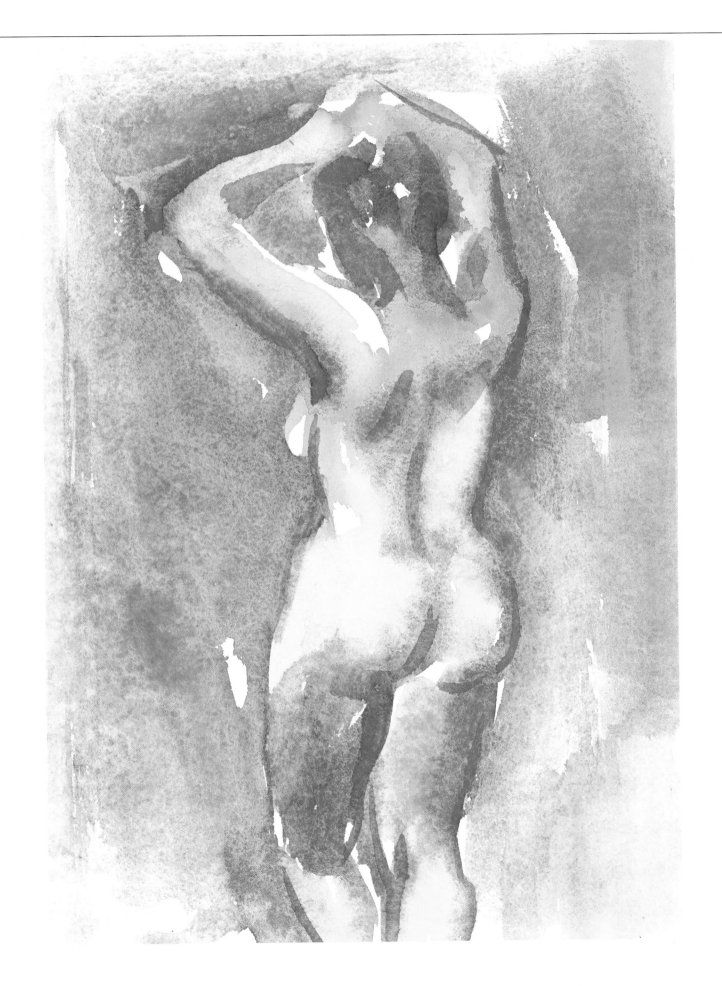

THE PRELIMINARY SKETCH

Below: Perspectively drawn axes following the body directions and volumes.

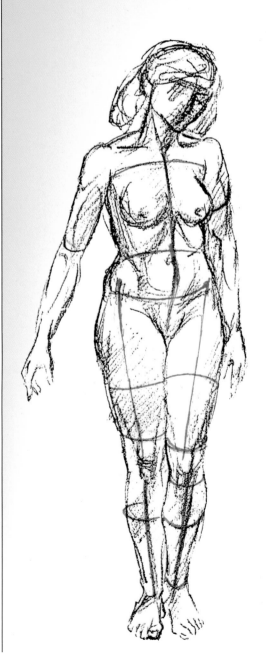

Before painting, the figure should be sketched from the model. The procedure is much the same as when sketching a landscape, but greater precision is necessary to avoid confusion at the painting stage.

The sketch should also be economical and indicate only the most essential features of the model, namely structure, general outline and movement. Where necessary the distribution of light and shade can also be lightly indicated.

A preliminary sketch is drawn lightly in pencil to record first of all the body axes. This serves as basic orientation for the construction of the whole figure.

The **perpendicular axis** is important in order to capture the posture accurately. In conjunction with this axis the **horizontal axes** also need to be taken into account. The principal horizontal axes run between the shoulders, the frontal pelvic tips and the knees respectively, dividing the human body crosswise into three roughly equal parts.

In addition to the general body outline this basic scheme should include important and defining characteristics. Inside the outline these are the nipples, the underside of the breasts, rib cage profile, navel, groin, crotch and knees. Clearly protruding parts of the skeleton should also be lightly sketched, such as the shoulder joints already referred to, pelvis, or shins. These points of orientation are less conspicuous in women than in men, and their visibility also depends on lighting.

The basic proportions are measured as in landscape or still-life painting.

Below and on the following page: A series of pictures showing drawing procedure of a standing figure from the preliminary sketch to the final phase, when plasticity was achieved by glazing.

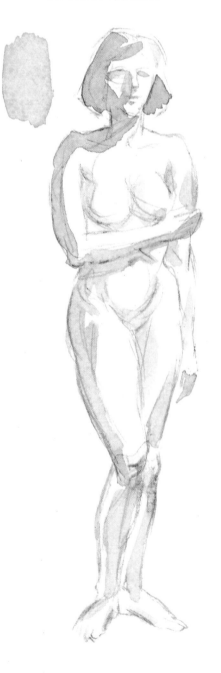

Practical exercises

First, let us deal with painting a figure lit in a three-dimensional way.

After the preliminary sketch, which can be done very lightly with a brush and colour, shades should be applied to cover fairly large surfaces thus enhancing the overall body structure.

The colour of the shades has to be carefully chosen so that, in relation to the other colours, it may help to express the body mass. This means it needs to be fairly cool, but should avoid an over-flat or harsh impression.

The right shade depends on careful observation and the light source. Natural light affects the colouring of a figure differently from harsh, artificial lamp light or diffuse lighting. The choice of shade will also depend on the artist's own sense of colour. The combination of colours used by the painter can be highly individual, but should always respect the rule that warmer colours move forwards optically, while cooler colours retreat.

In our choice of colours we must also allow for the colour scheme of the background and take into account whether the model's surroundings offer greater or lesser contrast not only in colour, but also between the illuminated and shaded parts of the body.

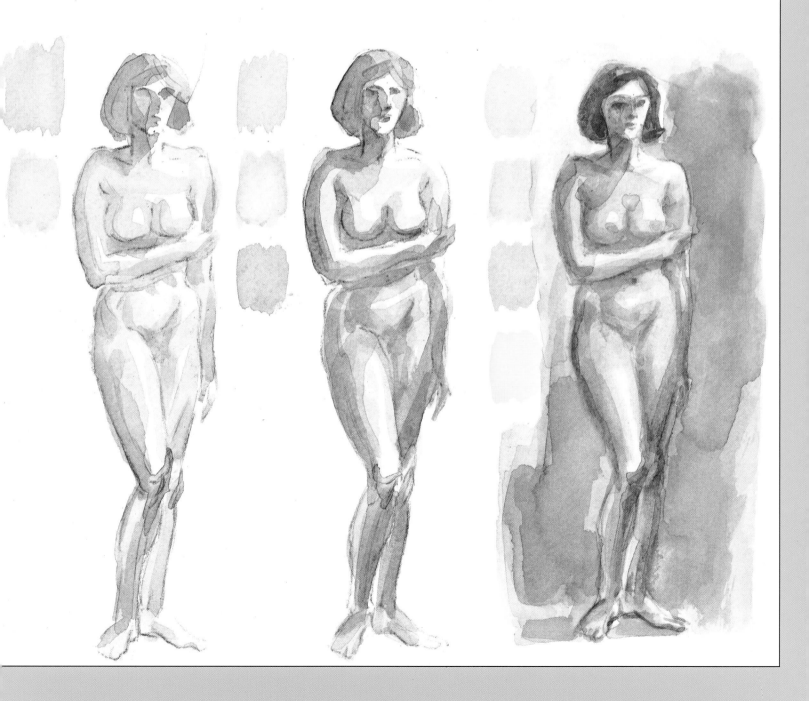

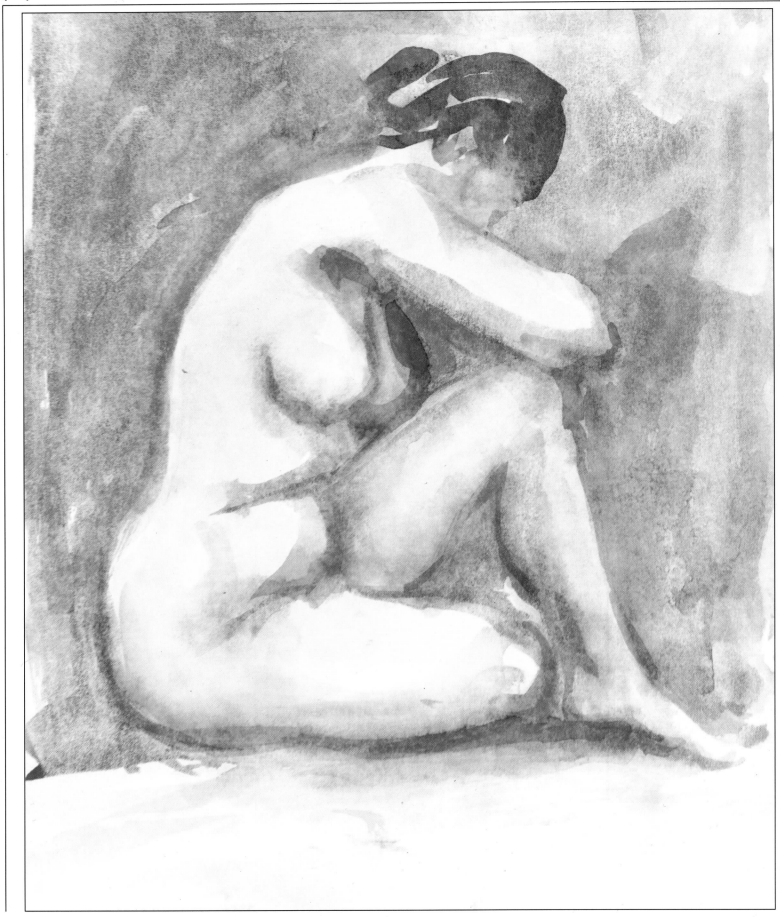

LIGHTING THE MODEL / CREATION OF VOLUME

For predominantly study purposes a model is best placed so as to be lit from the side. This highlights the musculature and makes it more three-dimensional. On the other hand, a figure lit from the front is less plastic, which facilitates an approach focusing more on colour, which is also of interest as human skin varies in many different subtle shades on different parts of the body. These subtle nuances can be skilfully captured in watercolours.

Once the shading is complete, the next step is to choose a warmer colour tone which will cover most of the body apart from the shaded and lit parts. This tone, which should be neutral (ochre or a combination of ochre and some warmer shade of red) should be applied carefully next to the shades. This may be completely dry, then the colour next to it should be applied so as to avoid too harsh a transition. Alternatively, it may still be wet, and you should try to prevent the two colours from running into each other and distorting the distinction between the different shapes which go to make up the body. A moderate diffusing of colours at these points can be all to the good.

Grey-green is a commonly used tone for shadows, but other colours can equally be used for shaded parts, such as violet with an admixture of brown or broken blue, etc. The chosen colour will depend on lighting, skin colour and the colours of the illuminated parts of the body, which may be in a warmer or cooler tone.

Left: A washed watercolour completed after drying using a few brush strokes with a richer colour to fill in the body construction, originally softened by washing.

Medium-lit surfaces are generally dealt with in some ochres with a small admixture of red, highlights in very thinned ochre or weak glazing in a tone corresponding to the source of light. Very thinned orange has also proved a good choice.

When selecting a red colour it is advisable to use a brownish shade. English or Indian red, or a very thinned caput mortuum are thus better than cadmium. If one is using the generally available set of twelve colours which usually contains two basic reds, their intensity can be broken by adding another darker colour such as a small quantity of black or green.

Thinning is a key factor here. It is better to thin quite a lot, since the desired degree of richness can always be achieved by overpainting, whereas too rich a colour or a badly chosen one can be hardly corrected later. Where some attempt is made to correct colour at a later stage, this also calls for changing the character of the other tones in order to readjust the colour correlations.

During the early stages of a study it is better to work with a limited number of colours, as this helps the beginner to learn how to mix colours.

The method described above, suitable for painting on dry paper, teaches us not to rely on chance factors, which can sometimes produce an unusual effect but also disappoint us when experience is lacking.

The above method can be complemented by another, which provides for painting in wet and depends on greater speed, using a simplified process for applying colour.

After a very simple preliminary sketch the next stage is to apply the colour of the shadows to it to create the overall construction of the figure. This colour should not be too rich because it need not be definitive at this stage. Starting from the edges of the shadows, while they are still wet, the medium light colours are then carefully applied. These two colours will intermingle where they adjoin to create soft transitions.

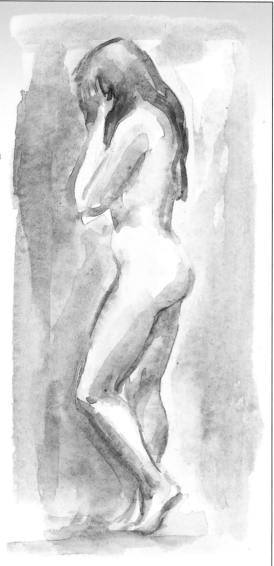

Creating volumes.

The medium light colour, which covers most of the surface of the body, is spread towards the highlights so that it lightens gradually. This can be achieved by applying progressively more water to the colour. Excess water can be carefully blotted.

This process creates the tonal values necessary to model the various parts of the body. Achieving the right volumes is in some cases the very essence of painting the human body and makes the painting richer and more complete.
Having created the underpainting in this way and omitted the highlights, the

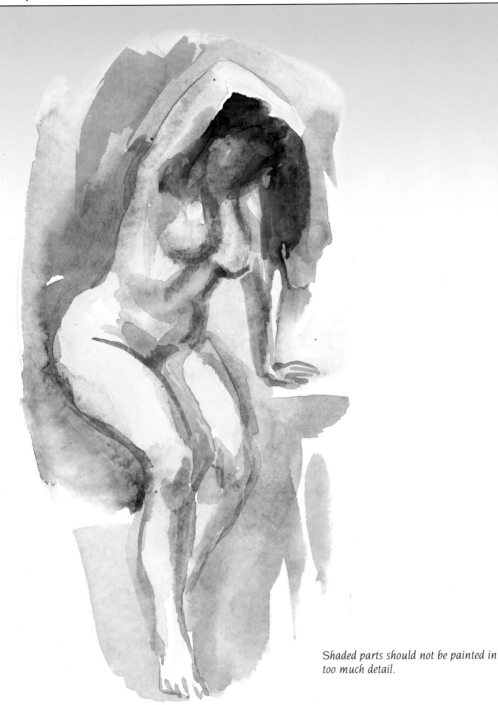

Shaded parts should not be painted in too much detail.

BALANCING THE WHOLE WITH THE DETAIL

During the final phase we must avoid complicating the original, usually simplified sketch with unnecessary detail. The primary purpose of this phase is to achieve the harmonization of all the components used in the picture. This means nothing but doing what will help to emphasize essential features or to adjust some harsh or disturbing imbalance between the light and dark parts.

In the same way, the lines discussed in the previous section should be used only where they will help to give the figure a more solid construction and enliven the whole.

One general rule is that shaded parts should be dealt with in a more tranquil way whereas detail, always carefully considered and selected, is used where more light falls on the figure.

next stage is to finish the painting. Since colour does not dry too quickly the final phase can still be carried out before the underlayer is completely dry, but this will also depend on how quickly the artist is able to complete the basic underpainting.

The finishing phase involves a return to the shadows, most importantly, where fresh colour should be applied in places needing greater emphasis. When the use of lines is called for (particularly in delineating the essential components of the construction, movement of the figure or the limbs) these should be drawn in a deeper colour. This colour will not have too harsh an effect if painted before the underlayer is completely dry thus running in it. The brush must not be too wet, or it would remove some of the undercolour. Avoiding this problem takes a certain amount of experience of both thinning colours and the reaction of the paper painted on.

Painting clothed figures

The advantage of this type of painting lies in its potential for creating interesting colour and pattern combinations, expressing the variety of the fabric of the clothes, as well as in the opportunity to portray or characterize an individual person.

A model is necessary also when painting a clothed figure. At first we chose a model dressed in clothes that are simple in cut and colour. Experience gained from painting nudes and the character of the fabric of the clothes help to produce the composition of colour and shape. Clothes should emphasize, not hide, the important parts of the body structure. This is evident from the picture on the right: the man's clothes are simple in colour and cut.

You must bear in mind that lighting is also an important factor in painting a figure. Artificial light emphasizes construction, natural light – colour.

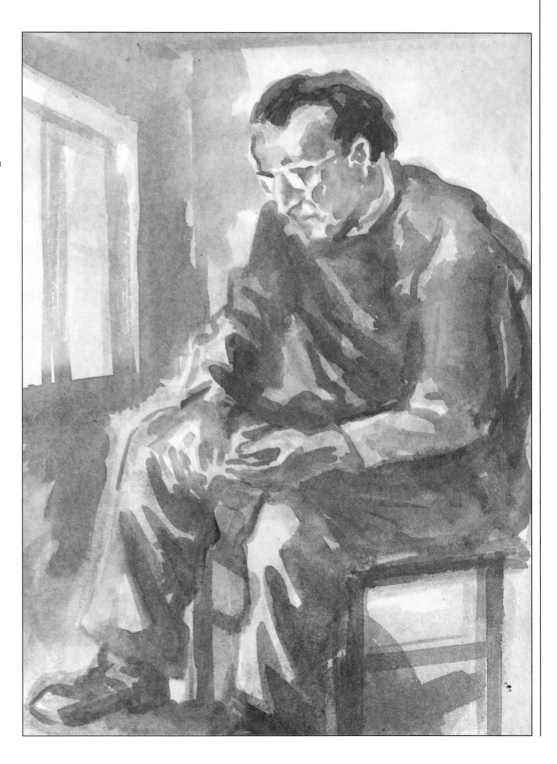

The lighting in this picture enabled the artist to focus attention on the draping of the garments.

DRAPERY

A basic element apart from the structure of the body which the painter has to master is the structure of drapery, arrangement of fabric in loose folds on the human body.

In the past drapery used to be the subject of detailed study and its complexity and grace played an important role in figural painting.

This interest derived not merely from the rich colourfulness of the clothes and the materials of which they were made, but also from their exceptional importance for composition. The folds on robes in religious paintings not only provided an opportunity to make paintings as decorative as possible, but were also used to express the personal relationships between various actors involved in the figural composition. It is in this way, though in a purely worldly sense, that drapery is used in modern painting. This is clear from the figural compositions of such artists as Picasso or the Surrealists, in which drapery commonly occupies a dominant expressive role adding to the content of the picture.

In watercolour painting, however, our attention will focus on the constructional function of drapery. This follows from the anatomy of the human body and its movement. Parts of clothing which change when the body moves are of particular importance. This may occur, for example, where the arm bends at the elbow, or the

A study of drapery which follows the construction of the body.

leg at the knee. When this happens the folds on a sleeve or trouser leg take on certain form in the fabric of the clothing which are subject to certain rules; expressing them correctly poses problems for the inexperienced painter.

Let us try to paint drapery as a free study, similarly as, e.g., Renaissance artists used to do. This helps us to grasp how thick, stiff or soft fabrics drape, or why fine fabric is characterized by richer and looser folds.

Classic studies used a unifying colour tone as a ground over which white was applied to create the drapery highlights. In watercolour techniques, however, we shall be dealing with highlights by leaving these areas blank. The darkest shadows are painted into the medium light areas, which are closest to the colour of the fabric. This is the procedure for painting wet-in-wet, in which the rich colour of the shadows to a certain extent blends into the basic undercolour to create fluid transitions. Where this colour adjoins highlights it can be softened by thinning it more or, if it is already dry, by dipping the brush in clean water.

Another method is based on the painting of the whole surfaces, in which the shadows are painted. Highlights are treated by removing colour while still wet with a clean brush from which water has been squeezed out.

When painting clothes, only parts defining the essential features of the drapery should be selected according to the nature of the fabric. However, if the garment is made of richly folded cloth (for instance, a ball-gown), then the drapery becomes an essential component of the painting and must be given an appropriate degree of attention, both as to colour and modelling. This situation, however, does not arise very often and only few artists have to face it.

Provided that the garment is not of particular interest, it can be dealt with freely and merely outlined. The colour scheme can likewise be fairly economical to avoid averting one's attention off the head, especially when the face is more important than the clothes.

At all events, however, drapery should not be underestimated when painting figures. Nothing looks worse than a coat or blouse sleeve painted like a piece of bent piping.

Painting a number of figure studies will gradually increase awareness of what needs to be done to characterize drapery effectively, without being flooded with too much detail, which tends to impoverish or even totally ruin the final effect.

The likeness and facial expression of the boy were crucial in this picture.

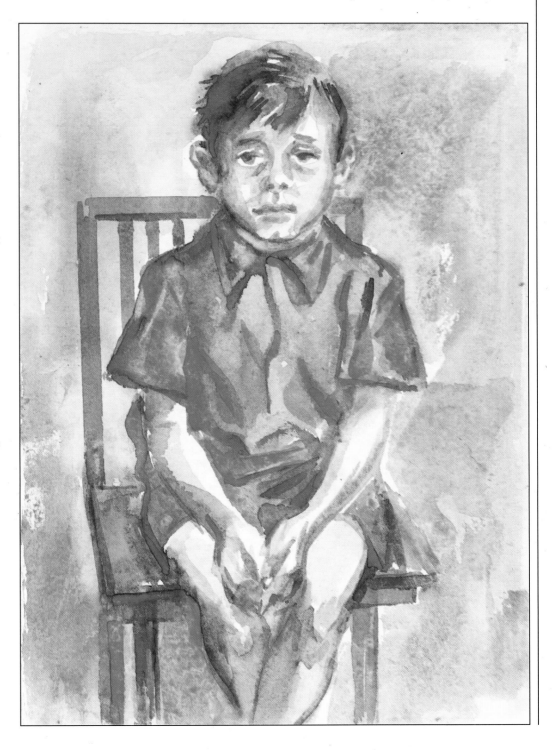

Practical exercises

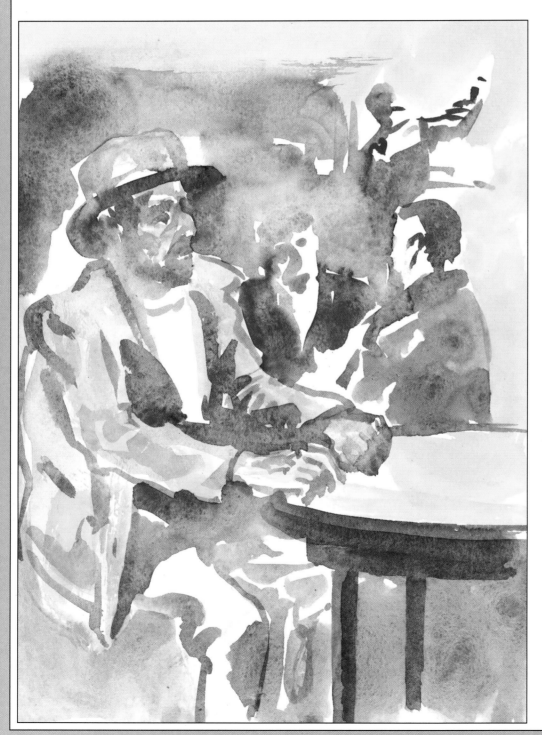

The procedure when painting a clothed figure is similar to painting a nude.

First comes a preliminary sketch of the figure, which should be as simple but as accurate as possible. Since too much correcting and erasing damages the paper, there is no harm in making do with a pencil sketch. This is the best way of recognizing what is essential for the painting stage. The study can then be lightly coloured, a procedure frequently used by great artists (e.g. Paul Cézanne).

Following the preliminary sketch, major areas of colour are applied in the overall colour scheme including the head and hands. Since the head is likely to be somewhat smaller in our picture than it would be in a portrait, the shape and main features should be carefully observed. And as there will not be enough space for details, it is nessary to aim at facial characterization. The same applies to the hands, the general form of which should first be blocked in to express their total shape and position.

Left: First we paint the colour scheme in large, simple and light surfaces, including the surroundings of the figures.

Right: A figure in characteristic motion with emphasis on the facial expression and romantic mood. The colours of the freely treated, vague background correspond to the colours used for the figure.

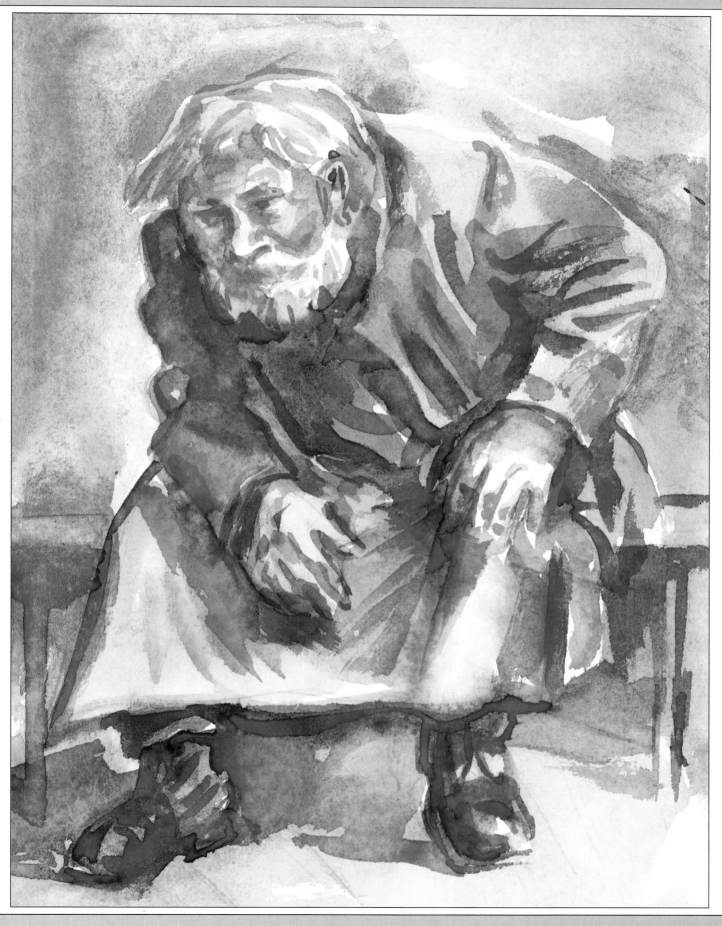

FIGURES AND THEIR SURROUNDINGS

The surroundings of the reclining woman in the picture below match the main subject in terms of colour, gradation and space.

If we include the model's surroundings in our picture, these must be painted at an early stage. It is wrong to paint the figure in detail and then to add the background or surrounding room. A picture must always be understood as a whole taking into account all major colour and other relationships. A wrongly chosen colour for the background can make the figure look artificial and unnatural in its surroundings.

The spatial problem is also solved depending on lighting, which means painting the background in a slightly lighter colour tone where the figure is in shadow, and darker where the surroundings touch the illuminated parts of the figure. Lighting affects colour and modelling as well. Diffused light emphasizes colour while lateral light intensifies modelling.

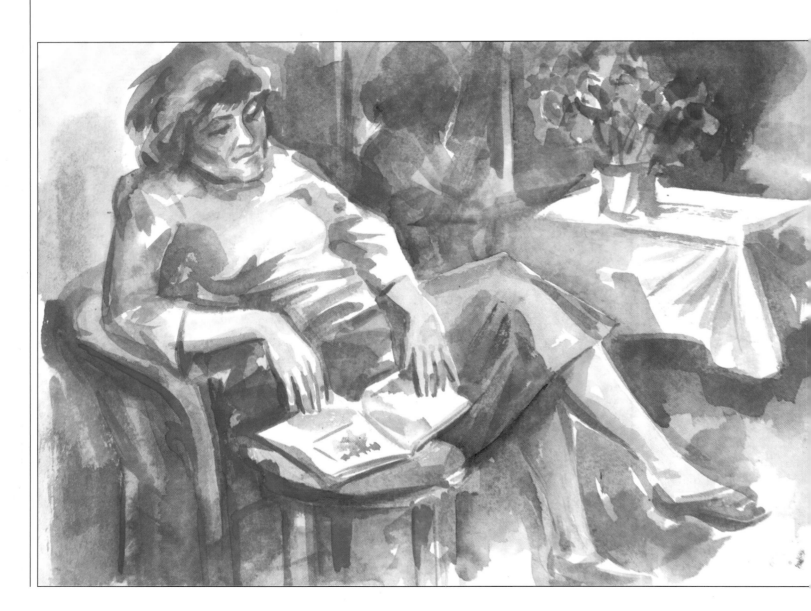

Painting heads: the portrait

If a portrait is to fulfil its purpose and give the artist a sense of satisfaction, a certain amount of detailed groundwork at the drawing stage is unavoidable.

One of the principal reasons for painting a head is to express the likeness, or at least the character of the model.

Painting a head in watercolours calls for a certain amount of experience and a steady hand when drawing. The advantage of using watercolours for portraits lies in their facility to apply surfaces of colour quickly and easily. This helps to portray the character of a face in a vivid manner.

The first stage is to draw a preliminary sketch of the main features of the head.

Key features – the eyes, nose and mouth, which are essential to achieve a true likeness of the model, cannot be dealt with correctly unless they are logical and integral parts of the whole, in the right correlations with the overall character and volume of the head. The outline of the face, including the main features of its bone structure, are also important.

Equally important are the distances from each other and proportions of various parts of the face such as the height of the forehead, the length of the nose, the part between the nostrils and the upper lip and the chin and the lower lip. The line of the lower jaw and its angle of inclination are highly characteristic aspects of achieving a likeness.

The shape and size of the nose and the chin largely determine the character of the face, as do the shape and expression of the superciliary arches and the set of the eyes, which may be shallow or deep depending on the bone structure around the eye sockets.

All the above factors constitute the basic prerequisites for a good watercolour painting of the head. To set out in the right direction from the very beginning, we must know the basic proportional rules concerning the structure of the head gained through centuries of observation.

Examples showing various facial types in different light.

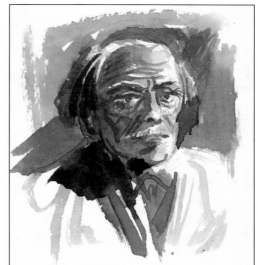

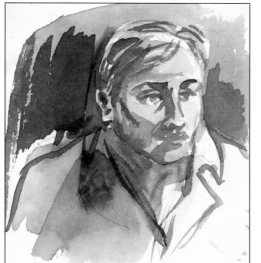

PROPORTIONS OF THE HEAD

According to the laws of proportion the face is divided into three approximate equal parts along a vertical axis.

The upper third is demarcated by the hairline and superciliary arches.

The second third delineates the distance between the superciliary arches and the tip of the nose.

And the last begins at the tip of the nose and ends at the lower edge of the chin.

There exist numerous deviations from this division, but it serves as an initial guideline.

Another useful aid is the distance between the eyes, which is usually the same as the width of one eye. Mistakes are often made with this measurement, especially when a head is being painted from a three-quarter perspective: a common error is to place the nearer eye too close to the base of the nose.

It is also worth remembering that the pupils of the eyes are usually on a perpendicular line with the corners of the mouth.

Another crucial proportion to achieve a likeness is that the distance between the lower edge of the nose and the line between the lips is usually shorter than the distance between the latter and the edge of the chin. The lower part is usually about one and a half times longer.

These measurements are only generally valid and will vary from case to case. This

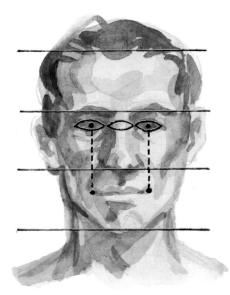

Proportional scheme for a man's head. The colours which were used are shown separately.

makes careful observation imperative and where necessary checked by measuring up, as in painting figures.

The most important aspect in the preliminary sketch is the outline of the face, which may be oval, square, round, etc. This shape needs to be carefully appraised and drawn accurately in relations to the basic inner features of the face such as the eyes, nose, mouth and the characteristics of the skull.

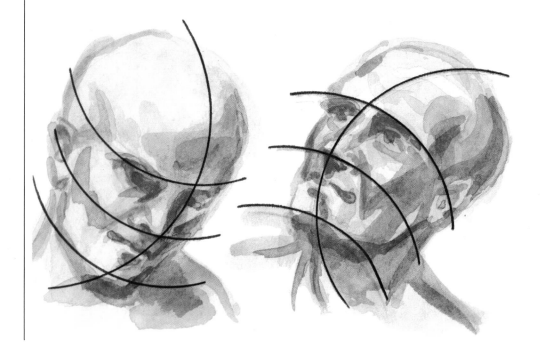

Left: Shifts in the vertical axis passing through the centre of the face and in the horizontal axes with the head lowered and raised.

STRUCTURAL DRAWING AND COLOUR CONSTRUCTION OF THE HEAD

A correct **structural drawing** is particularly important for watercolour painting, where there is little room for subsequent corrections or basic changes. It is therefore important to ensure that the above-mentioned facial features are captured accurately in the preliminary sketch.

Careful observation reveals that the different parts of a face can be divided into variously combined geometrical shapes of various sizes (squares, oblongs, more often trapezoids and triangles) which go to make up the volume structure of the head. This is particularly marked in models with more expressive features such as elderly people. These shapes can also be lightly sketched in with a pencil. Such structural division is especially useful in the early stages of study because it helps the artist to learn the detailed structure of the head. The distribution of colour also depends on this structure.

The **colour construction** of the head is also governed by the laws consisting in the careful and systematic use of warm and cool colour tones to model it.
The alternation of warm and cool tones frequently occurs in modern painting, whereas painters of the past usually dealt with modelling by means of tonal values.

The **modelling of the head** depends on the source of light used to illuminate the model. Provided the head is situated in a contrasting light, starker contrasts arise between the shaded and fully lit parts of the face. The effort to depict this more expressive modelling often leads to a certain lack of colour more typical of the classic approach to painting.

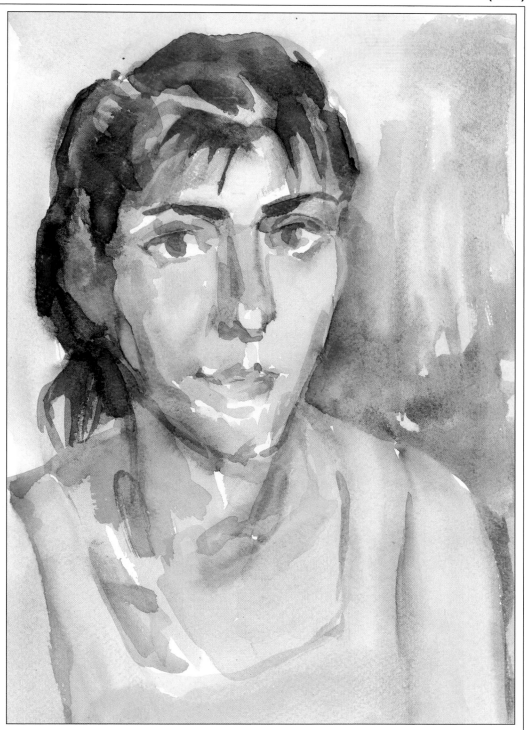

This portrait of a girl exemplifies the transposition of light gradations into colour.

Modern contemporary approach tends to be based on less contrasting light, which facilitates the use of colour in a purer form, less modified by light and shade. But pronounced differences between light and shade do not preclude preserving the purity of colour if we are able to transpose light values into colour values based on their tendency to stand out in the foreground (warm colours) and to recede into the background (cool colours).

Practical exercises

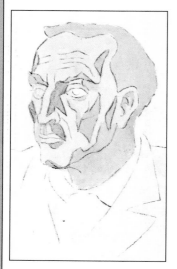

Schematic illustration showing the construction of a head in colour and volume.

A freely painted schematic working procedure using warm and cool colour glazing for modelling.

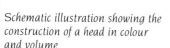

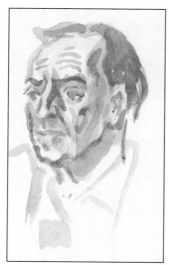

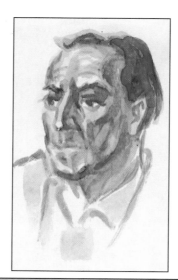

A step-by-step and methodical painting procedure consisting of a considered and careful application of colour in small areas of pre-sketched shapes corresponds to the (previously mentioned) detailed structural drawing.

At first we chose pure, translucent and not too intense colours, working from lighter towards darker parts within the observed range of tonal value gradation.

Light areas (the brightest of which there will be few and can be omitted at first) should be dealt with depending on the colouring of the model, in the weakest tones of reds (ideally brownish reds) and ochres. Shadows can then be applied in a cooler tone mixed from green with an admixture to break it, or blue with an admixture of red. The colours used for the parts in light and shade will differ from model to model and must be carefully observed in order to achieve the optimum combination. Shadows usually appear greyish or brown, and the inexperienced watercolourist will often mistakingly use also black. This is a serious error, particularly in watercolour painting, characterized by purity and lightness of tone.

Too strongly contrasting colour surfaces should be avoided, as these tend to fragment the painting. In the early phases of a study this is inevitable, but can be corrected at a later stage by unifying an over-complex surface by glazing.
The next layer of colour should be applied in larger areas and not too richly. This serves to establish the overall colour tone and to influence the colours of the illuminated parts, while leaving out the highlights. Shades are deepened as the model requires.

The procedure described here is but one of many and convenient for familiarizing oneself with how to sketch, model and construct a head in colours. Probably this method will not initially preserve the pure character of watercolour painting to the degree the technique deserves. It, however, facilitates a detailed and thorough study increasing the student's experience.

As has been said, it is eminently suitable for the study of an elderly face with distinctive features.

Painting a younger face with finer and less distinctive modelling calls for a rather different approach such as the wet-in-wet procedure. This facilitates the application of larger surfaces of colour with soft transitions between the various parts.

Let us paint on dampened paper, and first apply the predominant colour tone to the whole face. Another colour to indicate shadows is then applied. After a certain amount of experience it is possible to select these two colours so that they will combine successfully. Features such as the eyes, eyebrows and the line between the lips can be painted by brushing in a fine line in a contrasting colour, which will blur on the damp paper to produce soft shadows. When the undercolour is partially dry, shadows can be emphasized by repeated colour applications, which will help to define the drawing more accurately.

This approach is particularly suitable for the hair, an important feature of the portrait. Painting the hair consists in applying a suitable colour over a larger surface, followed by drawing the shapes and locks (instead of individual strands) typical of both the hair and the hairstyle. When the colour is almost dry, particular strands of hair can be emphasized. The same can be applied to the drawn parts of the face, but only where absolutely essential for fear that heavy-handed drawing would not interfere with the unity of artistic expression.

A variation of this procedure is to paint wet-in-wet instead of on dampened paper, in the same way as thus creating described for other themes. The essence of this technique is the application of large surfaces of colour which merge while still wet where required soft transitions in modelling. In this case drawn components can be included from the outset. The eyes, for example, can be painted directly in colour and modelled into the surrounding area by spreading colour outwards.

The final result is similar to that of the previous method, although it permits a greater precision of expression, because it represents a combination of drawing and painting carried out simultaneously. However, it already presupposes a greater degree of assurance and experience.

Another commonly used procedure is to paint in larger or smaller patches of colour which can overlap and thus create new

Use of colour in a portrait illuminated from the front. First the yellow and ochre tones of the illuminated parts were applied. While these were still wet, light green was added to the sides of the face. This created soft transitions between juxtaposed colour surfaces. The painting was completed in a single sitting without subsequent modifications.

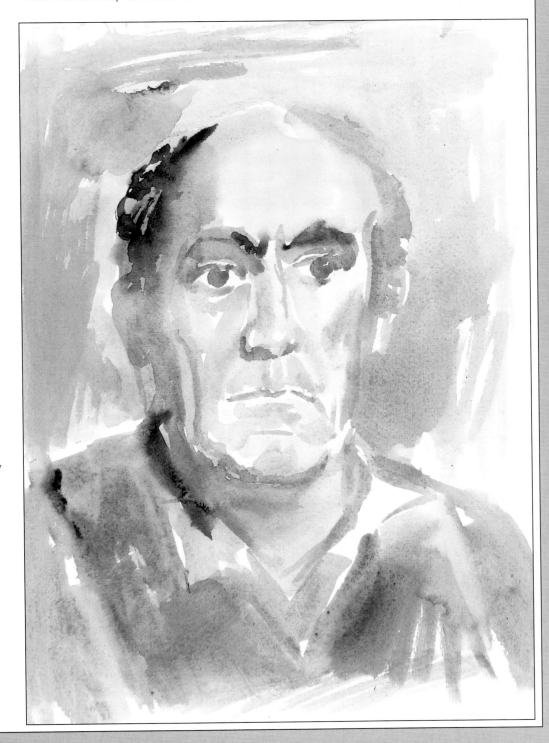

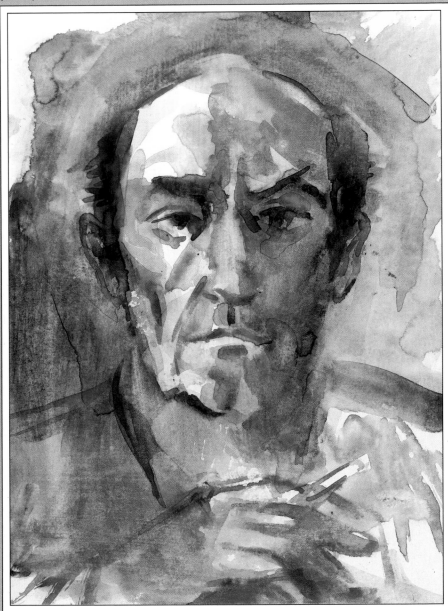

colour combinations. This is a somewhat impressionistic approach in which the painting proceeds towards its final form in a more spontaneous way than when using a more structural procedure. In this case, components of drawing are usually less determinate.

The applied method will depend both on the nature of the model and on the artist's intention and temperament.

Above: Stippling facilitates a step-by-step correction of the characteristic features of the subject to achieve a convincing facial expression.

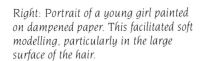

Right: Portrait of a young girl painted on dampened paper. This facilitated soft modelling, particularly in the large surface of the hair.

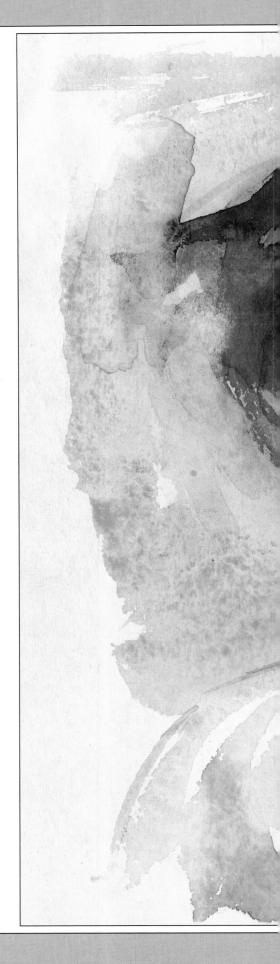

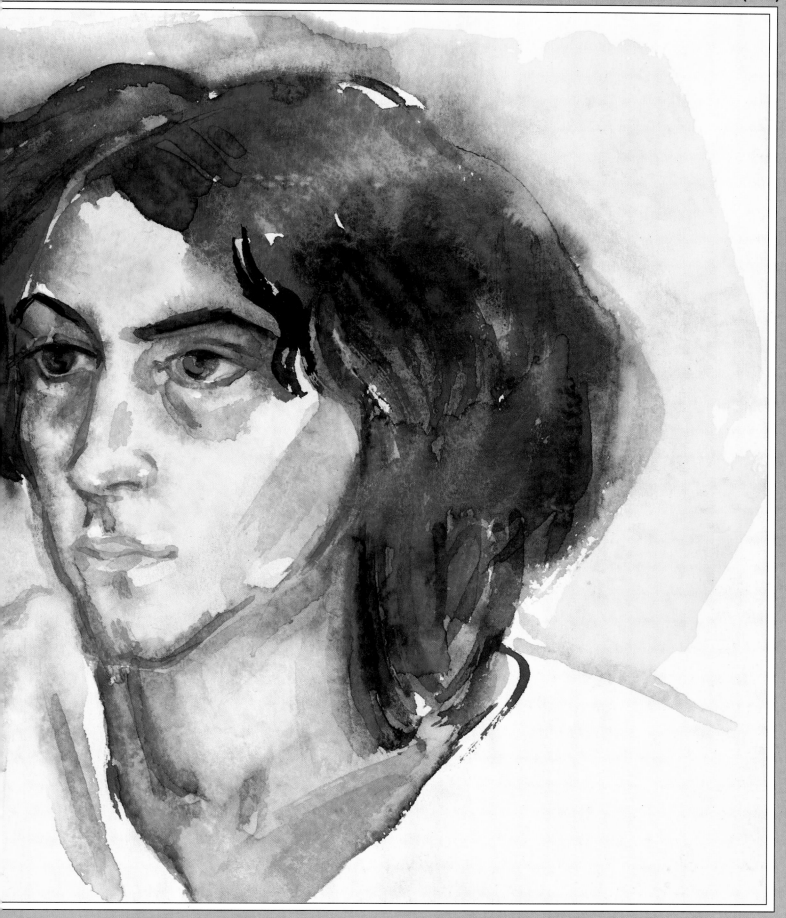

Coloured drawing

The pencil sketch was lightly coloured to capture the fleeting mood of morning lights.

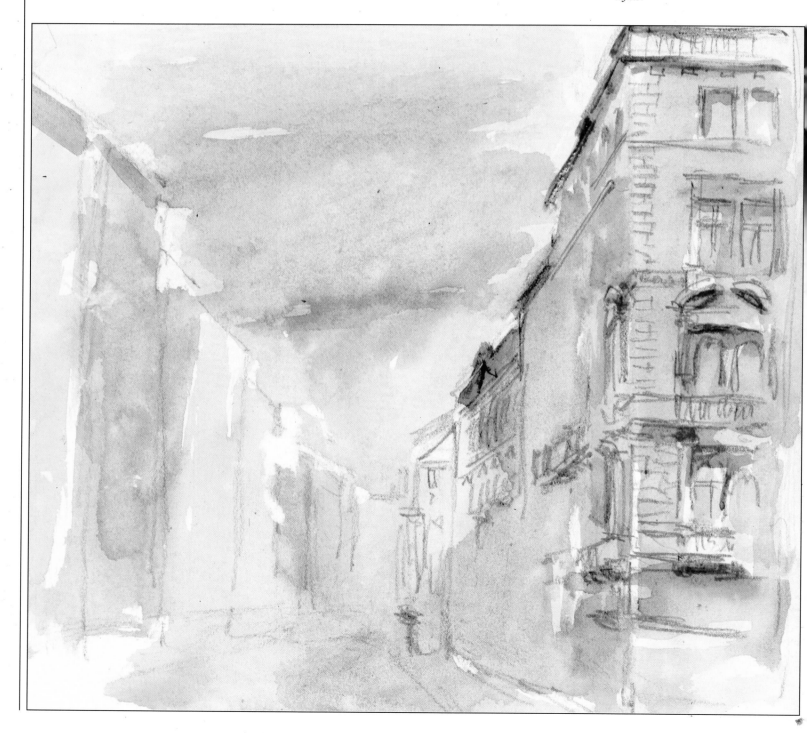

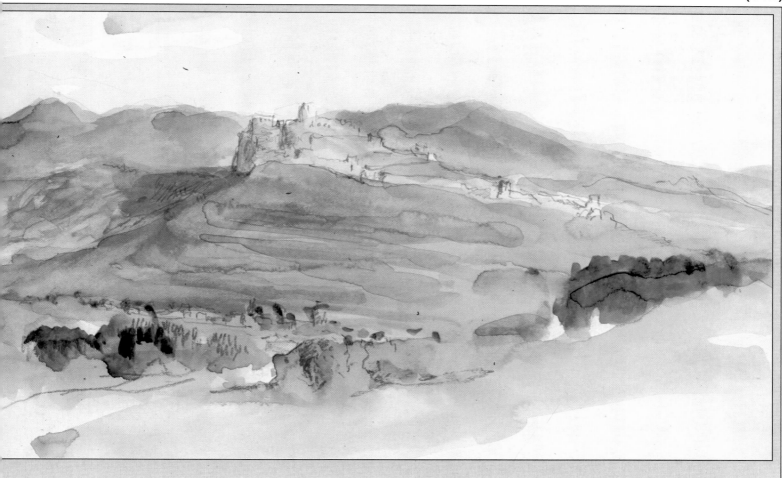

Watercolour (the castle of Spiš) with some pencil drawing is a fast record made in nature. It can be used later (with a more detailed drawing or photography) as a model for a larger painting, possibly in oils.

To complete this account of how to use watercolours something must be said about the combination of watercolours with drawing in pencil or some other material.

In pure watercolour work a pencil sketch serves only as a guideline and therefore tends to be very simple and virtually invisible once the painting is finished. However, a drawing coloured in watercolours is often viewed as a unified whole in which both components, the drawing and the painting, are of equal importance, or in which the role of either can change depending on the artist's intention.

In some cases the drawing can dominate, the colour becoming secondary and intended either to enliven it with colour, or slightly suggest modelling. Many book illustrators set great store by expressive pencil or ink drawn lines to create the contours, which are then filled in with colour. Examples of these and many other methods and combinations can be found in illustrated children's books. Coloured pen-and-ink drawings are a great favourite.

A skilfully drawn, lightly coloured record is often useful for various study and walking tours. A sketchbook filled with studies of this kind can quite often serve as the basis and inspiration for a free rendition in pure watercolour, carried out in the comfort of the home or studio.

Coloured sketches are sometimes more

Economically coloured pen drawing of a nude with colour following the modelling.

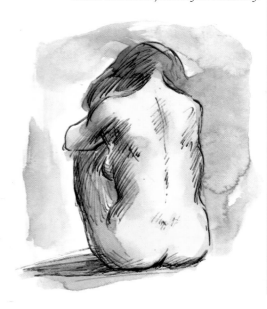

comprehensive than the best photograph, since they are more emotive and can, after some lapse of time, recall the artist's feelings when making the sketch.

Coloured drawings occur in the work of many outstanding artists (e.g. Cézanne). They may be either study sketches or purely visual notes in which the drawing predominates and the painting serves a purely complementary purpose to indicate colour or modelling.

Other known combinations include watercolour and gouache, watercolour and pastel or watercolour finished off in coloured pencil.

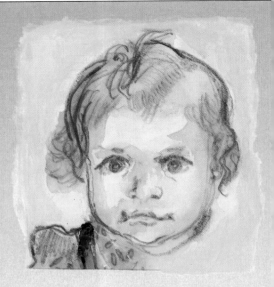

The pencil drawing of a little girl's head is further accentuated by colour. A suitable method for a quick work if there is a lack of time.

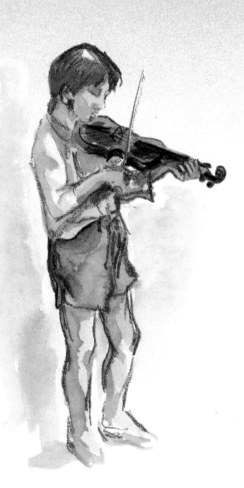

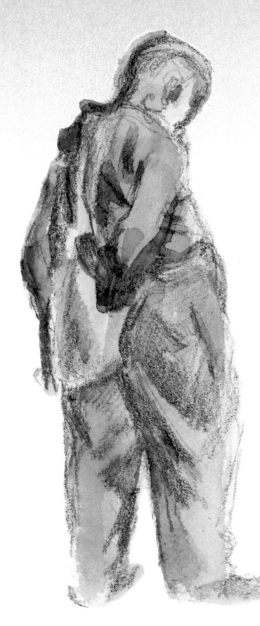

Above: Coloured drawing of a small violinist catches the unique mood of the very moment.

Left: This pencil sketch of a man who is dressing was completed with colour to emphasize drapery.

Gouache

The Italian term *guazzo* denoted
a technique of painting on plaster using
colours diluted in water and fixed with
a binder such as glue or casein.

One of the advantages of gouache is the
ease of mixing colours, as in oil-painting,
combining colouring, blending and
shading of colour with fine gradations of
tones and transitions. However, having
dried the colours will be lighter, which
must be taken into consideration in the
choice of colour and their intensity.

Though gouache is known as an opaque
watercolour, its preference over
watercolour is that it allows for
subsequent correction and change. This is
done by carefully applying water to the
place which needs to be corrected,
modified or changed and then painting
again on the dampened surface.

Since fading due to the paint drying is
uniform, the harmony between the colour
correlations will not be disturbed.

*This portrait was painted on a tinted
ground, using mainly white to create
the plastic impression of the facial
structure. This 'lightening' painting
procedure was frequently used in
classic painting. The portrait has been
left unfinished to illustrate this
procedure. In the next phase the
appropriate colour tones would have
been applied to the wet or semi-dry
underlayer. They could also be applied
to a completely dry ground, provided
the final phase allows for complete
overpainting. When only some parts
of a painting are to be overpainted it
is necessary to redampen them
carefully to regain the original
colours. Gouache dries to a lighter
shade, which must be taken into
account at every subsequent
modification made to a painting.*

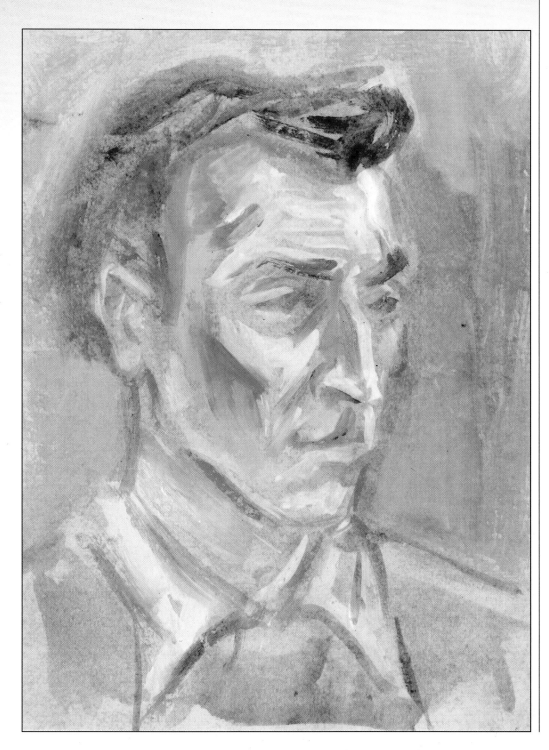

PROPERTIES OF GOUACHE COLOURS

Modern gouache is a painting technique using water-based colours which, unlike watercolours, are opaque, not transparent. This is caused by the admixture of white, which produces opaque, lighter, more subdued tones. Gouache is a luminous painting with a distinctive beauty of its own that closely resembles pastels in character.

The final effect is two-dimensional and decorative, which has made it a frequently used technique for murals. The choice of subjects should respect these properties.

Gouache paints may have a paste-like character, depending on the particular binder. Tragacanth is often used but methyl cellulose has much the same effect; it is, however, less stable and therefore needs to be combined with some reliable aqueous binder.

Gouache paints on tinted paper.

SUPPORT MATERIALS / USING GOUACHE

Papers used for gouache technique tend to be darker and colour-tinted. This darker ground helps to bring out the more subdued, opaque colour tones of gouache, which fade to a lighter shade when dry to produce a specific, pastel-like, subtle and ethereal effect. Here the quality of paper is not so crucial as it is for watercolour, although it should be fairly thick to cope with the effects of dampness.

Round brushes are mainly used for gouache work. Flat brushes with bristles can be used for larger formats.

Gouache painting is done on dampened paper. A constant level of dampness throughout the of work is maintained by placing blotting paper or damp fabric underneath it. Alternatively, if the paper is stretched in a frame, it can be regularly dampened on the reverse side.

Like any other technique, gouache has both advantages and disadvantages, and you must study it thoroughly to be able to use it to its full extent.

The gouache technique can easily be used for large format paintings, mural paintings on parget or plaster. The wall is dampened prior to painting and retains the moisture as long as required.

Let us give one example: the murals of the Czech painter Josef Navrátil (1798–1865), who decorated a number of Bohemian castles. His paintings in the castle at Libĕchov are particularly well-known. Navrátil also painted a number of delightful small gouaches with landscape and figural motifs.

A gouache painting can be either finished off or combined with pastels. The closeness of the two techniques is supported by the experience that gouache colours can be produced by mixing pastel powder in a solution of tragacanth or cherry gum.

Tempera is nowadays preferred to gouache and is comparable to it to some extent. Tempera colours also lighten when dry, can be spread and are non-transparent. Since tempera dries to a somewhat harder finish it does not produce such a soft effect as gouache.

This in turn affects the choice of suitable themes. Although basically any technique can be used to paint any subject, some techniques offer a range of characteristics which lend themselves to certain themes to a greater or lesser extent.

The character of gouache makes it very suitable for landscape painting, in which it can achieve spatial effects by gradating colour tones and values, which helps to create an airy perspective.

Gouache can also be used for painting architecture. Compared to the freer water-colour technique it facilitates a more precise rendition of concrete details. Various architectural features, houses and walls which attract attention through their diversity and the structures of their surfaces are all suitable for trying out gouache.

Gouache colours can also be used for painting flowers.

Right: This unfinished gouache painting of a bunch of tulips was done on dampened grey-tinted paper. Excess water was removed with blotting paper. Once the ground was prepared the diluted colour tones of the flowers and the background were applied onto the still damp surface. As the paper gradually dried off more paste-like colours were used to indicate the lighter, more brightly-coloured parts of the flowers. When the undercolour is semi-dry it is possible to paint into it using a different colour to create colour shades and flower volume. The background was only partly indicated with colours. Elsewhere the grey paper was left showing through. This painting is a typical example of pastel-like gouache technique.

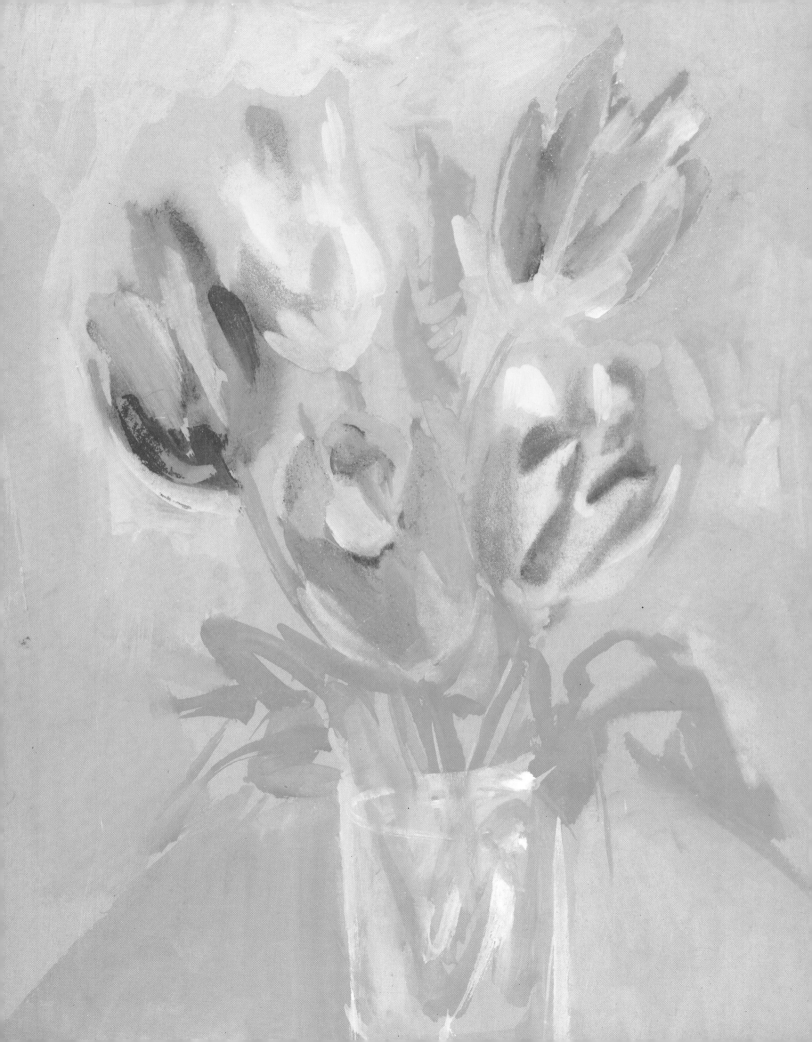

Practical exercises

A number of examples are given here to illustrate the typical characteristics of gouache colours and the way of working with them.

The working procedure may differ depending on the character of the model and the impression it makes on the painter. Before beginning he should assess the difference in substance of the various objects (flowers, vessel, landscape, sky), which determines a specific use of gouache.

The opaqueness of gouache paints helped to express the rough mass of the rocks and breakers. The detail shows use of paste-like colour layer on the underpainting. Compare with the watercolour on p. 64.

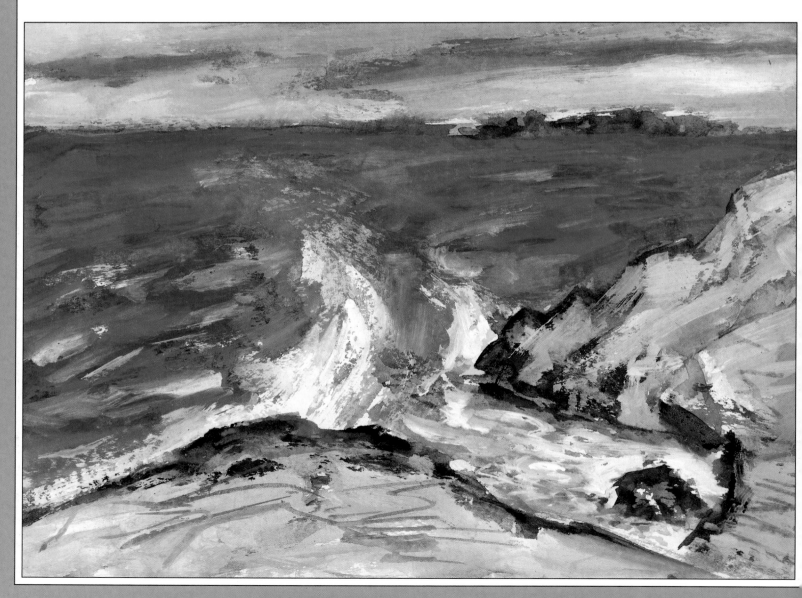

The preliminary sketch should be painted with thinner colours, which are then overpainted by more paste-like layers of thicker colours. Colour layers must not be too thick or the paint may crack. A gradual admixing of white to a colour where a lighter tone is needed helps to create volumes and space. This can be done both on a wet ground and on dried underpainting. Gouache permits relatively free use of brush and colour. Since gouache paints are opaque (unlike watercolours) overpainting presents no problem.

The still-life with bread and coffee pot, carried out in watercolour on p. 52, is another example of gouache painting. The mass of the pots is created with the aid of paste-like white paint. See also the detail.

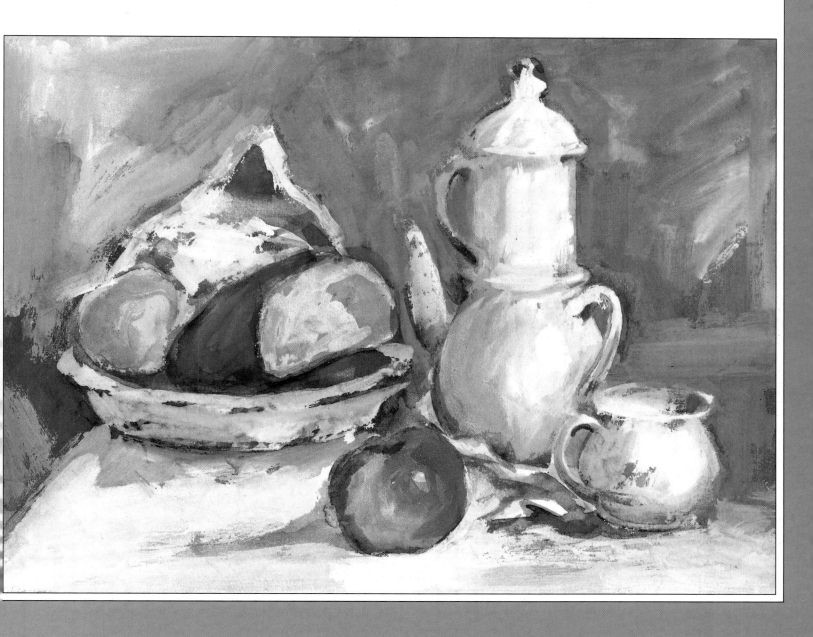

The stand of trees in the picture
demonstrates the technique of
watercolour combined with gouache.
Large surfaces of watercolour were
applied as the underpaint, over which the
painting was then completed in gouache.
This helped to indicate the volume and
structural complexity of the trees. The
alternation of transparent watercolour
surfaces with thin brush strokes using
pasty gouache also deepened the inner
spatial effect of the trees.

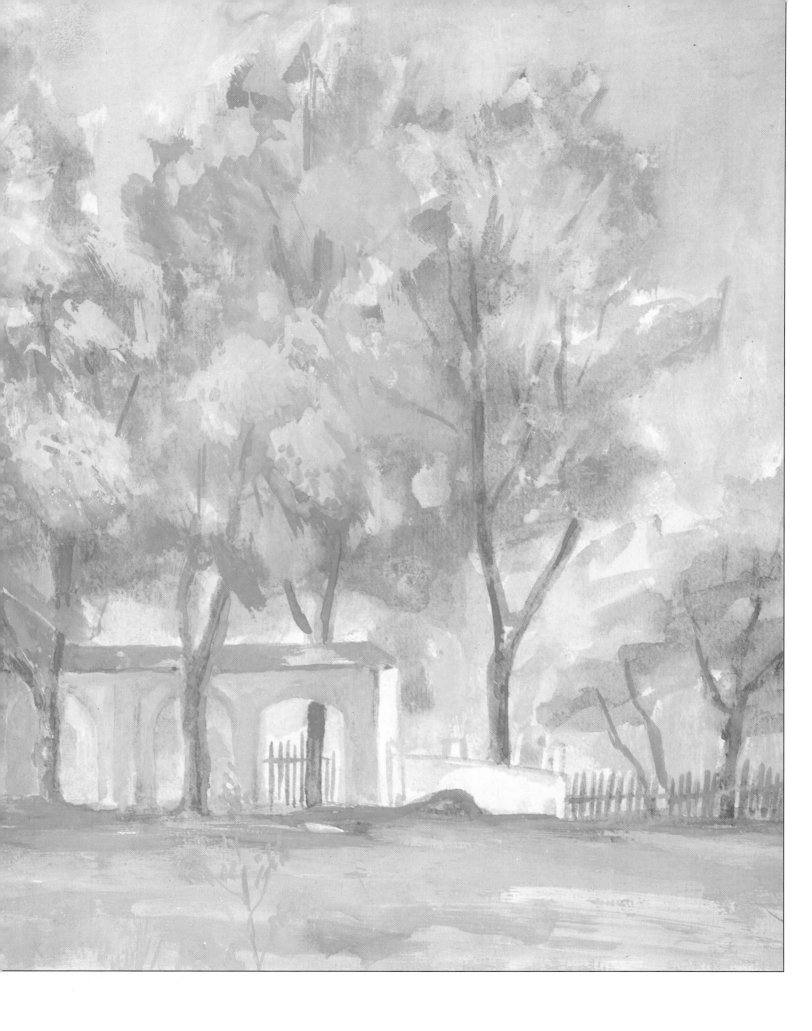

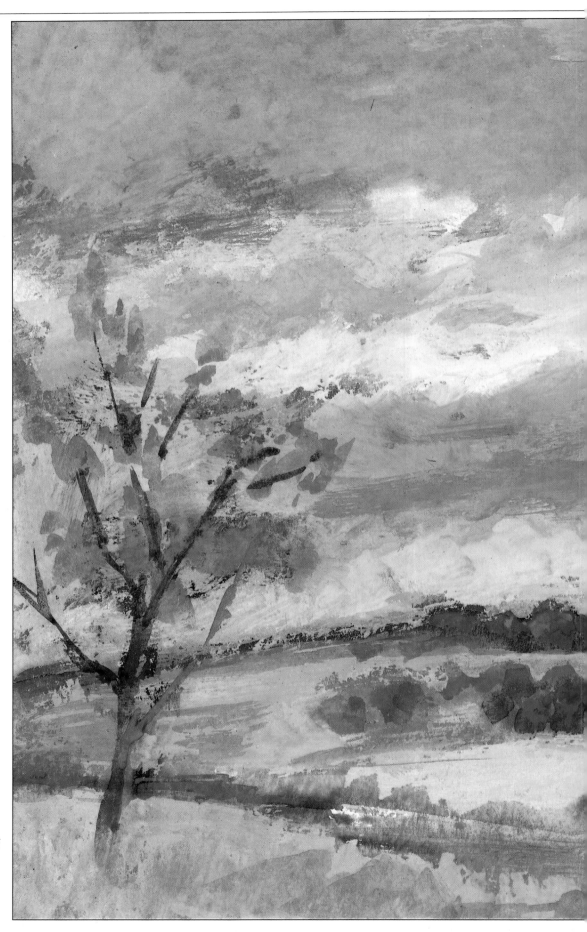

The picture of an undulating landscape with low horizon and higher content of the sky is a combination of watercolour (underpainting) and gouache (completion). The reason for this choice of combination was the attempt to differentiate between the landscape and the windswept sky. Watercolour technique is visible in the foreground and on the nearest shrubs and trees.

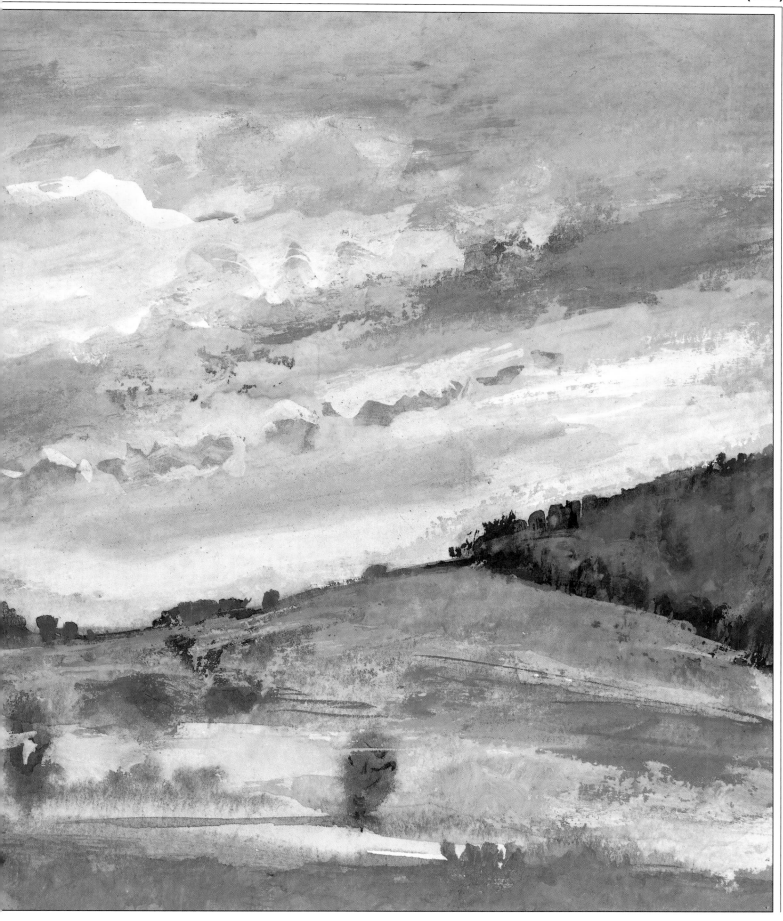

Conclusion

What can be said in conclusion? Having read this book anyone interested in watercolour painting and gouache will have learned a great deal about the techniques and their uses. You have acquainted yourselves with various working procedures which can be used to treat a diversity of genres ranging from the very simplest to more complex and demanding.

Not everyone interested in watercolour painting will be equally interested in all genres. Many readers will have a natural inclination towards a particular one, such as landscapes. By the same token, the methods recommended here are not necessarily the only ones which will suit budding watercolourists. This is natural enough, considering the changes painting techniques have undergone especially in the twentieth century. The rules guiding them in the past and which had a decisive influence on style have often been broken or totally forgotten in modern development. This has been reflected in various painting techniques, including watercolour. Nevertheless, the basic characteristics and potential of watercolour have remained the same, even though they may not always be used in the same way. Compare, for example, the free expressive watercolours of E. Nolde with those of the nineteenth century, which are marked by a more solid stylistic conception and a concern for realistic description.

This is why this book has also dealt with various approaches to watercolour painting to give students a chance, after gaining some experience, to choose the method best suited to their preferences, equipment and inclination.

If the hints and suggestions contented in this book help to contribute to the pleasure you find in painting and to the satisfaction at achieving good results, the publishers will be gratified, too.

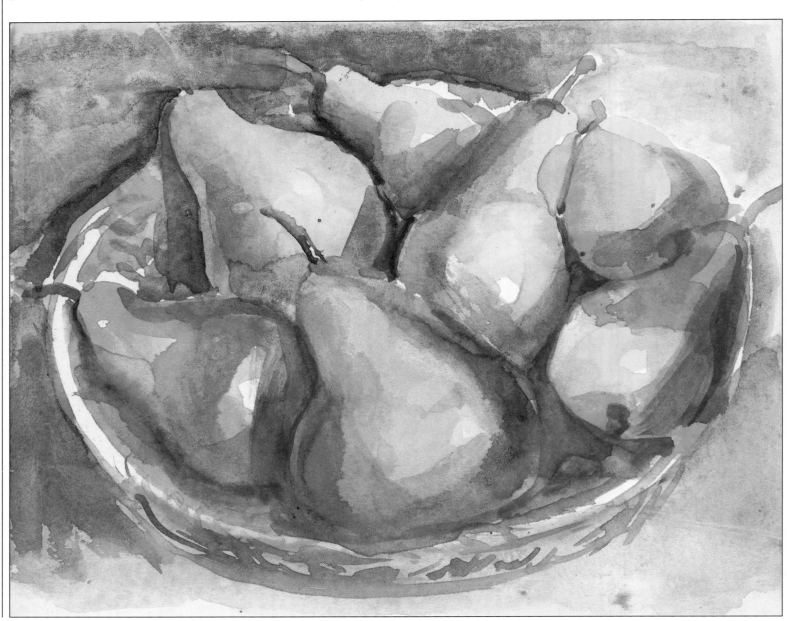

LIST OF FURTHER READING

Becket, W., and Wright, P., *The Story of Painting*, Dorling Kindersley Ltd., London 1994.

Das grosse Lexikon der Malerei, Georg Westermann Verlag GmbH, Brunswick 1982.

Doerner, M., *The Materials of the Artist*, Hart-Davis, London 1953.

Gair, A., *The Complete Step-by-Step Portrait Painting Course*, Reed Consumer Books Ltd., London 1993.

Gettens, R.J., and Stout, G.L., *Painting Materials*, Dover, New York 1960.

Hégr, M., *Malba, materiály a techniky* (Painting, materials and techniques), Orbis, Praha 1953.

Hlaváček, L., introductory word in *Mikoláš Aleš – Akty* (Nudes), Dekon, Praha 1993.

Lamač, M., *Paul Klee*, SNKLHU, Praha 1965.

Laurie, A.P., *The Painter's Methods and Materials*, Dover, New York 1967.

Losos, L., *Painting Techniques*, Artia–Octopus Books, Praha–London 1987.

Mayer, R., *The Artist's Handbook*, Faber, London 1973.

Mráz, B., and Mrázová, M., *Encyklopedie světového malířství* (Encyclopedia of the world's painting), Academia, Praha 1988.

Nicolescu, V., *Turner*, Meridiane Publishing House, Bucharest 1976.

Sabarsky, S., *Emil Nolde – Akvarely a grafika* (Watercolours and pieces of graphic arts; exhibition catalogue), Goethe Institut Prag and
 České muzeum výtvarných umění, Praha 1994.

Slánský, B., *Technika malby I. – Malířský a konzervační materiál* (Painting techniques I – Painting and conservation materials), SNKLHU, Praha 1953.

Slánský, B., *Technika v malířské tvorbě – Malířský a restaurátorský materiál* (Painting techniques – painting and restoring materials), SNKLHU, Praha 1953.

Taillandier, Y., *Cézanne*, Bonfini Press, S.A., Naefels, Switzerland 1977.

Vinner, A.V., *Akvarel a kvaš* (Watercolour and gouache), Bratislava 1953.

Wittlich, P., *Česká secese* (Bohemian Art Nouveau), Odeon, Praha 1985.

INDEX